COAL HOLLOW

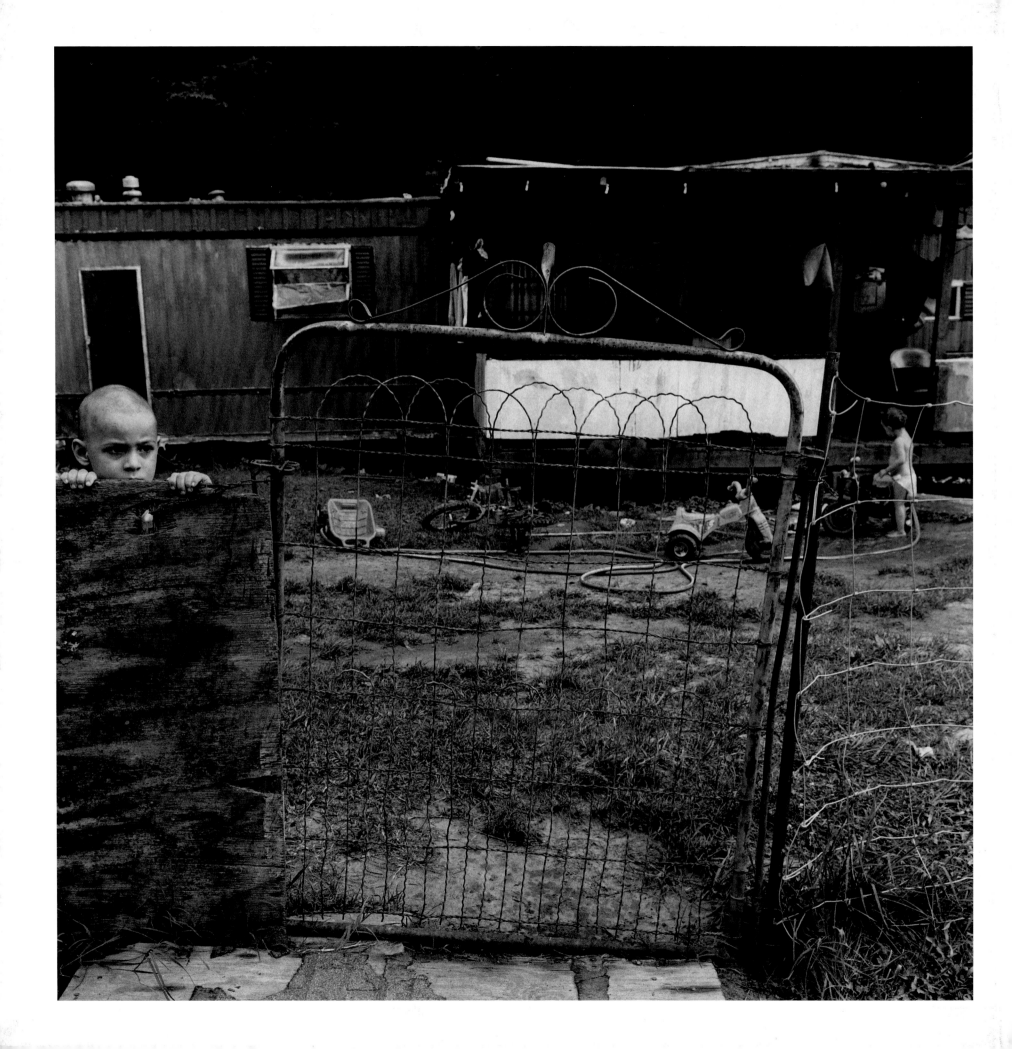

COAL HOLLOW

Photographs and Oral Histories

Ken Light and Melanie Light

With Forewords by
ORVILLE SCHELL and ROBERT B. REICH

UNIVERSITY OF CALIFORNIA PRESS
BERKELEY LOS ANGELES LONDON

Published in association with the Graduate School of Journalism,
Center for Photography, University of California, Berkeley

SERIES IN CONTEMPORARY PHOTOGRAPHY

**CENTER FOR PHOTOGRAPHY, GRADUATE SCHOOL
OF JOURNALISM, University of California, Berkeley**

Ken Light, Editor

Chicago's South Side, 1946-1948,
by Wayne F. Miller

*Assignment: Shanghai
Photographs on the Eve of Revolution,*
photographs by Jack Birns,
edited by Carolyn Wakeman and Ken Light

Sahel: The End of the Road,
by Sebastião Salgado

Coal Hollow: Photographs and Oral Histories,
by Ken Light and Melanie Light

University of California Press, one of the most distinguished university presses in the United States, enriches lives around the world by advancing scholarship in the humanities, social sciences, and natural sciences. Its activities are supported by the UC Press Foundation and by philanthropic contributions from individuals and institutions. For more information, visit www.ucpress.edu.

University of California Press
Berkeley and Los Angeles, California

University of California Press, Ltd.
London, England

Library of Congress Cataloging-in-Publication Data

Light, Ken.
 Coal Hollow : photographs and oral histories / Ken Light and Melanie Light ; with forewords by Orville Schell and Robert B. Reich.
 p. cm.—(Series in contemporary photography ; 4)
 ISBN 0-520-24654-3 (cloth : alk. paper)
 Includes bibliographical references.
 1. Coal-miners—West Virginia—Pictorial works. 2. Coal-miners—West Virginia—Interviews.
3. Poor—West Virginia—Pictorial works. 4. Poor—West Virginia—Interviews. 5. Coal mines and mining—West Virginia—Pictorial works. 6. West Virginia—Environmental conditions—Pictorial works. I. Light, Melanie, 1958-. II. Title. III. Series
HD8039.M62U646 2006
622 .344 0922754—dc22 2005015749

Manufactured in Hong Kong

15 14 13 12 11 10 09 08 07 06
10 9 8 7 6 5 4 3 2 1

The paper used in this publication meets the minimum requirements of ANSI/NISO Z39.48-1992 (R 1997) (*Permanence of Paper*).

FRONTISPIECE: DOUBLE-WIDE ALONG THE HIGHWAY. PREMIER, WEST VIRGINIA, 2002.

CONTENTS

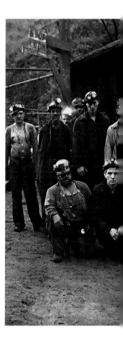

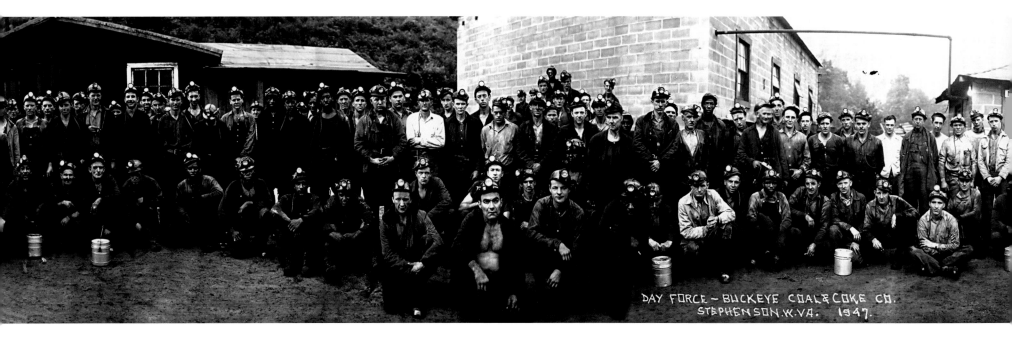

DAY FORCE—BUCKEYE COAL&COKE CO.
STEPHENSON.W.VA. 1947.

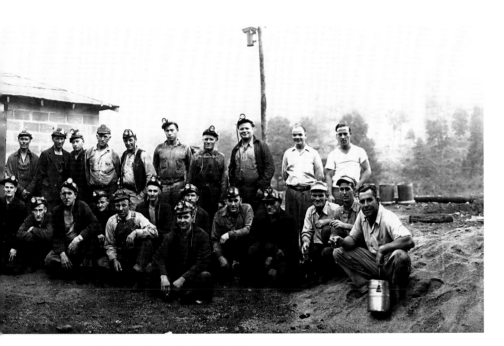

"Day Force, Buckeye Coal & Coke Co."
Stephenson, West Virginia, 1947. Photograph by
Rufus "Red" Ribble, George Bragg Collection.

FOREWORD

Orville Schell

Coal Hollow is a collaborative work that grows out of a long tradition of engaged documentary journalism. This tradition has evolved through a whole genealogy of photographers and reporters who, although often raised and educated in relative privilege, became interested in how others less fortunate than they worked and lived. Ultimately they were moved to undertake a kind of journalistic fieldwork, similar to what anthropologists and sociologists do. These reportorial pilgrims have had to cross the formidable barriers that have always divided classes, races, and cultures. Often what propels them in their explorations is a quite visceral indignation at the inequities suffered by fellow human beings.

Such odysseys can involve greater distances, in figurative terms, than far-flung journeys to exotic places. Bridging these distances is a delicate task, for if they are reported with even a whiff of condescension, self-righteousness, or infatuation with the "nobility of poverty," the work becomes as flawed as a cracked bell.

One of the founding fathers of this genre of documentary journalism that focuses on the lives of working people at the very bottom of the social ladder was George Orwell. Orwell's most famous works in this vein were *Down and Out in Paris and London* and *The Road to Wigan Pier*. The latter is a gritty chronicle of working-class conditions right in Orwell's own country, especially in the collieries of northern England.

In 1936 Orwell went to Wigan, a coal mining center between Manchester and Liverpool. He described it as a desolate area, "a world from which vegetation had been banished," a place where nothing existed but "slag heaps,

belching chimneys, [and] blast furnaces." It was here that he first entered a coal mine, an experience that made a profound impact on him. He found the working conditions of the miners—"line[s] of bowed, kneeling figures, sooty black all over"—unimaginably harsh. Over the next few months he wrote about what he saw and experienced in a diary that was the source for *The Road to Wigan Pier*.

Although he had gone to Eton, Orwell always felt himself an outsider, a trait that irrevocably divided him from the world of elitist Oxbridge Socialist intellectuals who became Britain's progressive movement in the thirties. For Orwell it wasn't enough simply to read and debate; he felt almost driven to share the life experience of his subjects. "I wanted to submerge myself," he wrote, "to get right down among the oppressed, to be one of them and on their side against their tyrants… See what their lives were like and feel myself temporarily part of their world."

Two other legends of this new kind of documentary journalism were the photographer Walker Evans and the writer James Agee, who in the 1930s set out like Orwell to make "a photographic and verbal record of the daily living and environment of an average white family of tenant farmers" in the American South. The result was the classic *Let Us Now Praise Famous Men,* which at the time was so original that several publishers turned it down before it finally found a home in 1939.

As in this work by Ken and Melanie Light, Agee and Evans agreed that it was essential to make the photos and texts equally important parts of the larger project of telling the story. As Agee wrote, "The photographs are not illustrative. They, and the text, are co-equal, mutually independent and fully collaborative."

Great collaborations of photography and print journalism succeed in showing a much more three-dimensional world than print or photography alone. They seek, as Agee put it, to make "an independent inquiry into certain normal predicaments of human dignity." Into this interactive equation, Agee also adds the reader and viewer. He calls such three-way communication "an effort in human actuality, in which the reader is no less centrally involved than the authors and those of whom they tell."

But Agee also has to admit that there is something "curious, obscene, terrifying, and unfathomably mysterious" that people with social privilege (Agee had gone to Exeter and Harvard) inevitably feel as they trek off to a place without privilege like Alabama to "pry intimately into the lives of an undefended and appallingly damaged group of human beings, an ignorant helpless rural family, for the purpose of parading the nakedness, disadvantage and humiliation of these lives before another group of human beings, in the name of science, of 'honest journalism.'"

Agee goes on to interrogate his own motives, asking: "Why we make this book, and set it at large, and by what right, and for what purpose, and to what good end, or none…"

It is an important question.

For Agee, all is justified in an "effort to perceive simply the cruel radiance of what is." But he also harbors a hint of hope that efforts to document the plight of these "human beings, living in this world, innocent of such twistings as these which are taking place over their heads," as they are "investigated, spied on, revered and loved," may leave some readers "kindly disposed toward any well-thought-out liberal efforts to rectify the unpleasant situation down South."

The job of good photo and print journalism is not necessarily to always "make a difference." Sometimes it is enough simply to bear witness. But most good journalists also share a lingering hope, however tentative, that their work will, in fact, somehow make a difference.

One cannot read the interviews or absorb the photos of Ken and Melanie Light's disturbing book and not sense this subterranean wish that life were not as it actually is for the coal miners and their families that they document in *Coal Hollow*. Like Orwell in Wigan or Agee and Evans in Alabama, a sense of respect and sympathy for their subjects radiates in myriad ways throughout all of their work. It imbues this book with a smoldering, unspoken feeling of outrage—but also with profound empathy.

Perhaps this sense of conscience comes from "living inside the subject," as Evans put it. Or from some almost ineffable feeling that derives, as Agee wrote, from the "strange quality of their relationship with those whose lives they so tenderly and sternly respected."

It is this underlying respect and sympathy, so abundantly evident in most great documentary photography and writing, that manages to transform subjects from bewildered people ravaged by difficulties into fellow human beings. Behind this alchemical ability to catalyze a photograph of misfortune from mere image into something truly evocative, or a piece of writing from a mere telling into something truly moving, lies the genius of great journalism.

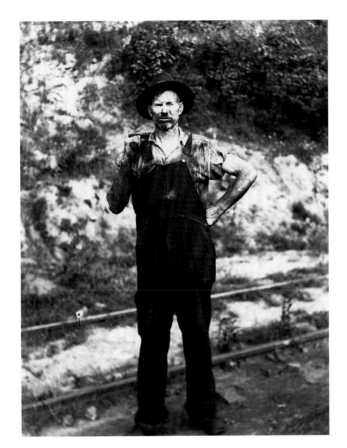

Coal tipple worker. Fayette County, West Virginia, ca. 1922.
Photograph by Rufus "Red" Ribble, George Bragg Collection.

FOREWORD

Robert B. Reich

I remember my first trip to the coal mines of West Virginia, as U.S. secretary of labor. I was slightly worried about traveling deep into the earth and then walking a mile or more through mining shafts measuring five feet by five feet. My staff assured me that it would be safe, that the shafts were well ventilated and the ceilings firm. Nonetheless, I wasn't looking forward to the experience. I've always suffered a mild case of claustrophobia, and the thought of being down there sent my head spinning.

As we descended into the darkness, accompanied by half a dozen miners and their supervisor, I tried thinking about what it would be like to do this every day. Mining coal is safer and more automated than it used to be, but it's still dangerous work. And it's still hard on the mind and the body. It corrodes lungs, tests muscles, tears ligaments. It subjects miners to long hours under the earth. The people who accompanied me had been doing this job for many years. The strain showed in their faces, in the way they stood, in how they spoke.

Why did they mine coal? I asked. Because of the money, they replied. They could earn more mining coal than they could selling fast food or working as hotel clerks or hospital orderlies. Their fathers had done it. Their families had worked the mines for generations.

The elevator reached bottom, and we set out through the shaft toward where the seam was being mined. I'm less than five feet tall, so the five-by-five shaft posed no obstacle for me; the others had to bend. The lights on our helmets revealed the way. As we walked, I focused my mind on what I knew of the labor history of the industry—the fiery John L. Lewis and his United

Mine Workers union, the strikes and labor stoppages that had once rocked the entire U.S. economy, the mine explosions and other disasters. I tried not to think about how far we were below the earth's surface, and how tiny the space was.

When we finally reached the long wall where the coal was being cut, I was surprised by the complex machinery. Somewhere in my mind I'd pictured miners with pickaxes. But these miners were technicians. They monitored dials, took measurements, oiled the equipment. They were in constant motion, continuously vigilant. The machines were huge and loud, and I could feel their vibrations through the floor of the shaft. As the coal seam gave itself up, the miners inserted metal joints to prevent the slabs of coal ceilings from collapsing. (This seemed risky; as I watched, part of one ceiling collapsed notwithstanding.) I was pleased to see it all up close but was also pleased when it was time to leave.

For generations now, coal mining has not only used up people; it has also used up the environment. Coal mining is but one part of a giant system for creating the energy on which our economy depends. But, like many parts of this worldwide system, it is not sustainable. The goods and services we buy are being purchased at a price we can't possibly afford over the long term—that price is the depletion of our natural world. Many of the former hills of West Virginia are now leveled, and the former valleys and hollows are filled in. Abandoned mines fill with water, and the land over them is caving in. Coal seams that were once easily accessible now require deeper mines, longer shafts, more disruption at the surface. Keeping these sites safe necessitates more complex equipment and more intensive monitoring.

There is growing evidence that the survival of societies depends on how they treat their human and natural resources, for that is, ultimately, all they have. History shows that societies tolerating larger and larger disparities of wealth and opportunity—which, in effect, evolve into small classes of rich owners and larger ones of poor providers—become unstable, susceptible to riots or violent revolutions or to demagogues spewing hate. Societies that use up their scarce natural resources likewise become vulnerable—to food shortages, diseases, or climate changes.

Twenty-first-century America is strong, in many respects. But we are not investing enough in our long-term survival. For a society as rich as ours, we are not treating many of our working people nearly as well as they should be treated. Disparities of income and wealth are wider than they've been in more than a century, and the middle class is shrinking. Nor are we taking adequate care of our natural environment. In too many instances, we are plundering it.

The following pages present a vivid visual and written record of the human and environmental costs of coal mining in America—and, by implication, the costs of how we have organized our economy and society. Ken Light's wonderfully haunting photographs and Melanie Light's evocative oral histories allow us to understand what is normally hidden from view—hidden even from labor secretaries who might visit coal mines from time to time. And such understanding is the first step toward committing ourselves to a better and more sustainable future. My thanks to Ken and Melanie, and also to the Graduate School of Journalism at the University of California, Berkeley, for helping bring this volume to fruition.

TO OUR DAUGHTER, ALLISON ROSE,
WHOSE ENDLESS JOY AND UNWAVERING
BELIEF IN JUSTICE HAS PROMPTED US TO
MOVE BEYOND OUR PERSONAL LIMITS.

ACKNOWLEDGMENTS

Sometimes the rugged hollow roads can swallow you up. But the hands of many friends and strangers always pointed us in the right direction, answering questions, giving directions, introducing us to others, and sending us off on new adventures. Many people that we would love to acknowledge were part of small, chance encounters that seemed inconsequential at the time but later proved to be important connections. Others are colleagues who love this region and shared with us their wisdom and knowledge about Appalachia. Both of us are deeply grateful for the generosity and honesty expressed by all the people who participated in this project. It is certainly not easy to share your life with a stranger, yet all the people in this book trusted us to tell this very important story about the long-term consequences of a government that yields too easily to the pressure of private industry. It's really true that people in West Virginia are the most friendly and helpful people in the world.

This book would not have been possible without the continuing support of Orville Schell at the Graduate School of Journalism at the University of California, Berkeley, and the generous and ongoing support of Susie Tompkins Buell, who is committed to seeking a better America.

· · ·

Together, we want to thank the many people who took time to tell us personal stories and to discuss the issues involved in mining. Their contributions gave our research depth and breadth. We thank George Bragg for his help with the region's historical photographs. Annette Fox, at the *Register-Herald* in Beckley, West Virginia, did everything possible to help put us in touch with the right

people, as only a deeply committed journalist could. Steve Fesenmaier at the West Virginia Library Commission was fully prepared to educate us via film about coal mining issues in Appalachia. He spent a great deal of time hand-picking films for Melanie to view, all of which deepened her understanding of a part of America she had not experienced before.

Jack Spadaro's insights and his knowledge of mining practices in the region were immensely important to this project. Jimmy Shumate's unpublished manuscript about his life in a coal camp gave us a vivid sense of the miners' lives before mechanization. Long conversations over liver sandwiches with Jerry Herndon could fill their own book. John Williams offered early advice about the region and wise guidance, as did Merle Moore. Dorothea and Stanley Light watched our daughter, Allison, as we traveled the backroads of West Virginia, making our journey together easier. And a big thanks to former secretary of labor Robert B. Reich for taking the time to look at this project and write a foreword.

FROM MELANIE

First and foremost, I want to thank Ken for his unflagging faith in the project and in my ability to pull the text together. His focus and persistence are remarkable, and he is also fun to work with. It has been a privilege and a gift to collaborate with Ken and a wonderful way to expand our lives together.

Ken might never have approached me to write this project had it not been for Inez Hollander Lake, who was my writing instructor. In addition to providing spectacular coaching, she believed in me and persuaded me that I really am a writer. I would also like to thank the members of Inez's writing group for their kind support and incisive feedback. Alison Owings read the early manuscript and asked all the right questions. Later, as I wrestled with how to integrate the oral history material with the pictures, Lonny Shavelson enthusiastically shared his considerable knowledge and offered terrific feedback about different ways to solve this problem. Thanks to Catherine Saint Louis at the *New York Times Magazine* for giving me a research assign-

ment that allowed me to make an additional trip to this region and conduct many more interviews. Finally, I would like to thank the wonderful staff at Asilomar, where I escaped to write at the critical junctures of the project.

FROM KEN

I would especially like to thank Melanie for her wise advice, insightful perspective, and wonderful collaboration in the field and in life. I have wanted to work with her for years, and the opportunity finally came. It has been a stimulating challenge for us to work together outside our daily family routines and a great gift to share this book with her. I look forward to our next collaborative journey.

My colleagues at the Graduate School of Journalism at the University of California, Berkeley, continue to be an inspiration, as each of them perseveres in the challenge to bear witness to the struggles of our time. I want to thank staffers Roy Baril and Scot Hacker for their continuing and cheerful support in response to my computer questions and their help in fixing technical problems. Paul D'Ambrosio and the Mamiya staff made my shoots possible by quickly fixing my cameras. For looking at the ongoing work and sharing their thoughts, thanks to Michelle Vignes, Fred Ritchin, Brian Storm, Christina Cahill, Wayne and Joan Miller, Jean-François Leroy, and Robert Pledge and Jeffrey Smith at Contact Press Images, who also represent these photographs. I am especially thankful to Carl Levinson, Edward Levinson, and Charlotte Talberth for their support.

• • •

Finally, we both agree that the staff at the University of California Press has been amazing and a pleasure: Sheila Levine, Tony Crouch, Nicole Hayward, Rose Vekony, Mary Renaud, Amy Torack, and Randy Heyman all gave generous amounts of time and unstinting support to create this book. The financial support of the Max and Anna Levinson Foundation and the early support of the Puffin Foundation contributed to the photography. To all, a hearty and deep thank-you.

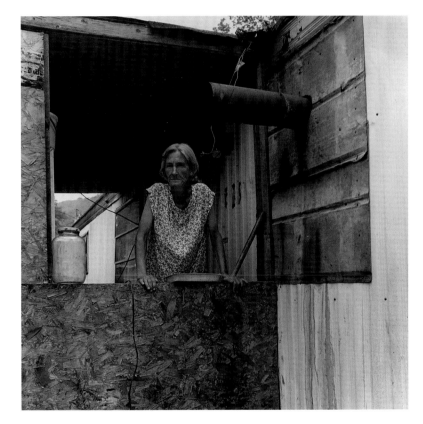

"Momma," fifty years old. Stephenson, West Virginia, 2000.

INTRODUCTION

SLAG

Melanie Light

If it can't be grown, it has to be mined. Look around any room and really consider any random manufactured object. The materials with which it was made came from the Earth: animal, plant, or mineral substances of some kind. No matter the origin, every object we buy has been processed by machines that were themselves shaped and tempered by white-hot, coke-fired foundries. The mining of coal is at the root of the magnificent abundance of things we create. Coal not only produces electricity, but it has thousands of by-products that find their way into items we use every day. Consider this sampling: batteries, aspirin, street paving, germicides, baking powder, toothpaste.[1] We all use coal. We all have a responsibility to know why this versatile substance is produced so cheaply. The core of that story is really the story of Appalachia; how this particular kind of people, their land, and coal, the black fruit of its womb, were an integral element in the rise of the United States as an economic superpower in the Industrial Age. Locked for decades in an intricate relationship between the land, the government, and the owners of coal production, Appalachia today is determined to overcome its handicaps, to rebuild itself and join the mainstream economy. Yet the scars on the land and on the people remain.

The mountain folk of Appalachia are a cultural paradox for much of America. On the one hand, they have been mythologized in a nostalgic way and acknowledged as the source of much American folklore and culture. On the other, they are seen as shameful "trailer trash," ignorant hillbillies. But, in

truth, most Americans do not think about Appalachia at all, sensing that it is caught in an unfashionable past, which is worse than being dead.

Yet these mountain people tell a cautionary tale that we must heed as an aggressive, take-no-prisoners brand of free enterprise is adopted around the world. In our globalized economy, hundreds of millions of people experience the tragic destruction of their lives, communities, and culture as investors roam the globe to find the cheapest labor market. As it stands, the United States no longer owns its means of production, because the manufacture of U.S. goods is largely done in foreign countries. But now even the middle classes of the developed world are beginning to experience the same vulnerability that the indigent and powerless have long faced, as computerized processes and the Internet allow skilled jobs to be moved offshore, where educated workers cost far less to employ. The process of globalization has put enormous power into the hands of the relatively small group of people who run multinational corporations. Governments and national boundaries pose no obstacle to these captains of international industry. As a result, countries will increasingly have similar profiles, with a great divide between the haves and have nots. As the middle classes of countries like India grow, other countries like the United States may develop more pockets that look like Coal Hollow.

The dramatic history of the coal industry in Appalachia is an oft-told story, to be sure. The southern region of West Virginia figures as a central player, not only because it has been historically a very productive source of coal but also because some of the most intense struggles between the miners and the owners and operators took place there. Many beautifully written and compelling accounts of those battles have been brought to the public's attention, albeit with no lasting or substantial effects. Harry Caudill wrote his classic *Night Comes to the Cumberlands: A Biography of a Depressed Area* in 1963. Lon Savage's *Thunder in the Mountains: The West Virginia Mine War, 1920-21* describes the bloody origins of the battle to unionize. Most recently, Barbara Freese compiled a history of the global coal industry in *Coal: A Human History*. The miners' struggle was given mainstream exposure in John Sayles's 1987 film, *Matewan,* which depicts the events surrounding the Matewan Massacre, a precursor to the West Virginia Mine War.[2]

Coal is still king in much of Appalachia. West Virginia, after Wyoming, is the second largest producer of coal in the United States.[3] Coal meets more than half of our nation's voracious appetite for energy. While other developed countries are actively seeking alternative sources of power that do not devastate the environment, U.S. dependence on coal is expected to increase.[4] The business of coal is steady and strong.

The black rock has been a blessing and a curse to us all. Those dirty lumps of fossilized plant and animal life are the essential building blocks of the economic food chain and the foundation of life as we in the developed world know it. In the sixteenth century, England discovered its hardwood forests so decimated that wood had become a precious commodity and there was a serious fuel shortage. The rate of population growth had outstripped the rate of forest renewal. The crown pushed for the development of coal for domestic use, and by 1661 the entire city of London was encrusted with coal soot.[5] The pace of technology and economic development was no longer limited by wood, which could not throw off enough heat for industrial use. In the eighteenth and nineteenth centuries, the tremendous heat thrown off by burning coal fueled the blast furnaces and steam engines that spurred the Industrial Revolution.

There are two basic ways that coal is extracted from the earth: underground mining or surface mining. The oldest and least cost-effective method is underground mining, in which a tunnel is bored into a mountain. The coal is then blasted and hauled to the surface, where it is separated from the accompanying shale, sandstone, clays, and other refuse, known as slag. The coal is loaded directly onto a railcar, and the slag is left in a heap. Surface mining, which can be done by strip mining or mountaintop removal, has been controversial from its inception because the damage to the earth is so dramatic and severe. Strip mining became the dominant method in the 1960s and early 1970s. This process involves stripping away all the unwanted layers of earth to expose the coal, which is fractured with explosives to allow removal. The land is then reclaimed by grading, compacting, and replanting the spoil, or slag. The newest surface mining method, mountaintop removal, entails blowing up and removing entire mountaintops to expose the coal seam. Although this process requires more capital and engineering skill, "it allows the operator to extract virtually the entire coal seam. . . . Today it is economical to remove as much as two hundred feet of mountain to reach a sizable coal seam."[6] None of the mined area is backfilled or reclaimed; it is merely pushed into an adjacent valley or hollow. The raw, exposed land and the filled-in valley become very unstable; this is particularly true in the Appalachian environment. The extracted coal is washed in slurry ponds, which become a lethal toxic soup. By law the slag and the ponds must be reclaimed, but often they are simply abandoned.

The price that each of us pays for our daily comforts is evident in our environment. The process of mining has devastated some of the most beautiful land across our country, and the resulting pollution is vast and deadly. The effects of coal-burning energy plants have damaged the health of millions of people and poisoned our food chain. So much mercury has drifted into rivers, lakes, and oceans that many varieties of freshwater fish are no longer safe to eat.[7] These problems cross international borders and even oceans: a signifi-

cant portion of the air pollution on the West Coast of the United States comes from coal-burning power plants in China.

Less evident is the price we pay for treating human beings like slag. Over the long history of coal mining in the United States, the miners and their families were cast aside when no longer a profitable commodity, left to sink into the underclass. Untold wealth was created and concentrated in the families and corporations of coal barons. Little of the profits reached the coal mining areas themselves. The out-of-state coal mine owners and investors built mansions, museums, libraries, and art collections in their own cities of New York or Philadelphia. Coal miners and their families would have to travel hundreds of miles from Appalachia to see the fruits of their labor. As a result, the people who literally fueled the American economic engine live in a poverty that seems unimaginable in the United States. They are bereft at every level. Not only are the living conditions harsh deep in the hollows, but we witnessed very little of the kinds of activities that bind a community—spiritual life, the creation of music and crafts, or locally sponsored sports leagues and social events. An air of hopelessness hangs over many of the people.

The United States has poured billions of dollars into many undeveloped areas around the globe. Yet West Virginia and other poverty-plagued regions within the country have languished. Somehow, the suffering of America's poor is not real to its citizens. It seems to happen farther away than Africa, so far away that the American media do not report on it and the politicians can afford to leave it for another day. As a result, many of us are ignorant of the extent of extreme poverty in our own country. Eventually, the rents in our national fabric will grow longer and deeper. We all suffer economically and spiritually when we allow American workers to be viewed as a commodity. After all, it has been proven many times over that profitability does not suffer when workers are treated with dignity.

In World War II, coal miners were considered so critical to the nation's war effort that they were exempted from the draft. Over one hundred thousand men toiled with pride in West Virginia during that war. Although poor, they believed their children would have a better life as a result of their labor. But the seesaw of the coal market, the complicated relationship between the United Mine Workers union and the coal owners and operators, and the increased mechanization of mining created a human disaster for the children and grandchildren of these men. In 2002, West Virginia produced 152 million tons of coal, roughly the same amount that it had mined in 1948. The approximate number of miners required to accomplish that dropped from 125,000 to 14,000.[8]

The region's crushing economic woes moved President John F. Kennedy to convene the President's Appalachian Regional Commission (PARC) in 1963.

The recommendations of that report were translated into legislation, laying the groundwork for the Appalachian Regional Commission (ARC), to which President Lyndon B. Johnson quickly committed as part of his War on Poverty. Investments in long-range economic development to foster the potential of the next generation were voted down, while projects that promised to pass with a quick vote and yield a quick return became the darlings of Congress. The House Appropriations Committee called for the commission to implement a finish-up plan in 1983 because it had been impossible for the ARC to find investments that would meet the growth potential required by law.[9]

The Appalachian Regional Commission managed to persist, however. Today the ARC has two primary activities: building and connecting highways and roads from the interior mountain area to the federal interstate highway system and providing non-highway catalyst and gap funding for state governmental programs and entrepreneurial start-ups. After two generations of programming, the only real improvements to the quality of life in the rural areas of Appalachia are some new roads and highways, a few medical clinics, and a handful of small businesses.

Indeed, while time and progress marched on for the rest of the nation, rural southern West Virginia deteriorated. A comparison of visual records speaks volumes. In *Images of Appalachian Coalfields,* photographer Builder Levy documented this same region over a fourteen-year period in the 1970s and 1980s. These were critical transitional years in the industry. Mechanization of the mining process released coal operators from the cost of labor and weakened the union's power. The few remaining jobs required more skill, and strip mining opened the way for the wholesale degradation of the land. The images and text of Levy's book bemoan the disintegration of coal camps into "rural slums" and the loss of community spirit.[10]

If one were to place Levy's photograph of Donna Muncy (Levy, p. 69), taken in 1970, alongside Light's image of James standing in his kitchen in 2001 (fig. 44), the contrast would be shocking. Clearly Donna is poor, but the kitchen floor looks scrubbed, and the linoleum lays in one continuous piece. A clean curtain hangs in the window. The window casings are painted, and the windows seem to fit into them. True, the plaster on the walls looks cracked and the washtub against which she stands is crudely built. She seems a bit anxious, perhaps wondering what someone is doing in her kitchen with a camera. James, on the other hand, watches with an empty gaze as his photograph is made. The paint is peeling in sheets from the collapsing ceiling, the cupboard is filthy, the door has a huge patch on it, and a film of grime clings to everything.

. . .

This project is about the people that the coal industry left behind, those who remain after the high drama of the struggle between labor and management

has passed. The true cost of doing business with no thought either to the stewardship of the land or to its residents cannot be reckoned in dollars or conveyed in statistics. Rather, it must be understood through a personal connection with the people and a glimpse at the chronic hardship of their lives. Together, the pictures and stories collected in this book create a visceral experience of the human cost of coal production and its continued role in our developed society.

After so many intrusions by outsiders over the past century, it seems fitting that the people should tell their own stories. Coal Hollow is a composite, ersatz community fashioned from the interviews and photographs logged during travels over thousands of miles across eight counties. The oral histories were chosen to represent as complete a cast of characters as possible: retired miners, men and women who have never had permanent employment, a local coal industries owner, a justice for the West Virginia Supreme Court of Appeals, a writer who bravely ran for governor on a third-party ticket, and people who returned to the hills when their lives failed elsewhere.

The point of entry into this unseen world is Beckley, West Virginia. A thin net of roads is cast southward over the deep furrows of the ancient, rolling Cumberland Mountains and coalesces along the bottomlands. The coal camps have idiosyncratic names, reflecting both immigration patterns and a haphazard approach to development: Jolo, Amigo, Oceana, Giatto, Yukon, Coalwood, Big Sandy, Johnnycake Junction. The land is blessed with beauty and majesty. The blue ridges recede far into the distance, screens that partition the inhabitants into a private, isolated world.

It takes a bit of time for an outsider to grasp the hybrid nature of the land and its people. As deeply as the people have etched the land to take away coal, the land has been etched into the fiber of the people. Trailers and houses and trees and bushes are woven together. Although today's residents don't live directly off the land to the extent their forebears did, families still have gardens and hunt in the woods. But even beyond their intimacy with the land, the people of Appalachia have a deep connection to their way of life. They express a great reluctance to leave their family and community and feel that they can always come home to the hills.

Up close, West Virginia is a disturbing overlap of two parallel universes. One is the functioning universe of employed West Virginians, hoping to diversify their economy and their state by insisting on education for their children and working hard to develop tourism and business parks. These people work in the mines and in the government jobs that Senator Robert Byrd brought to the state. Their cozy brick homes sit on well-groomed lawns, with a late-model car in a driveway of newly poured asphalt.

The other West Virginia could be mistaken for a slum in some part of the Third World. Coal camps still line the creeks like peas in the folds of an apron, but they are shrunken and dried out. Dilapidated houses and trailers litter the hollows like piles of waste mixed up with denuded forest, jagged, abandoned swaths of strip mines, and toxic slurry ponds. Raw sewage flows down the creeks along some of the most beautiful mountains in our country. Clumps of toilet paper still cling to tree roots, left from the last floods. Big cities like Welch or Mullens that once teemed with a hundred thousand people or more are now cavernous, disintegrating mazes. Aging and disabled miners, their widows, and a lost generation of people who have never lived in a viable economy are hanging on, passing time in front of the TV or "settin'" on the porch. Anyone who could leave has already gone somewhere else to live and work. Along with mineral debris, the coal companies left behind human slag. The broken earth and the broken people await reclamation.

NOTES

1 "Coal Tree," diagram provided by the National Energy Foundation for use in elementary schools: www.coaleducation.org/lessons/twe/bytree.htm.

2 Harry Caudill, *Night Comes to the Cumberlands: A Biography of a Depressed Area* (Boston: Little, Brown, 1963); Lon Savage, *Thunder in the Mountains: The West Virginia Mine War, 1920–21* (Pittsburgh: University of Pittsburgh Press, 1990); Barbara Freese, *Coal: A Human History* (Cambridge, MA: Perseus Publishing, 2003).

3 Energy Information Administration, "Annual Energy Outlook 2005 with Projections to 2025," DOE/EIA-0383 (Washington, D.C., January 2005): www.eia.doe.gov/oiaf/aeo/overview.html.

4 Energy Information Administration, "Annual Energy Outlook 2005": www.eia.doe.gov/oiaf/aeo/electricity.html.

5 Freese, *Coal,* pp. 32–37.

6 Mark Squillace, *Strip Mining Handbook* (Washington, D.C.: Environmental Policy Institute and Friends of the Earth, 1990), pp. 25, 26.

7 John Fialka, "Mercury Threat to Kids Rising, Unreleased EPA Report Warns," *Wall Street Journal*, February 20, 2003.

8 West Virginia Office of Miners' Health, Safety and Training, "West Virginia Coal Production and Employment 2004": www.wvminesafety.org/month2004.htm.

9 *Appalachia: Twenty Years of Progress* (Washington, D.C.: Appalachian Regional Commission, 1985), pp. 28–30.

10 Builder Levy, *Images of Appalachian Coalfields* (Philadelphia: Temple University Press, 1989).

PHOTOGRAPHS

KEN LIGHT

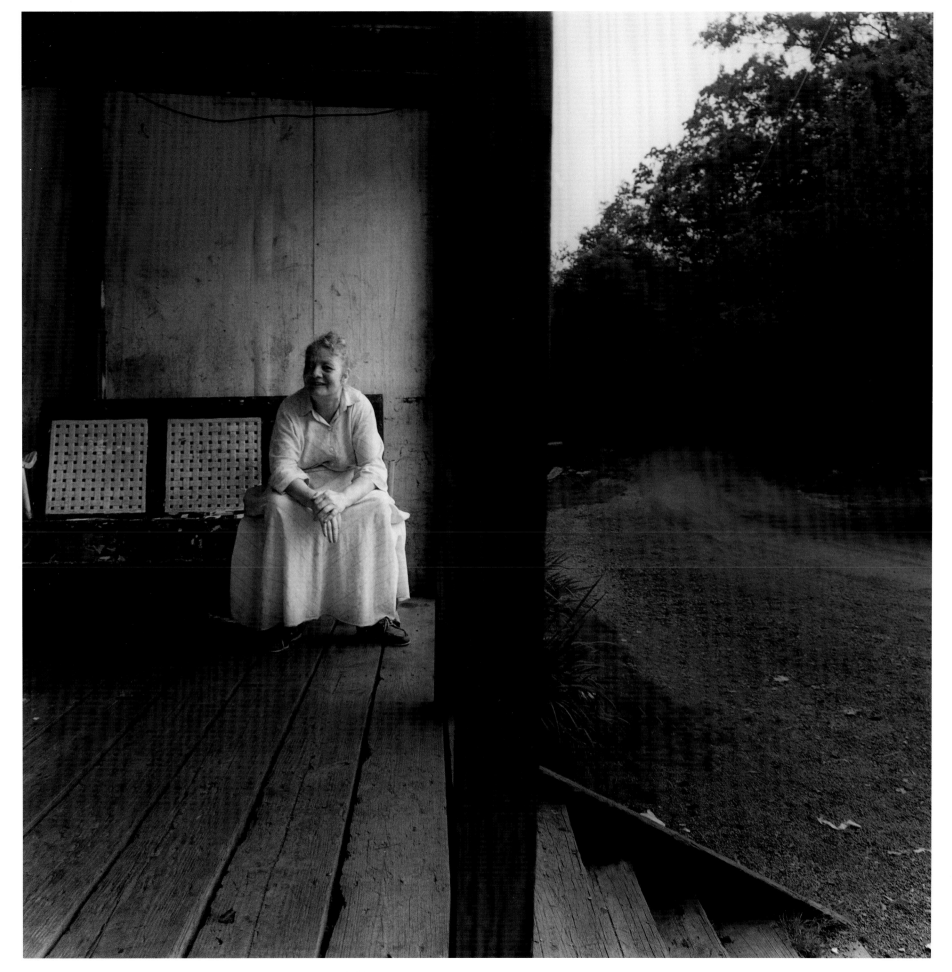

1 Lorraine, fifty-two years old, on the porch. Tommy Creek Hollow, West Virginia, 2000.

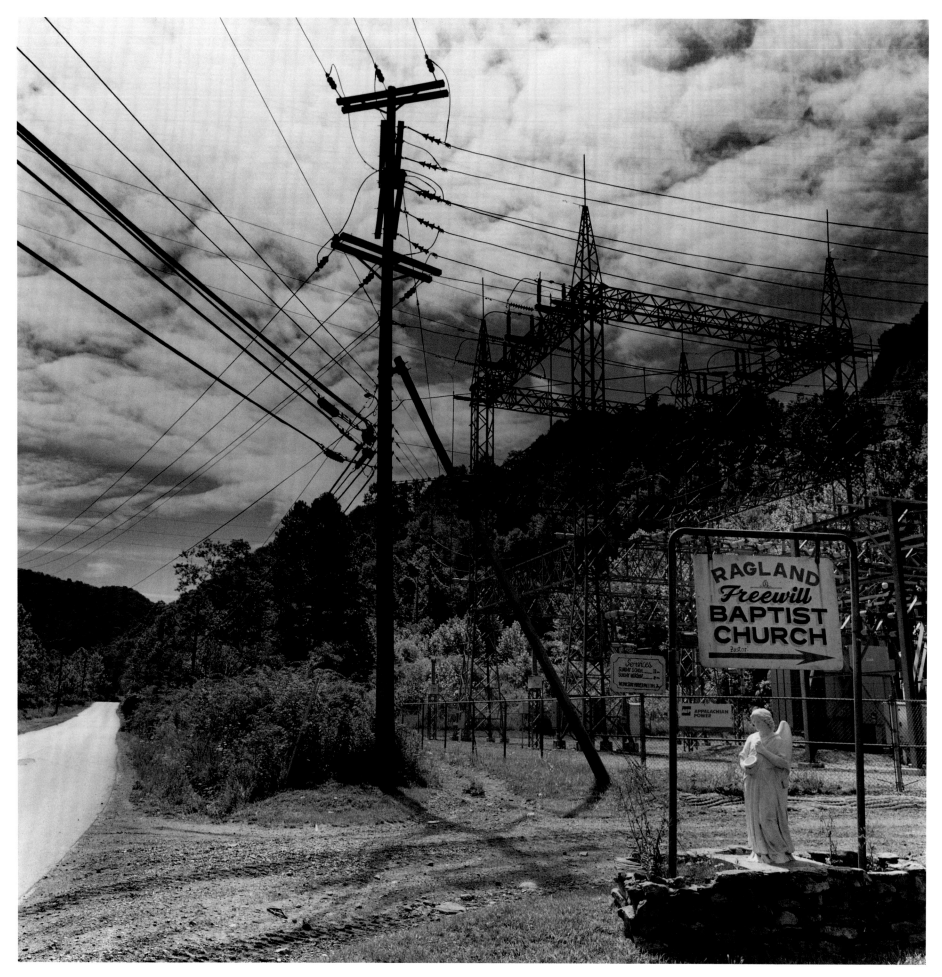

2 Turnoff to Ragland Freewill Baptist Church. Ragland, West Virginia, 1999.

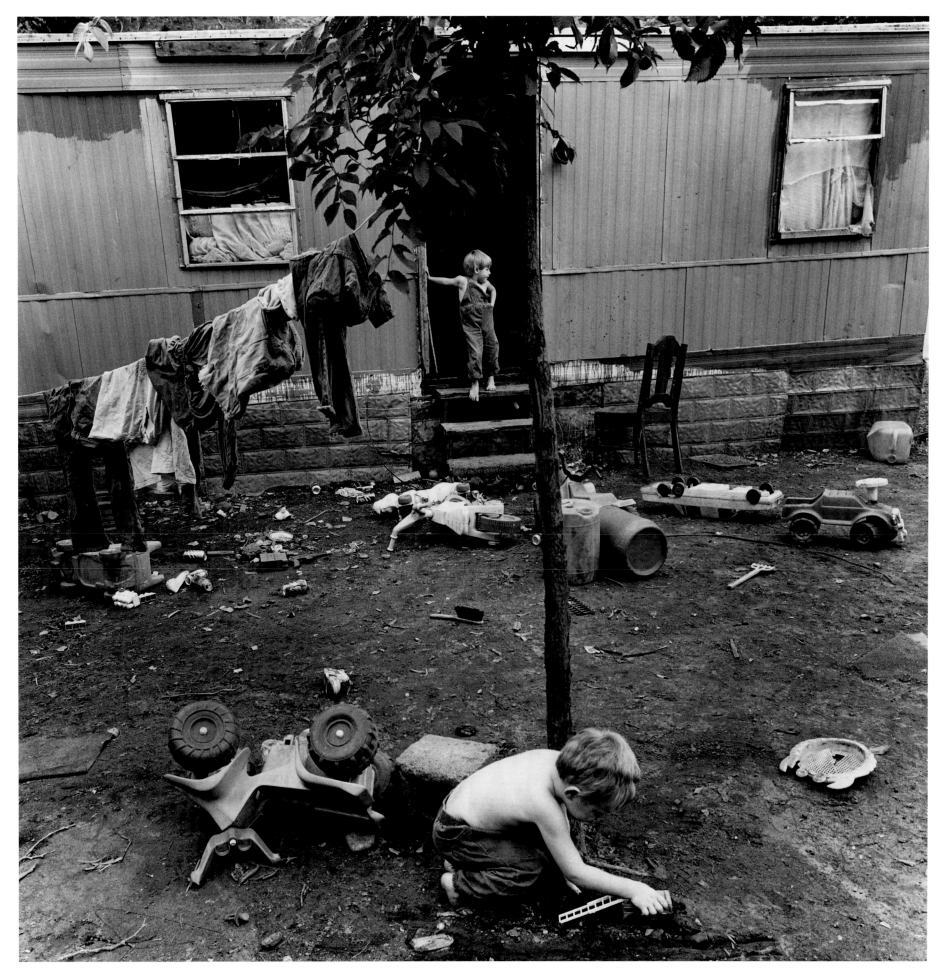

3 James and his brother J.R., three and five years old. Thacker Creek Hollow, West Virginia, 1999.

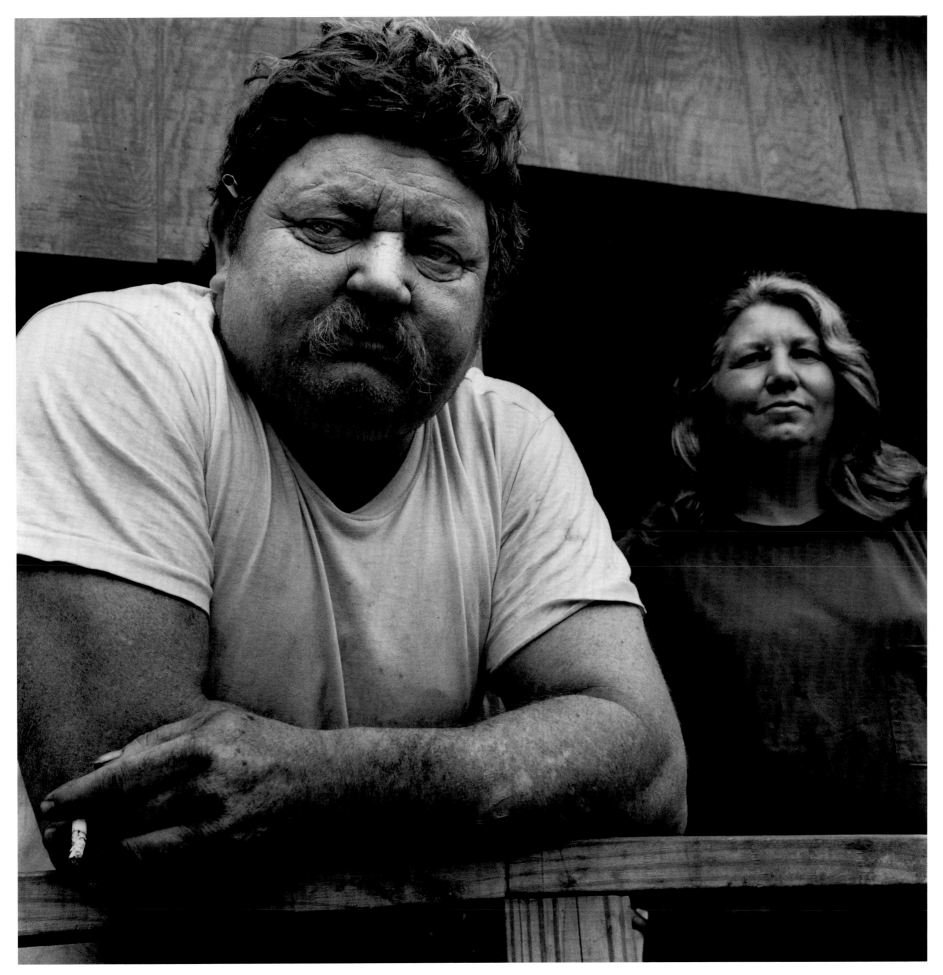

4 James and his wife, Patricia. Riffe Branch Hollow, West Virginia, 2001.

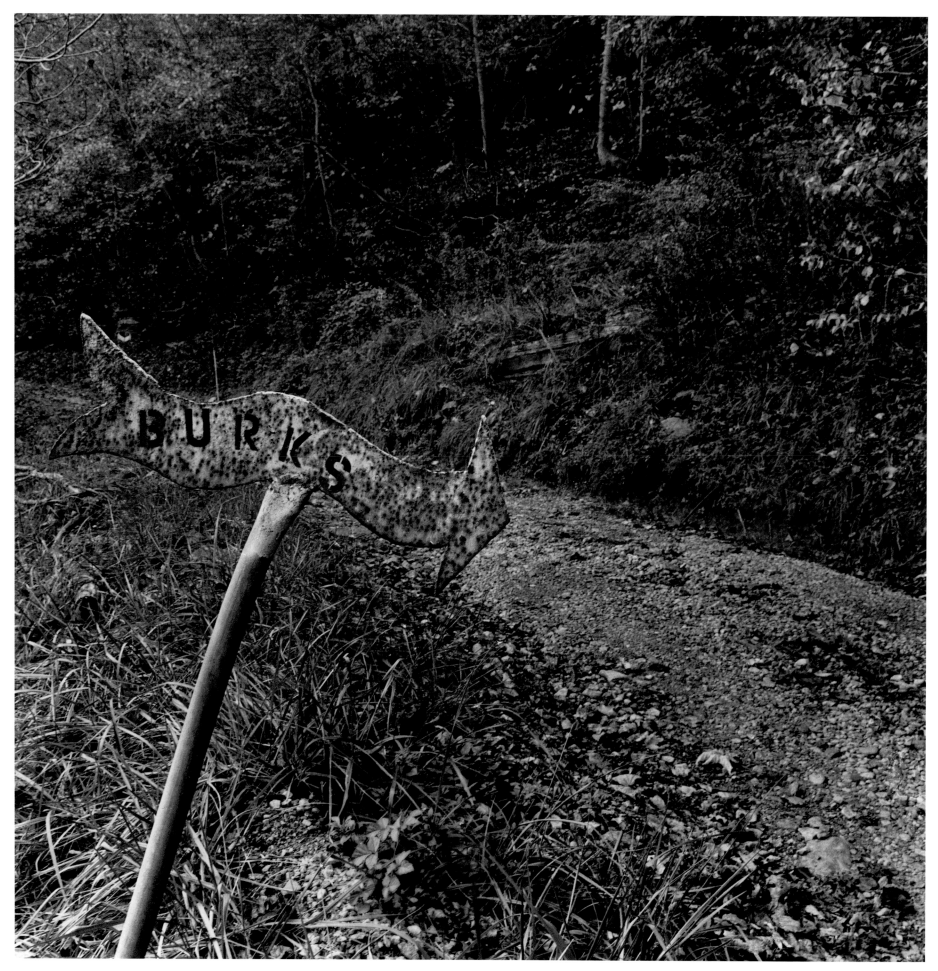

5 Along a Hollow road. McDowell County, West Virginia, 2002.

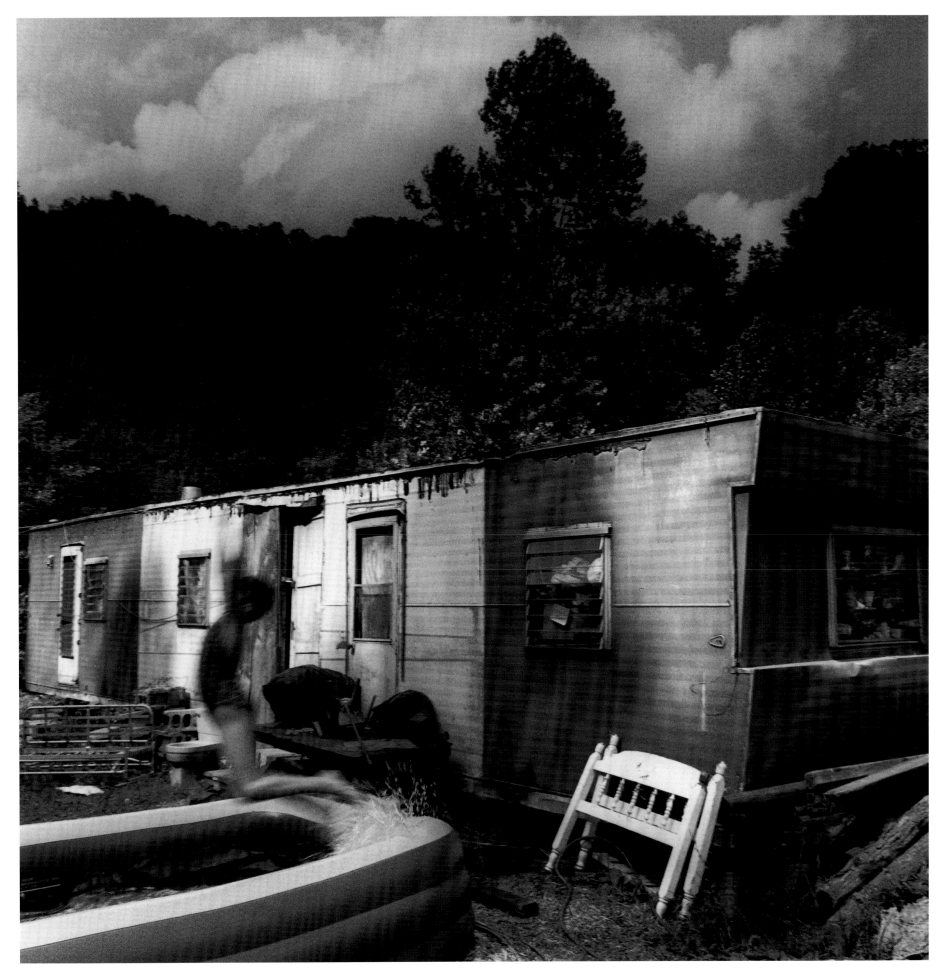

6 Jumping into the inflatable pool. Grapevine Branch Hollow, West Virginia, 2001.

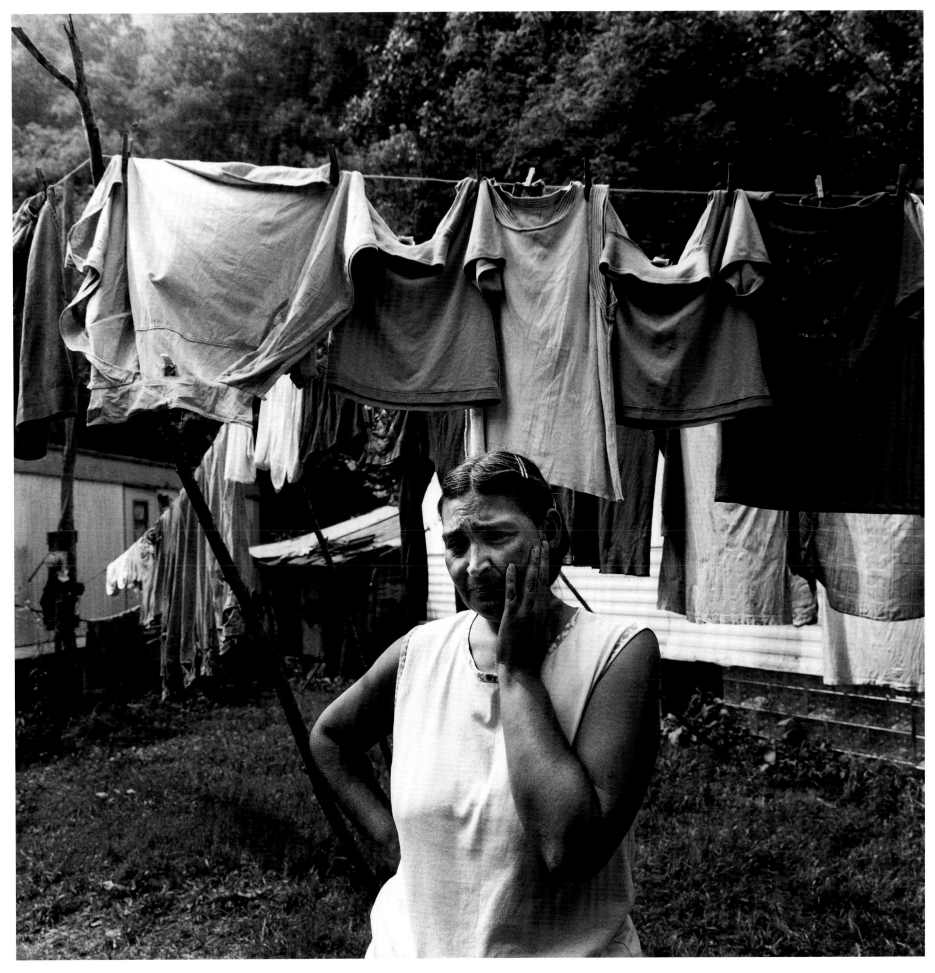

7 Laura, forty-five years old, on laundry day. Crane Creek Hollow, West Virginia, 2002.

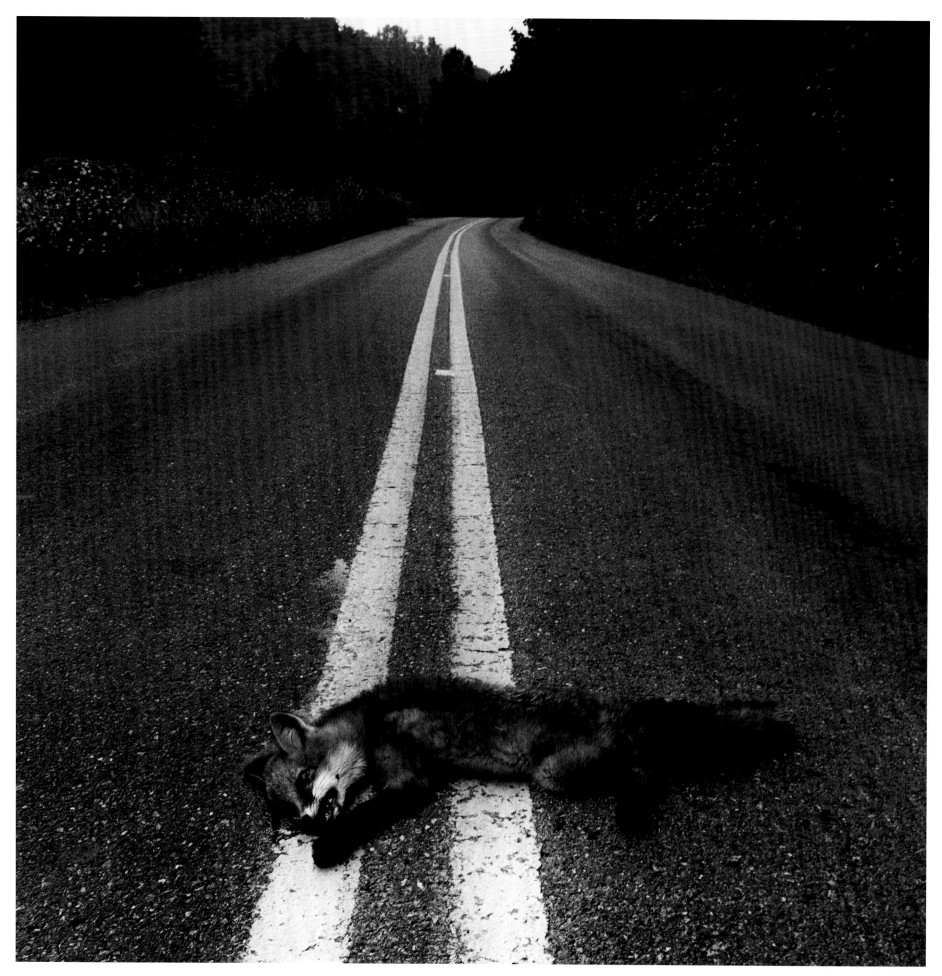

8 Roadkill. Coal City Road, Raleigh County, West Virginia, 2001.

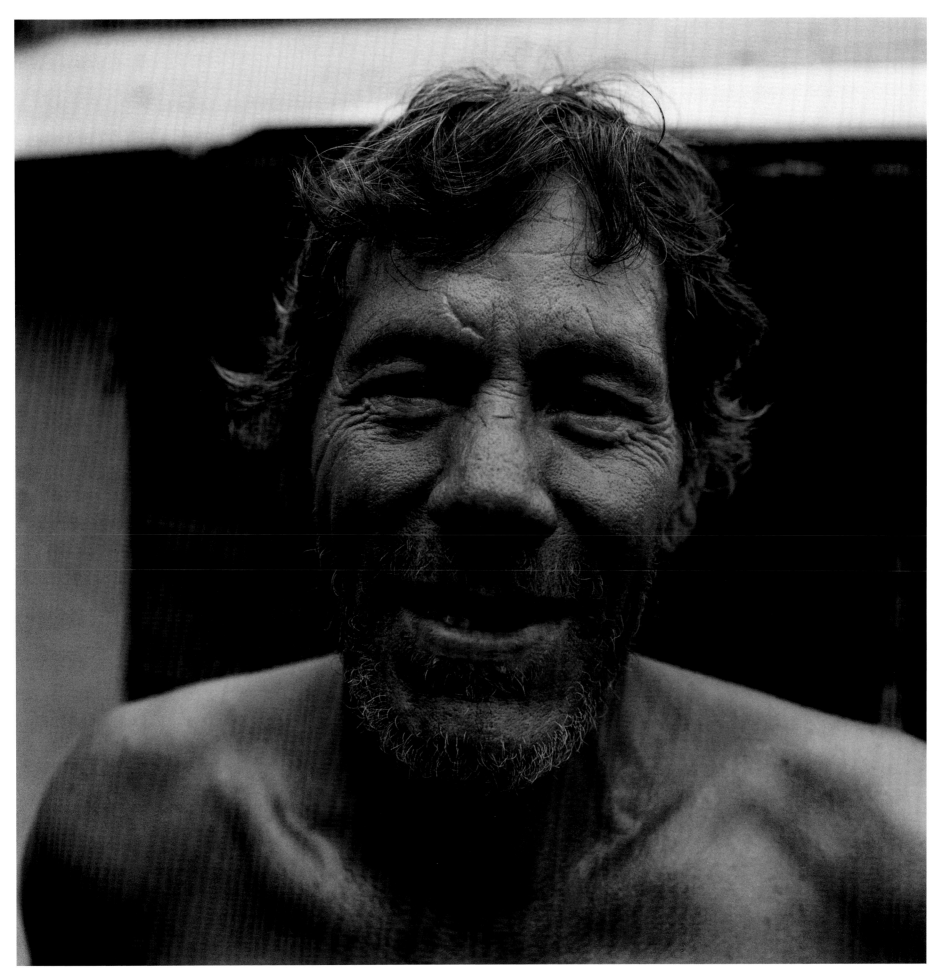

9 Ricky, forty-seven years old. Fireco, West Virginia, 2001.

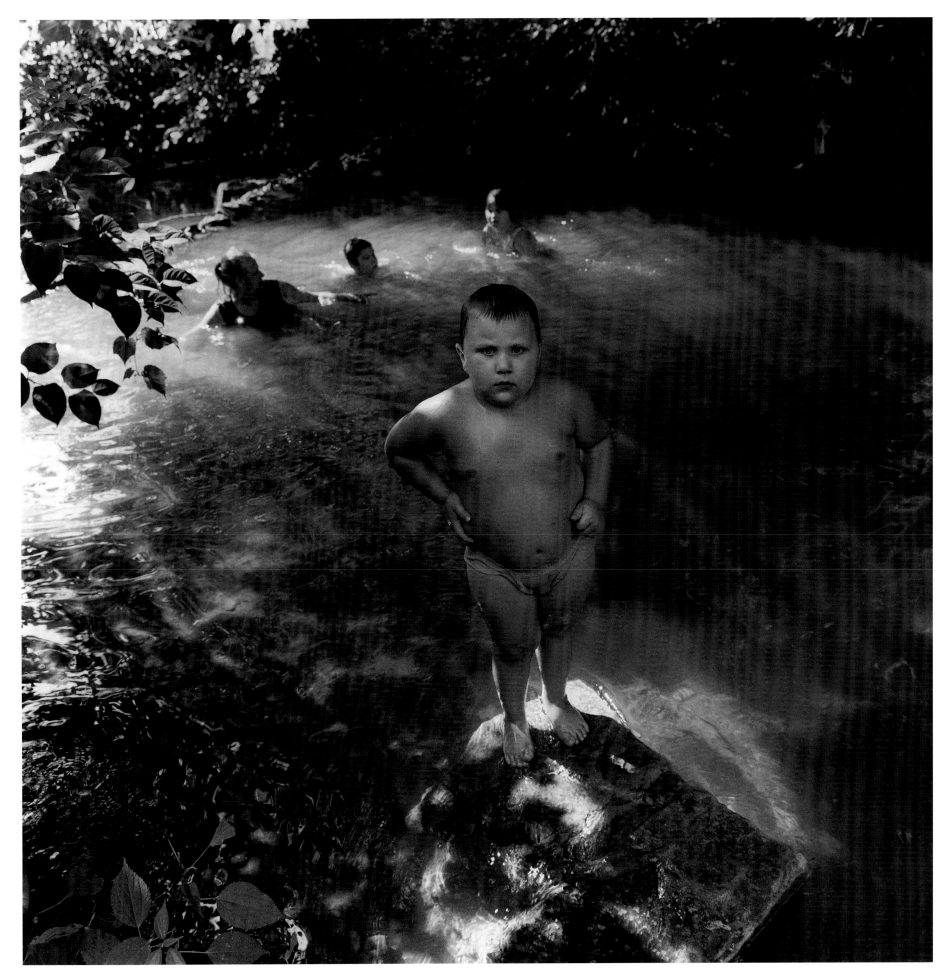

Bryan at the swimming hole. Laurel Creek Fork, West Virginia, 1999.

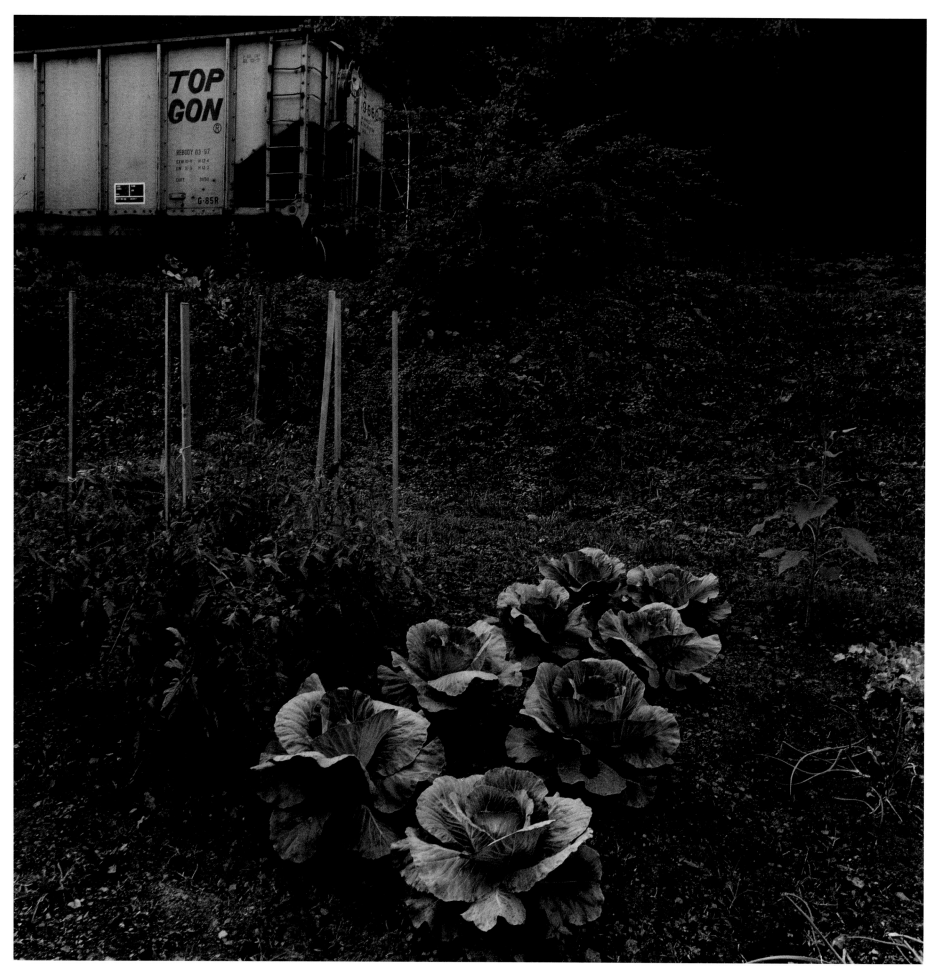

11 Coal car and a garden. Riffe Branch Hollow, West Virginia, 2001.

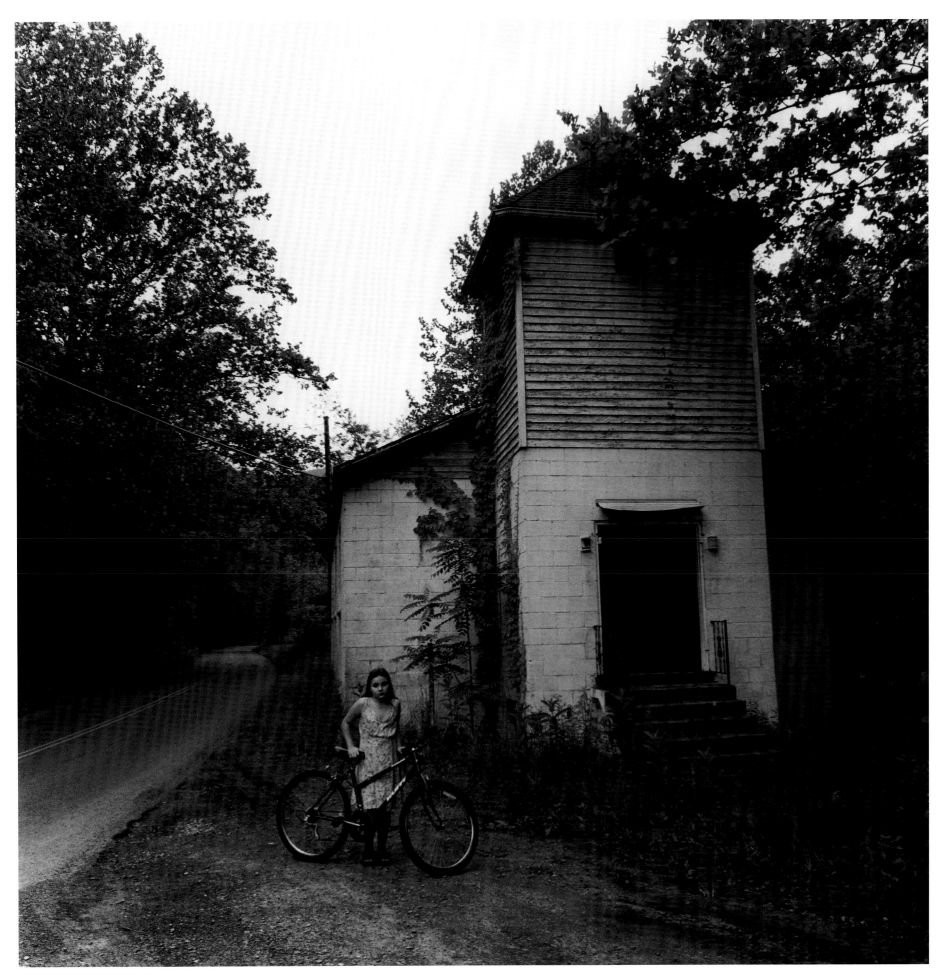

12 Casey, nine years old, in front of an abandoned church. Coal City Road, Raleigh County, West Virginia, 2000.

13 Running horse. Horse Creek Hollow, West Virginia, 2001.

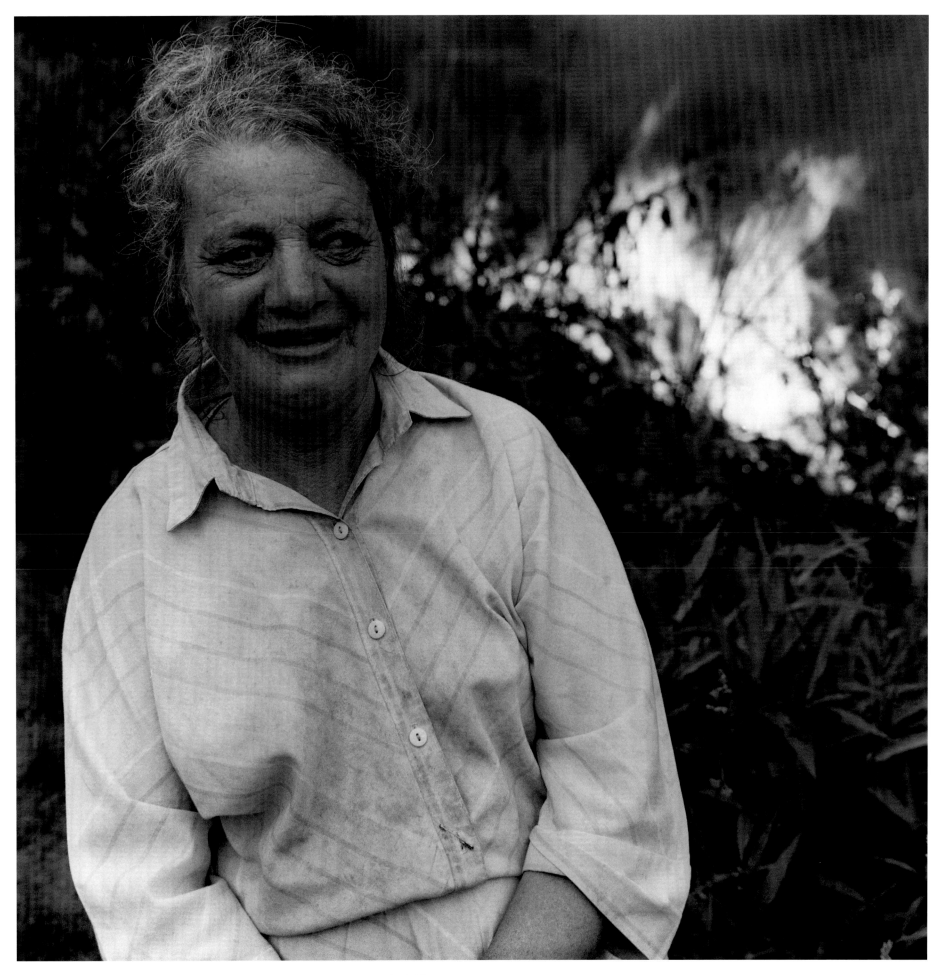

14 Lorraine, fifty-two years old, burning wild roses. Tommy Creek Hollow, West Virginia, 2000.

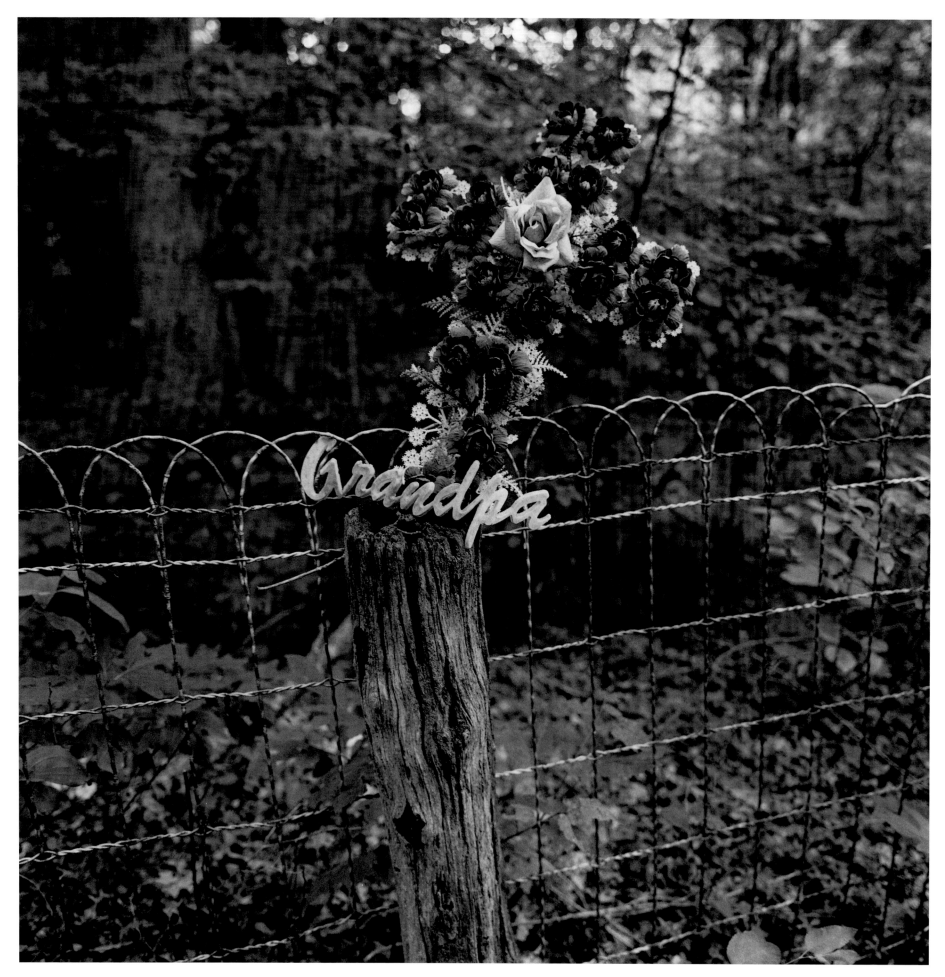

15 R.I.P. Grandpa. Coal City Road, Raleigh County, West Virginia, 2001.

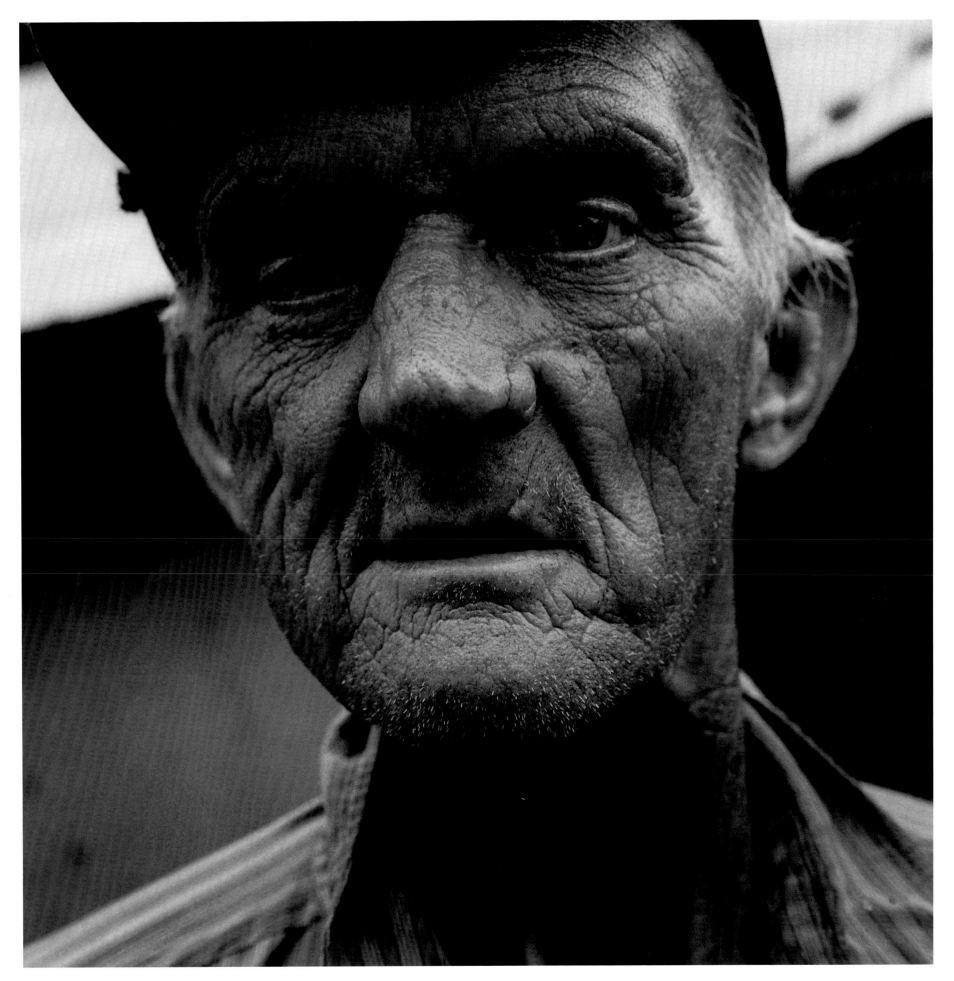

James on his sixtieth birthday. Fireco, West Virginia, 2001.

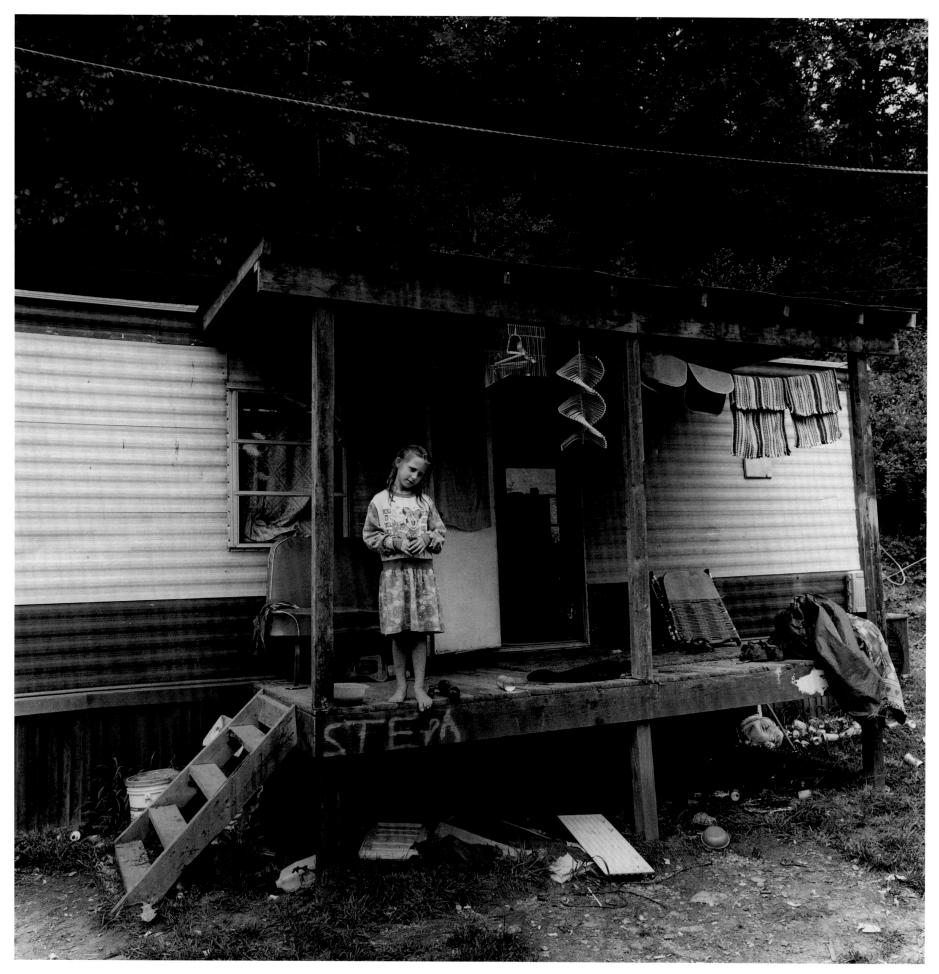

17 Natasha, eight years old. Laurel Creek Hollow, West Virginia, 2002.

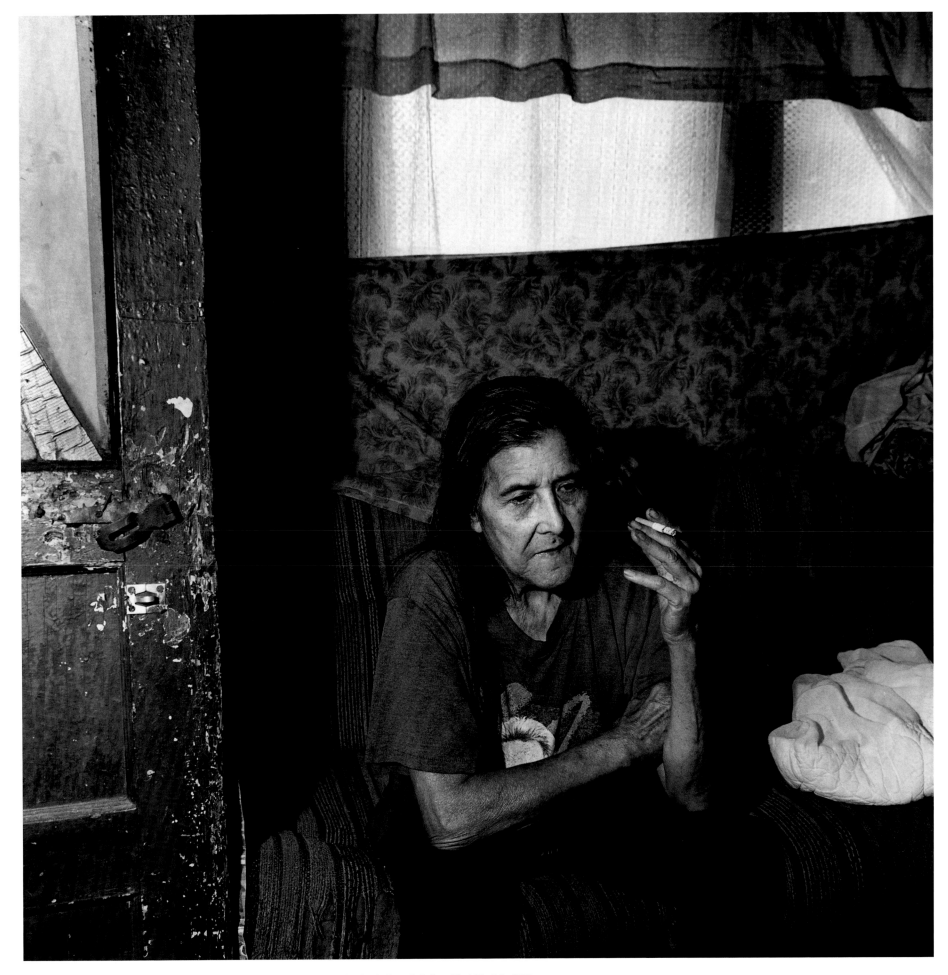

Rebecca, seventy years old, who raised twelve children in her house. Shortpole Branch Hollow, West Virginia, 2001.

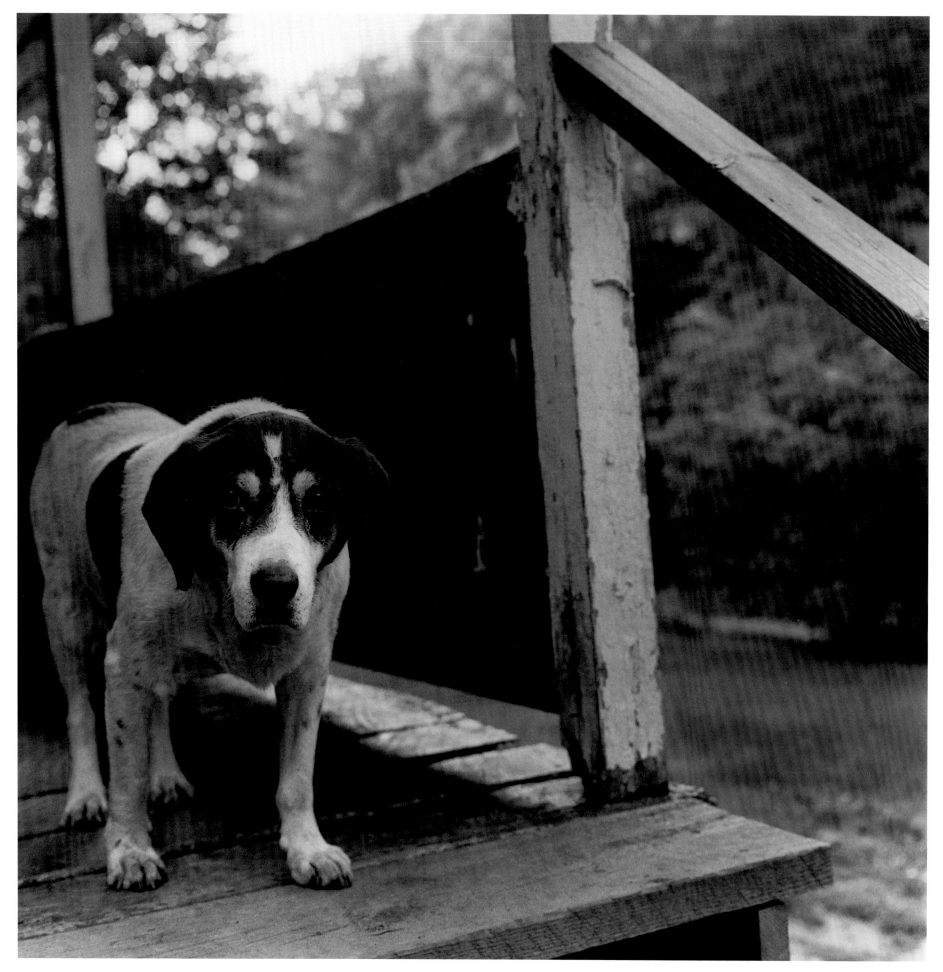

19 Hound dog. Coal City Road, Raleigh County, West Virginia, 2000.

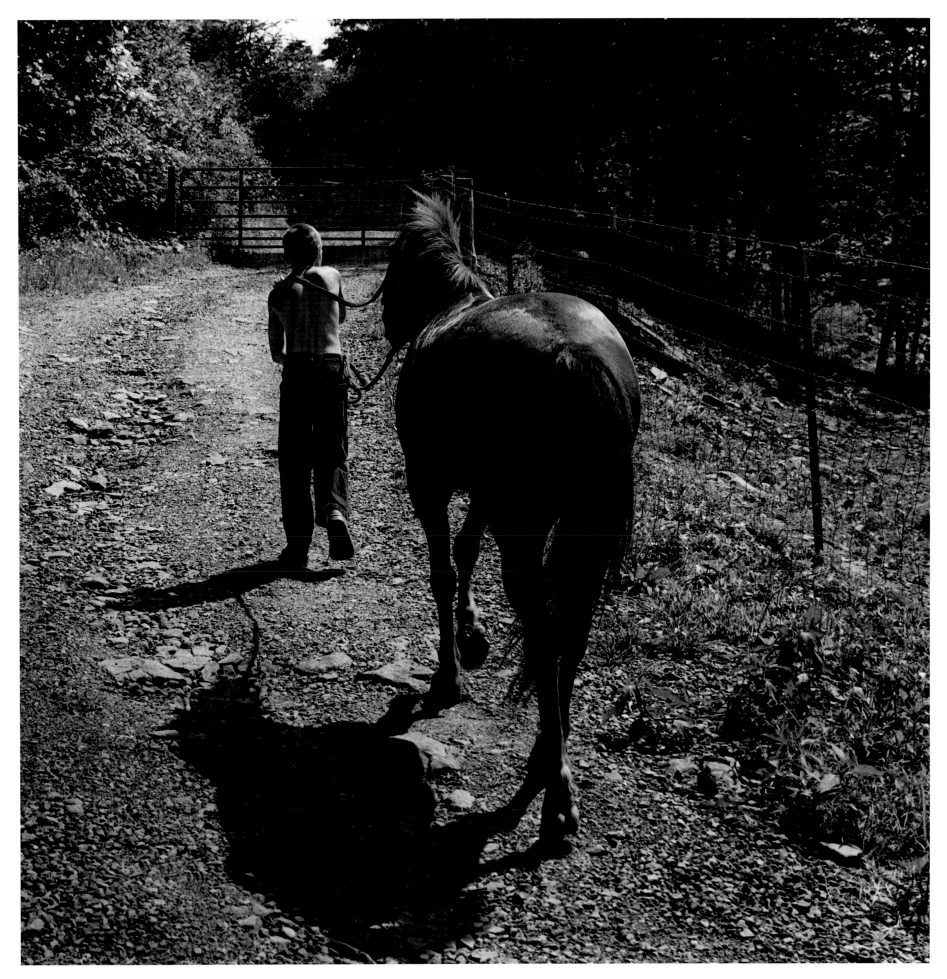

From up on the mountain. McDowell County, West Virginia, 2002.

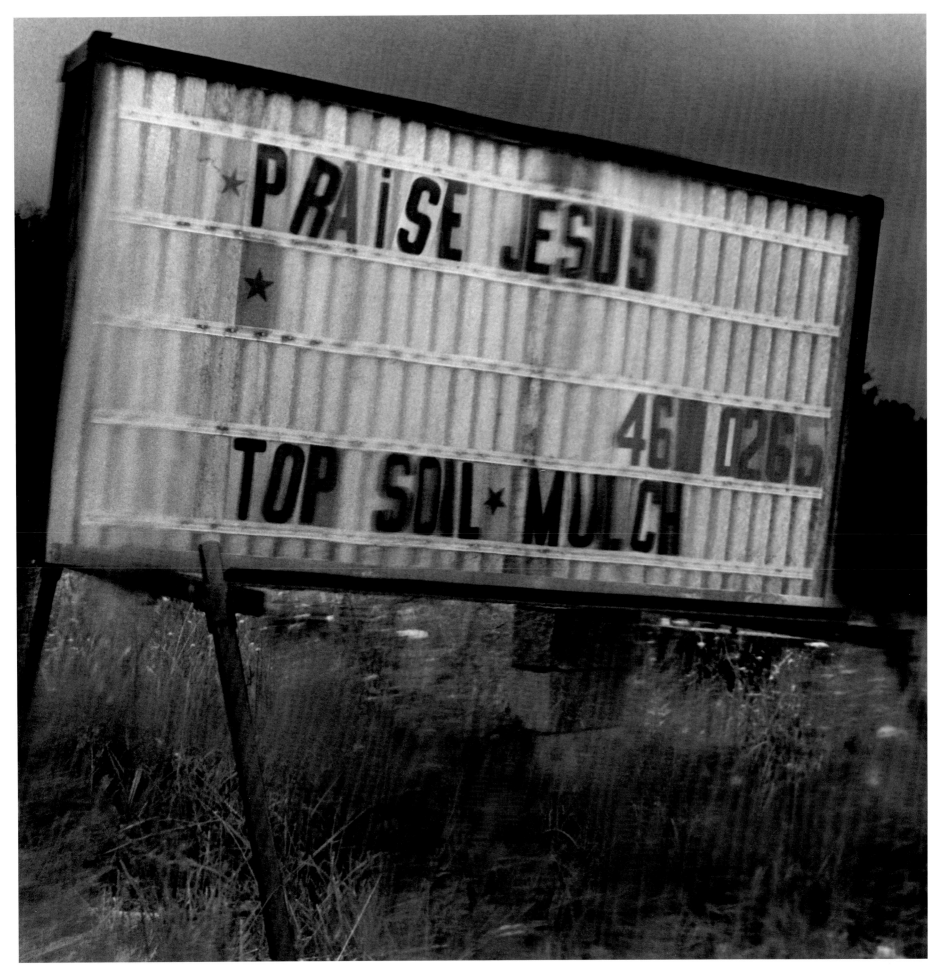

21 "Praise Jesus, Top Soil & Mulch." Raleigh County, West Virginia, 2002.

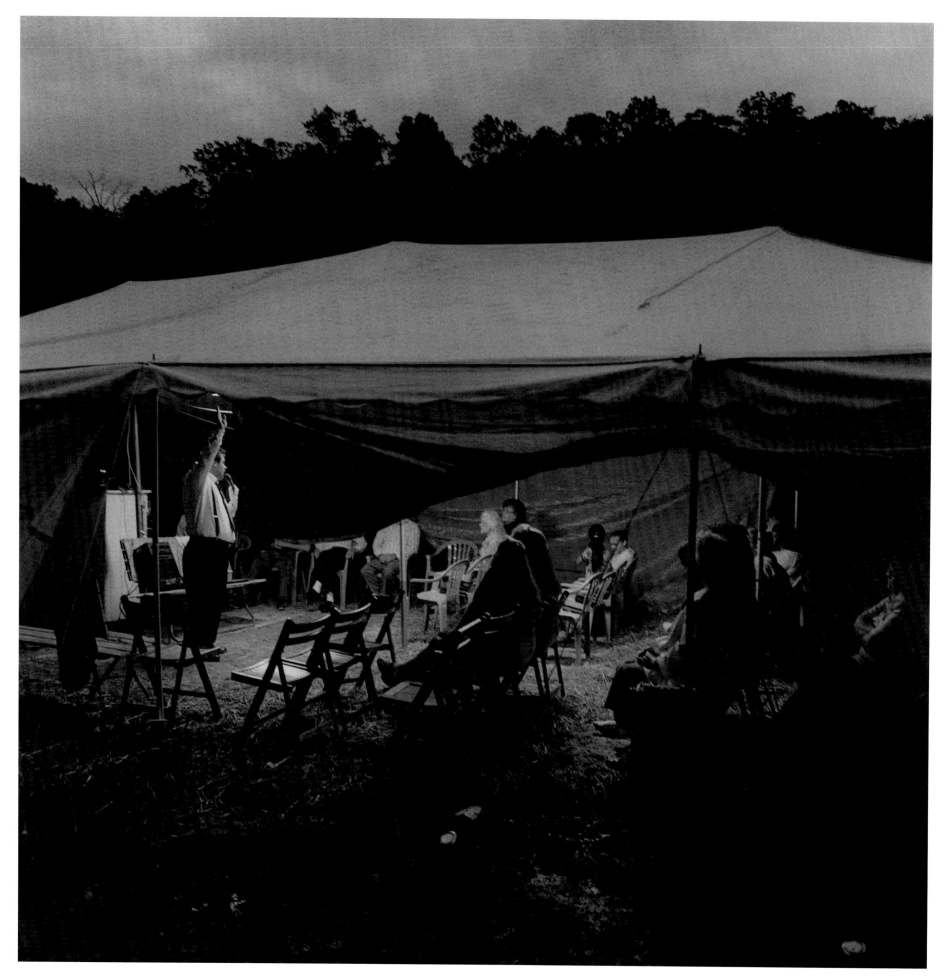

22 The preacher at a tent revival. Delbarton, West Virginia, 1999.

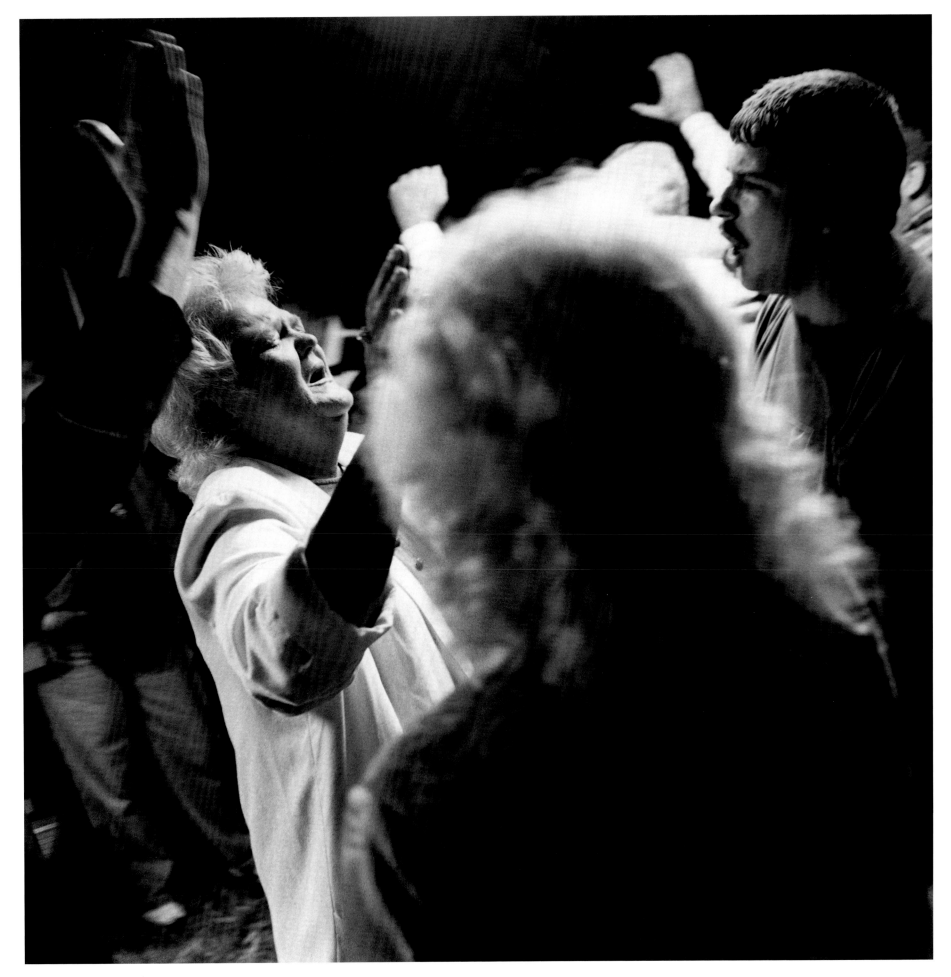

23 Tent revival. Delbarton, West Virginia, 1999.

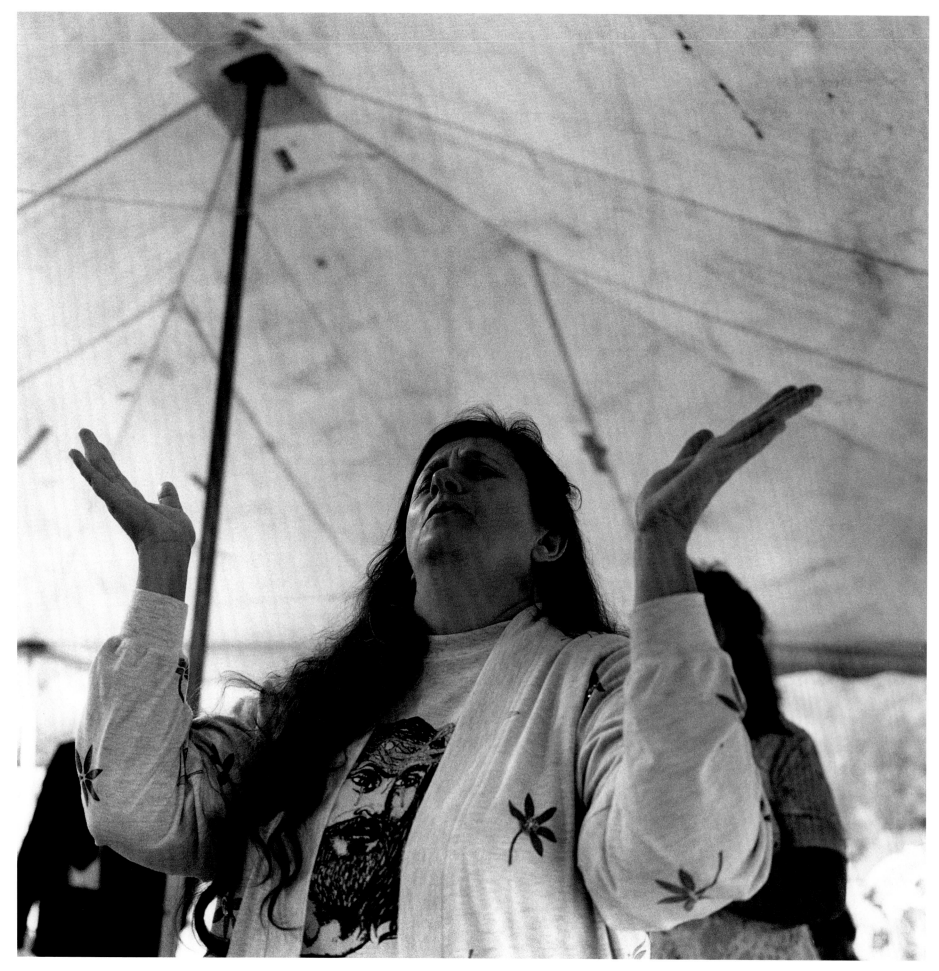

24 Tent revival. Delbarton, West Virginia, 1999.

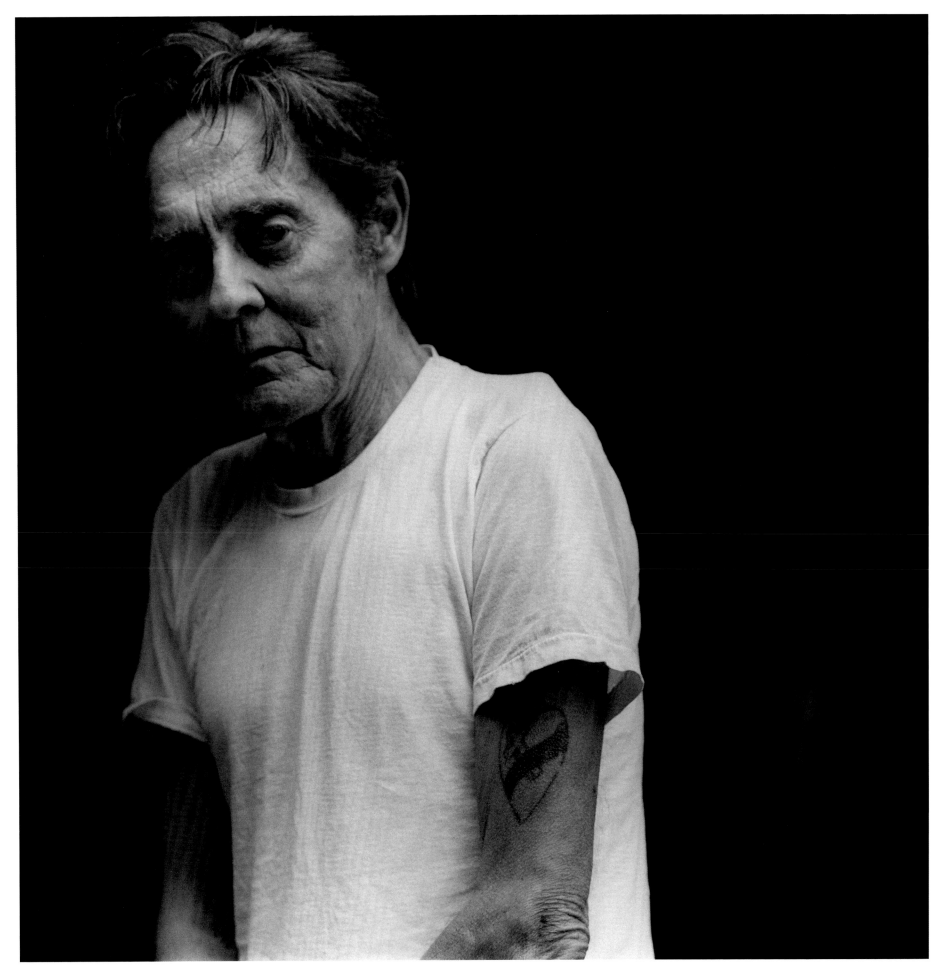

25 Keith, sixty-six years old. Delbarton, West Virginia, 1999.

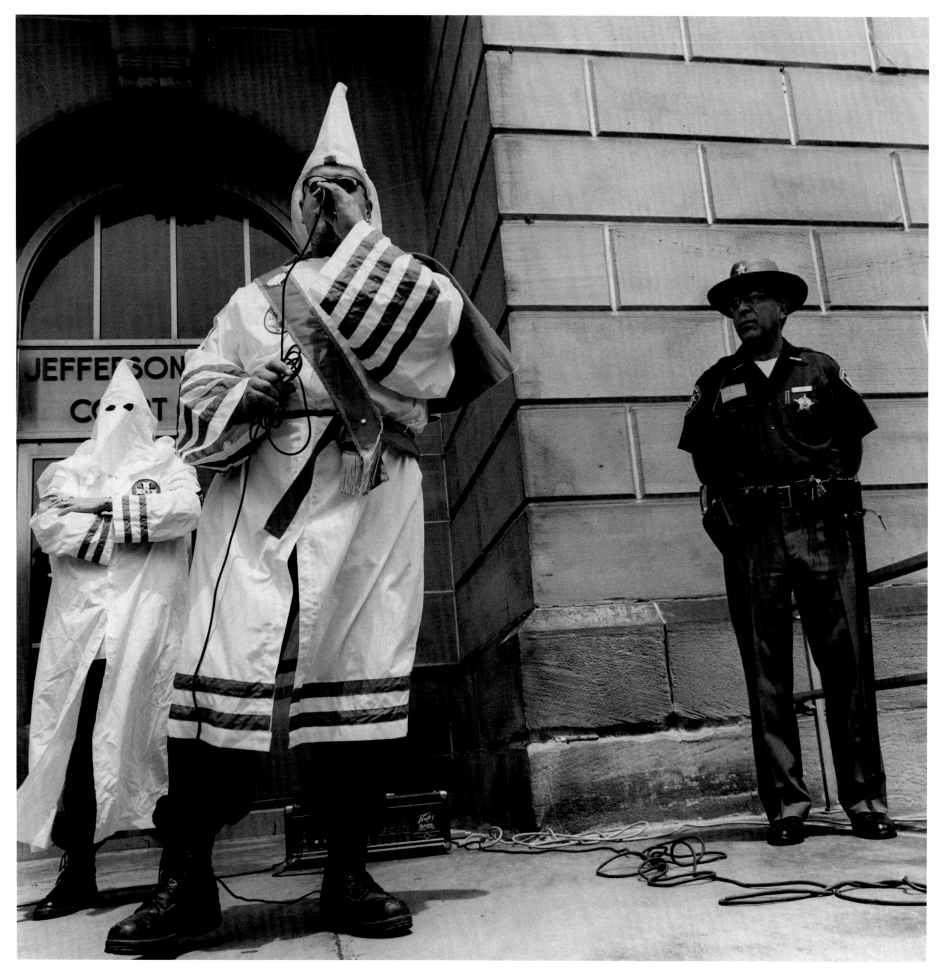

26 Ku Klux Klan speech at the county courthouse. Ohio–West Virginia border, 1999.

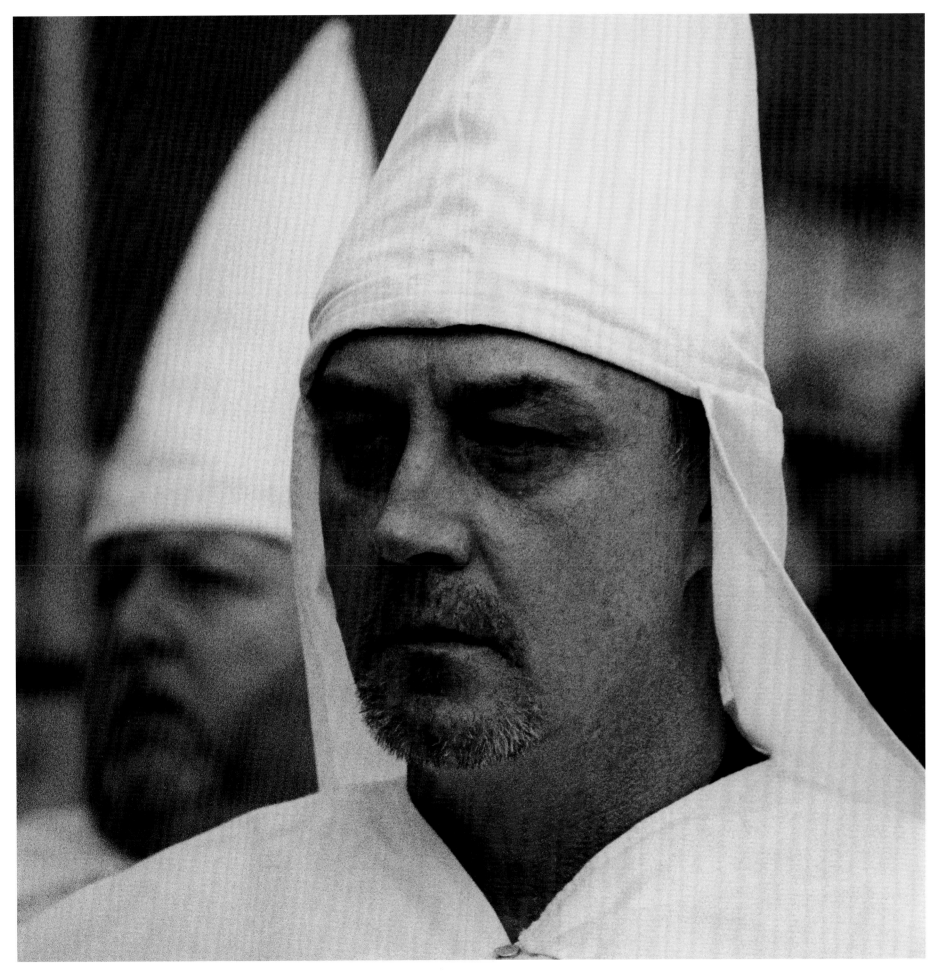

27 Klan member at a downtown rally. Fayetteville, West Virginia, 2002.

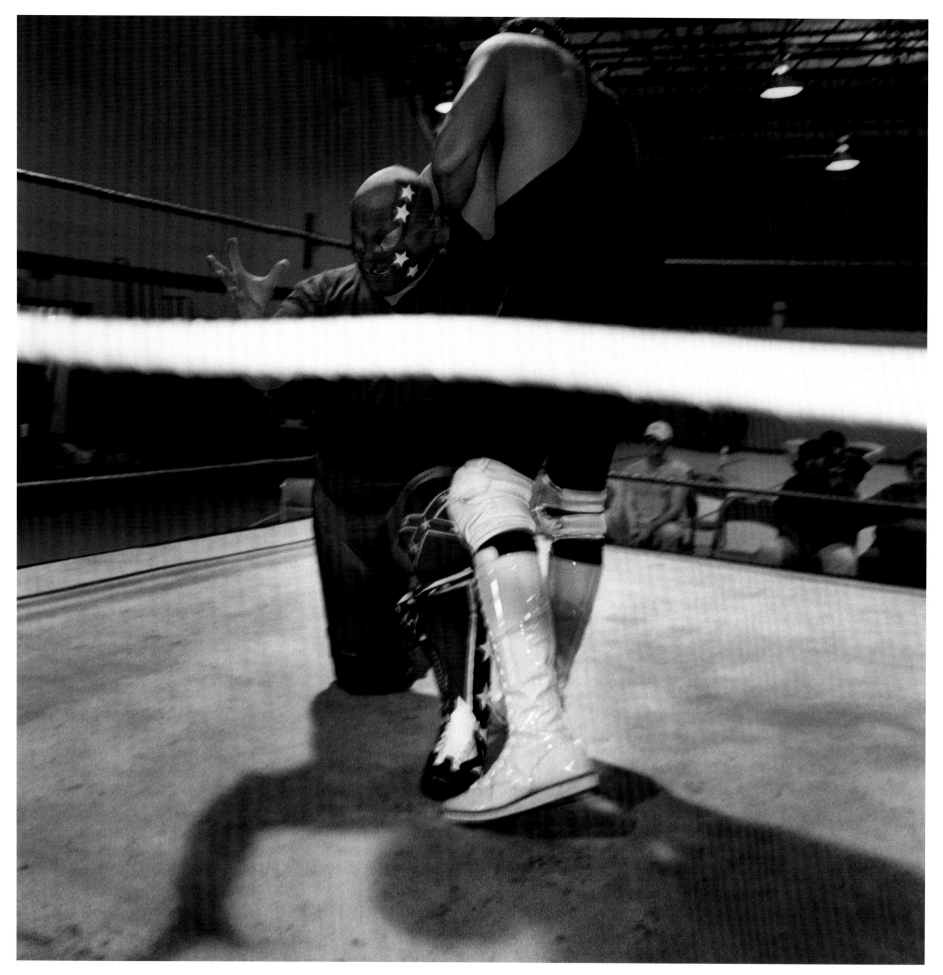

28 The Rebel, "hillbilly wrestling." Princeton, West Virginia, 2001.

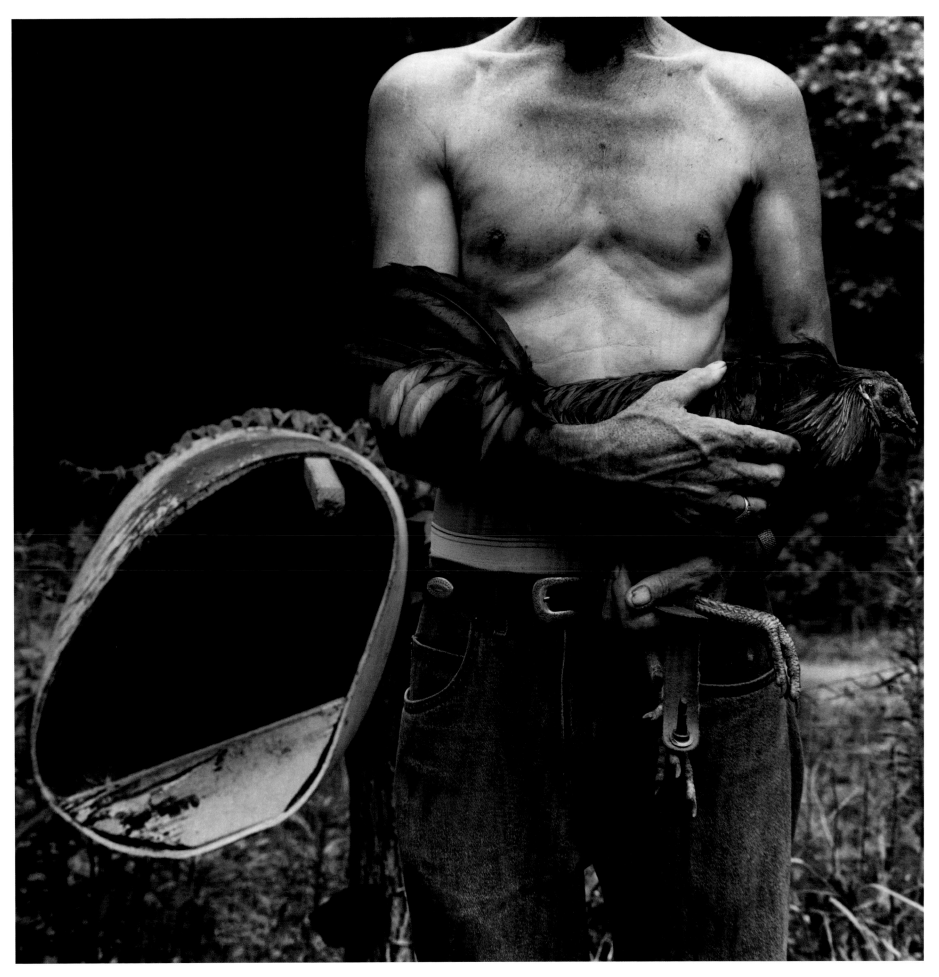

29 Retired miner Billy Joe, sixty years old, with brown, red, and gray fighting cock. Avondale, West Virginia, 2001.

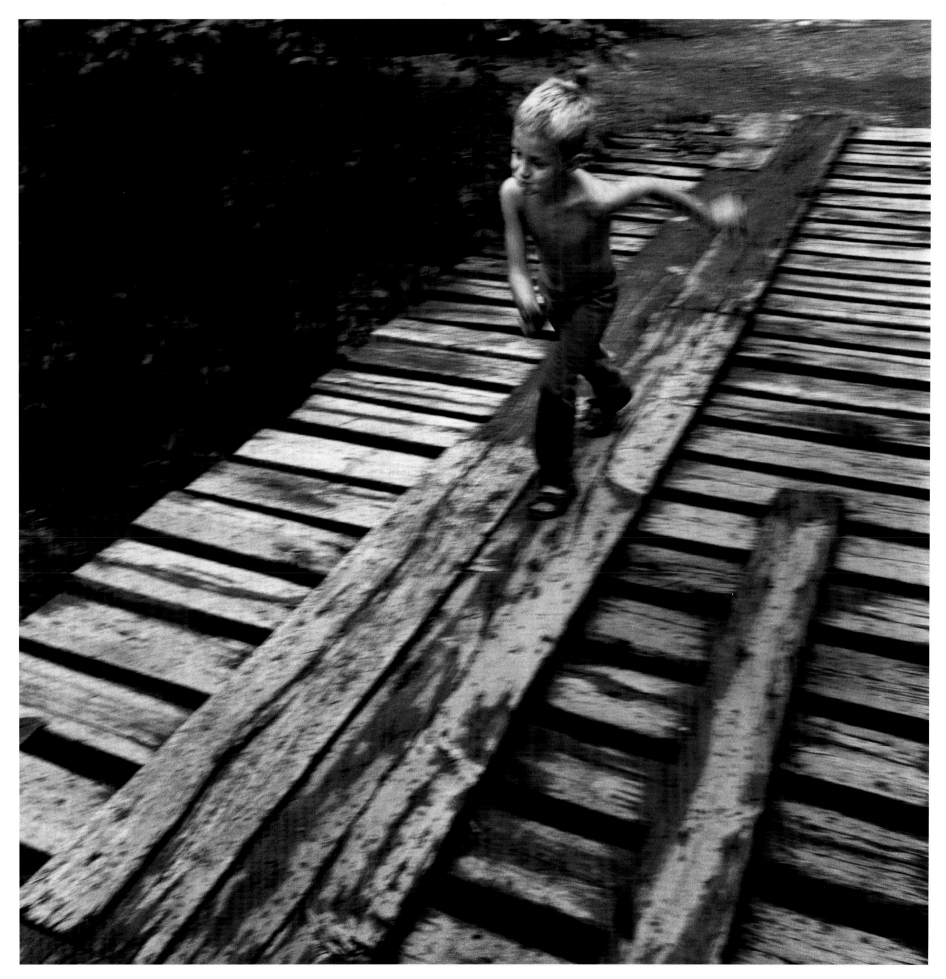

The bridge toward home. Riffe Branch Hollow, West Virginia, 2001.

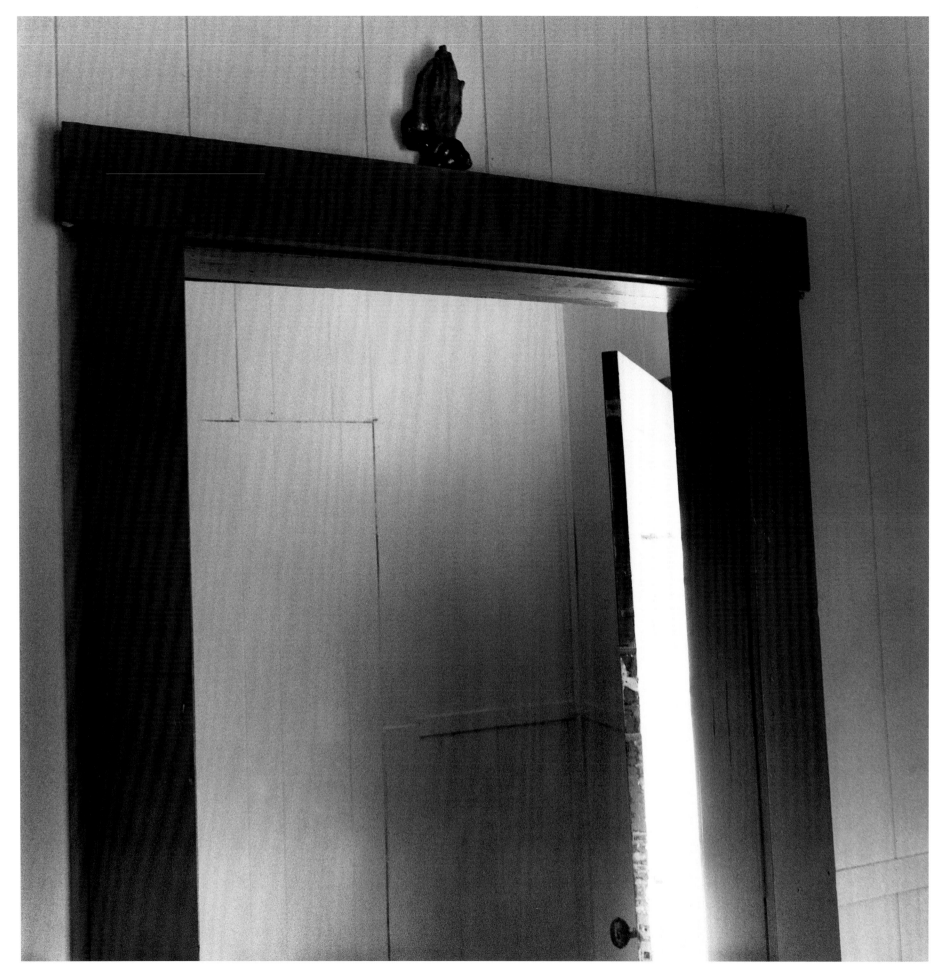

31 Coal camp door. Wyco, West Virginia, 2001.

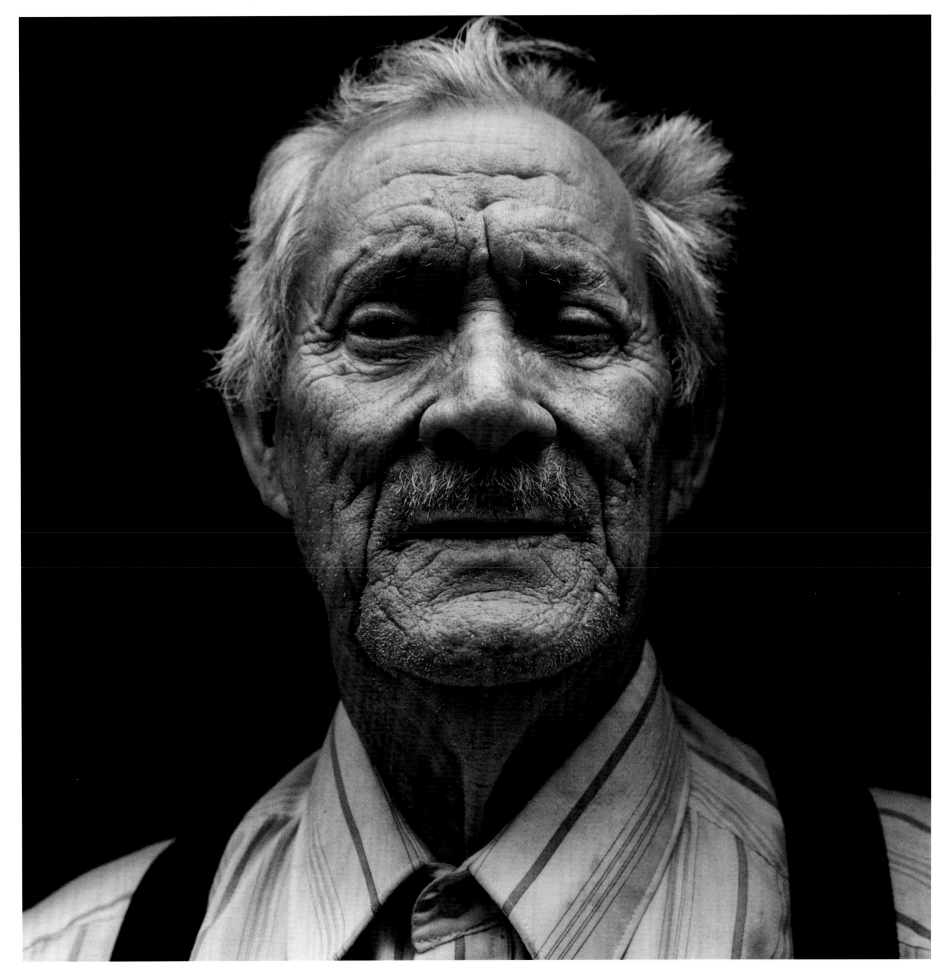

Alvin, sixty-five years old, who lives on a monthly Social Security check of five hundred fifty dollars. Rhodell, West Virginia, 2002.

33 Kudzu vine. McDowell County, West Virginia, 2001.

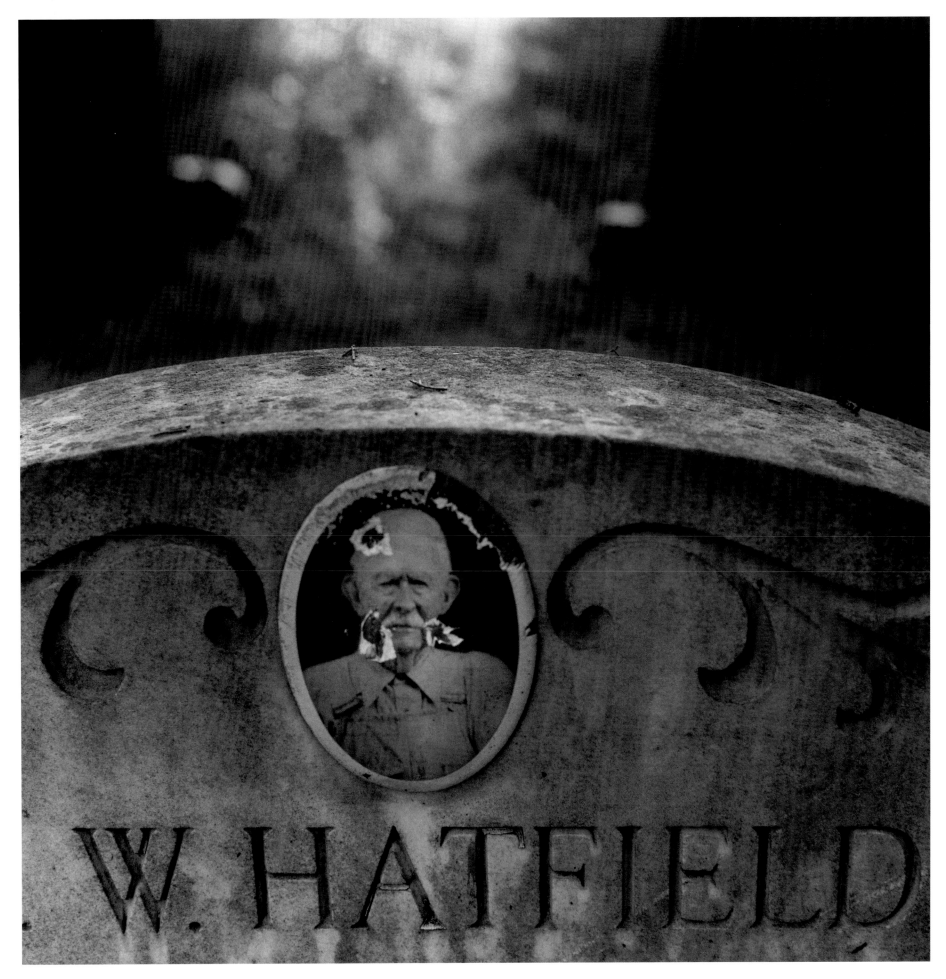

34 Hatfield grave. Hatfield and McCoy Trail, McDowell County, West Virginia, 2002.

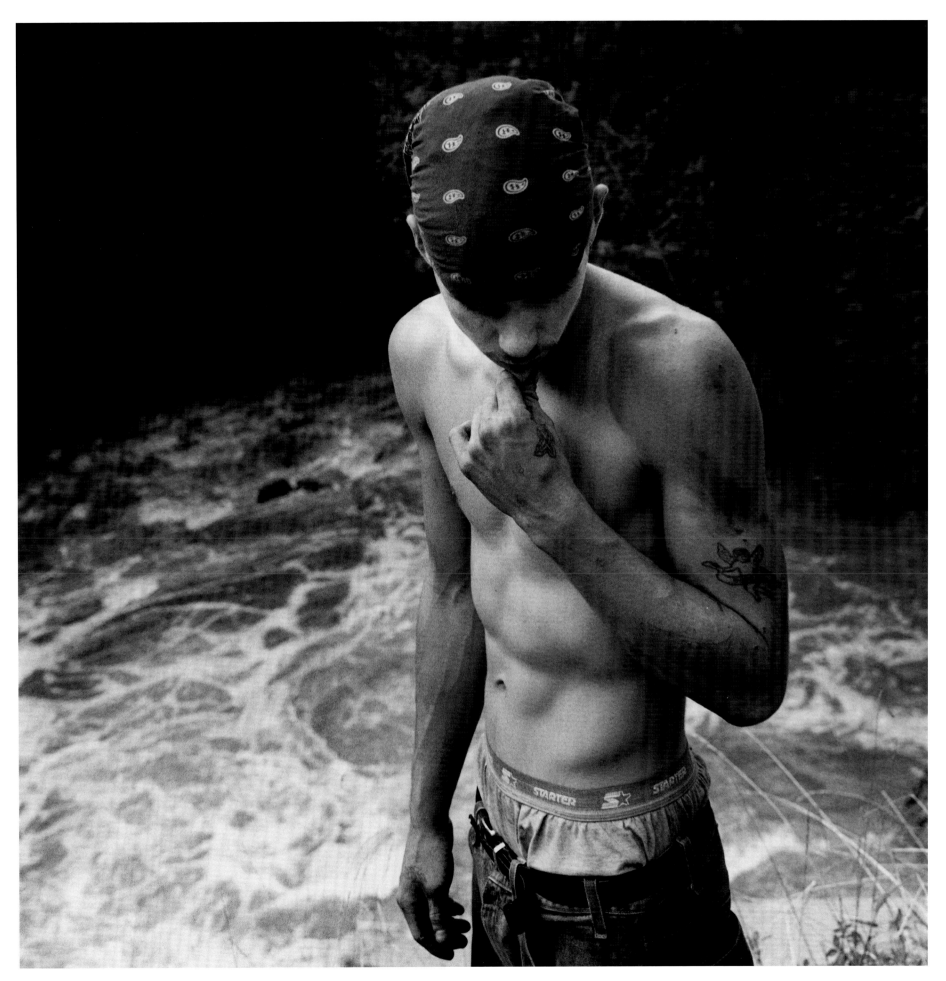

35 After the storm. Devils Fork Hollow, West Virginia, 2002.

36 "Are You Ready to Meet God" at the Church on the Rock in Jesus Name. Bramwell, West Virginia, 2002.

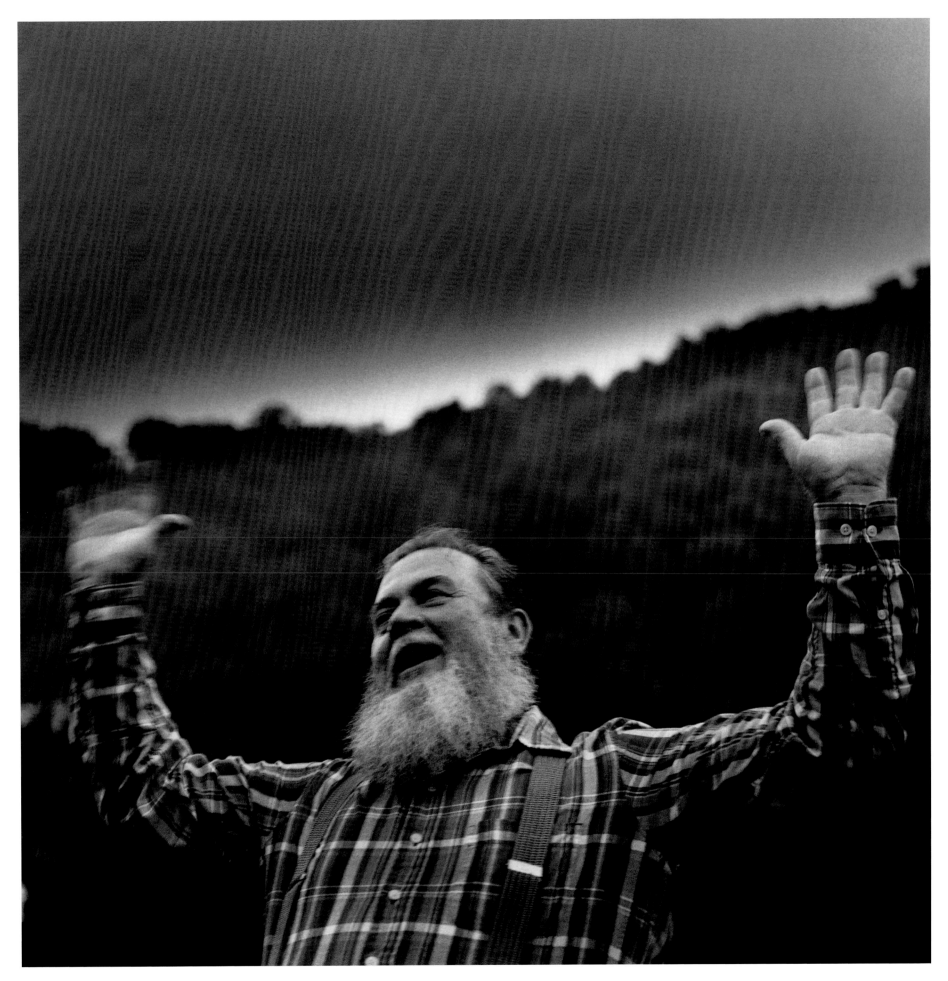

Brother James, sixty-one years old, at a tent revival. Delbarton, West Virginia, 2002.

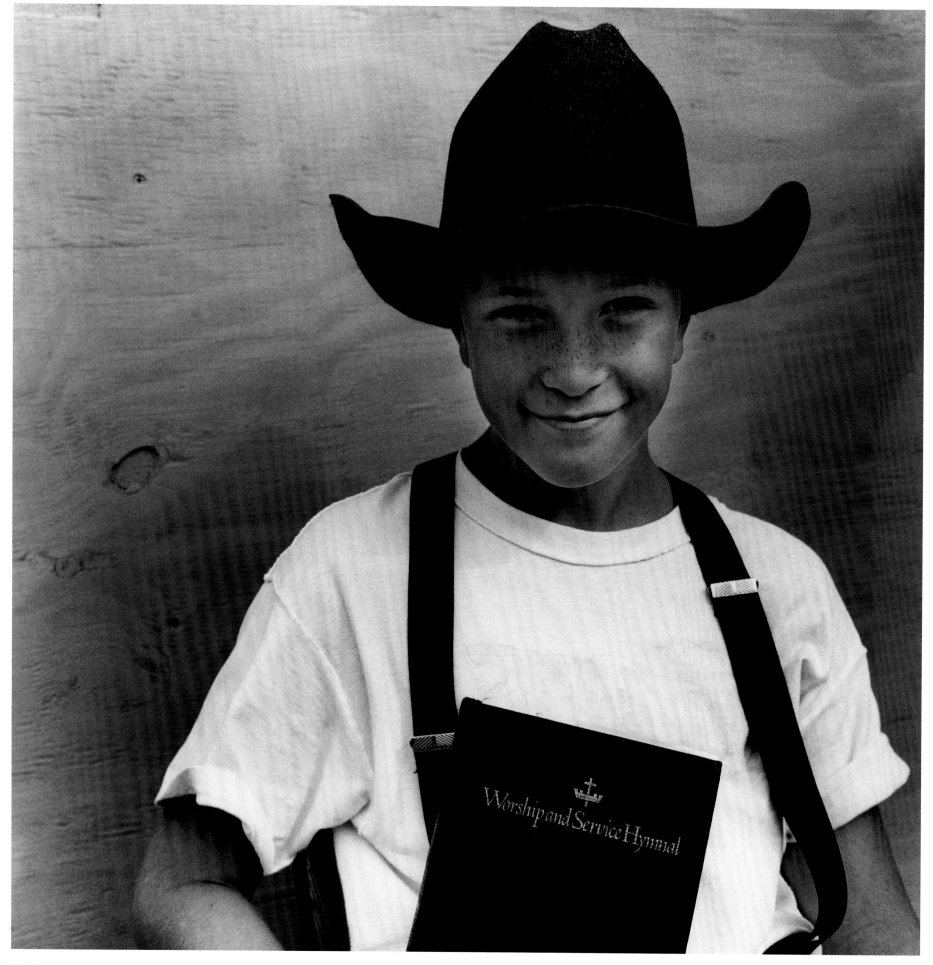

38 Young preacher boy, John Henry Days parade. Hinton, West Virginia, 2002.

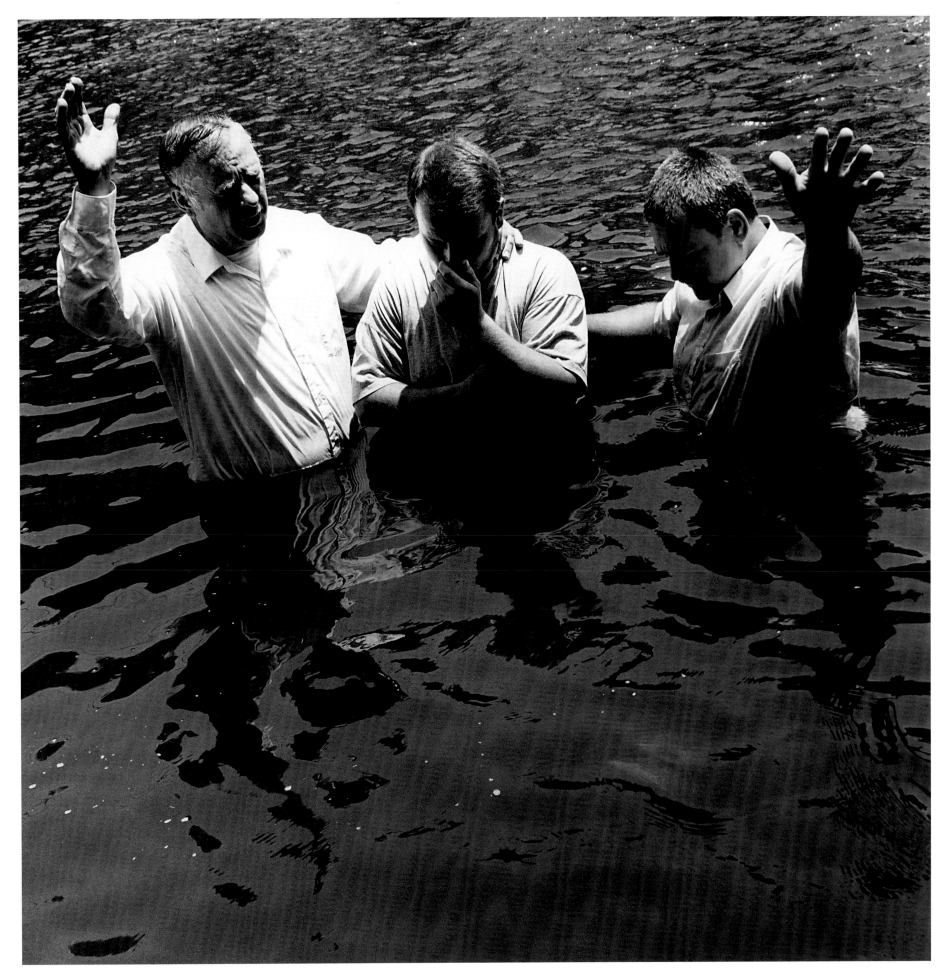

39 River baptism of Grassybanks Community Church. Devils Fork Hollow, West Virginia, 2000.

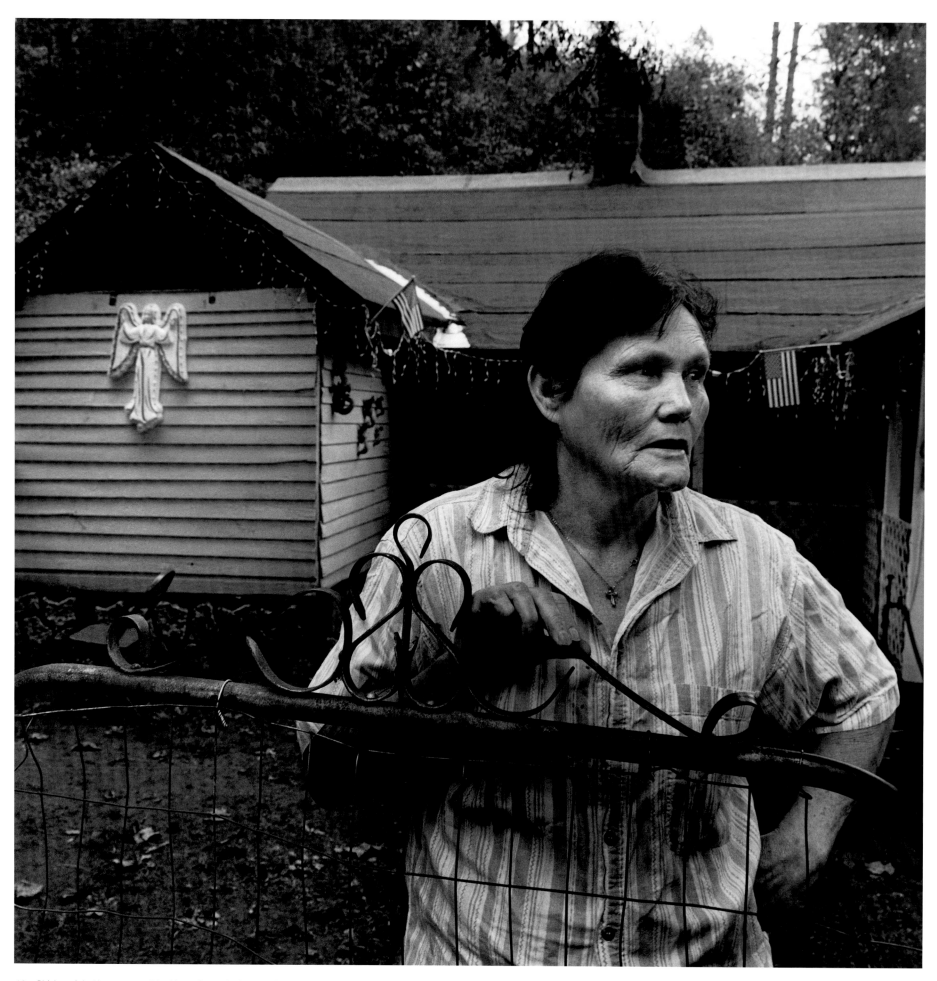

40 Shirley, sixty-three years old, widow of a coal miner, coal camp house. Elkhorn Creek Hollow, West Virginia, 2002.

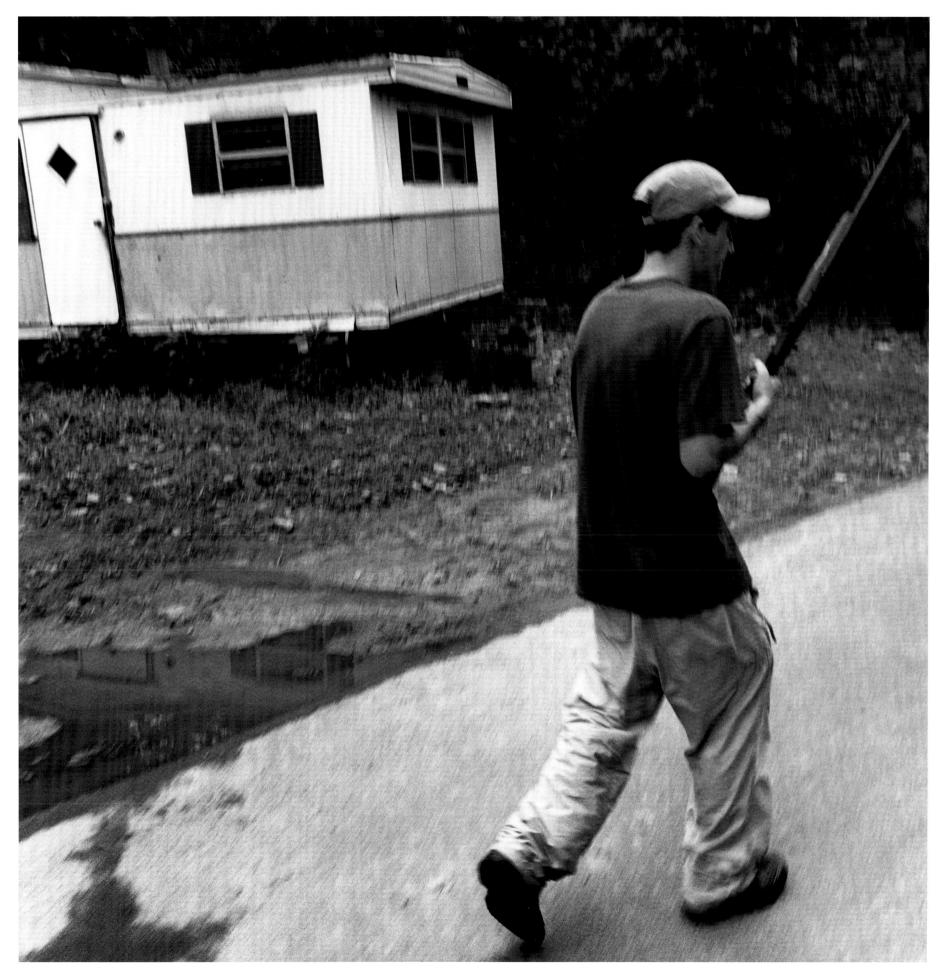

41 Shooting snakes. Stephenson, West Virginia, 2001.

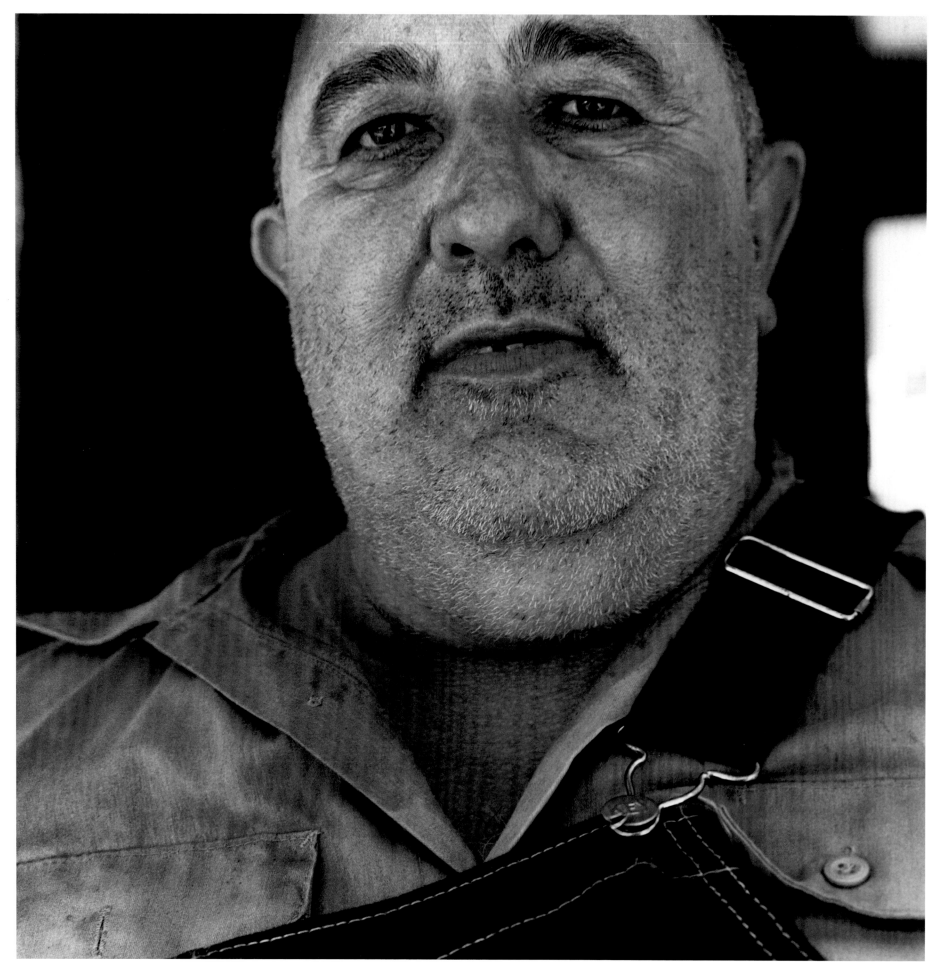

42 Cody, fifty-eight years old. Oozley Branch Hollow, West Virginia, 2002.

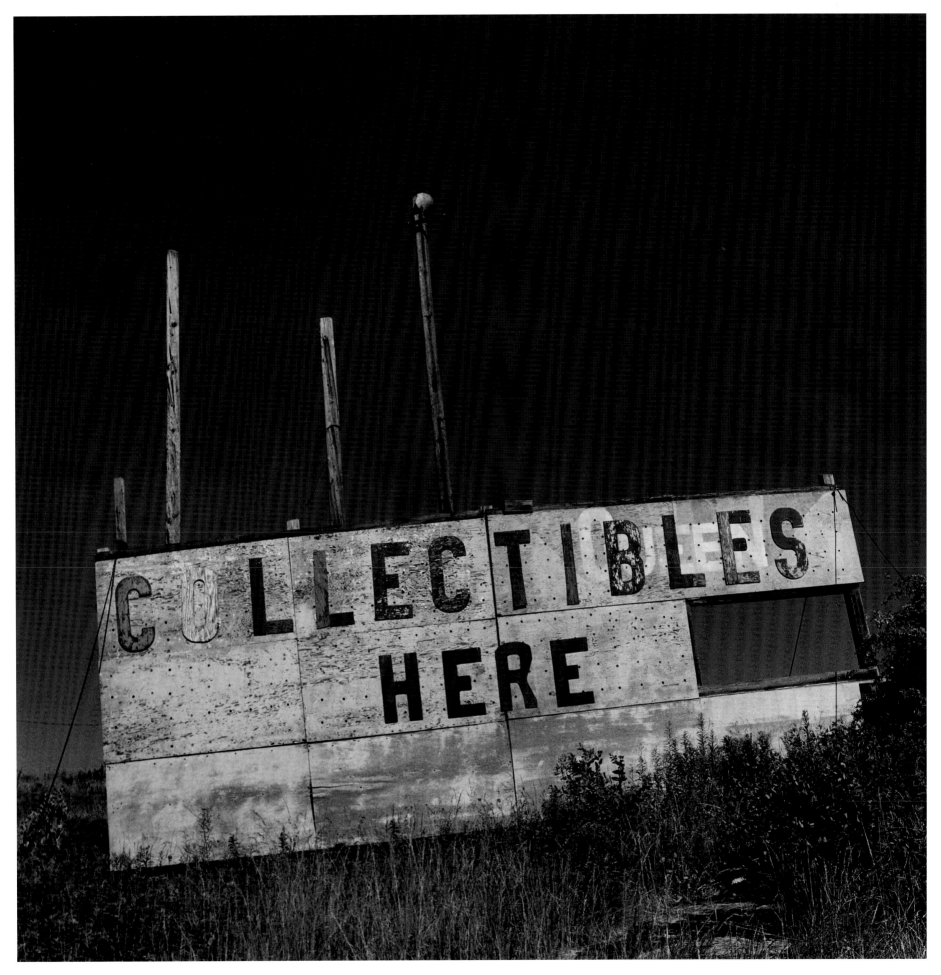

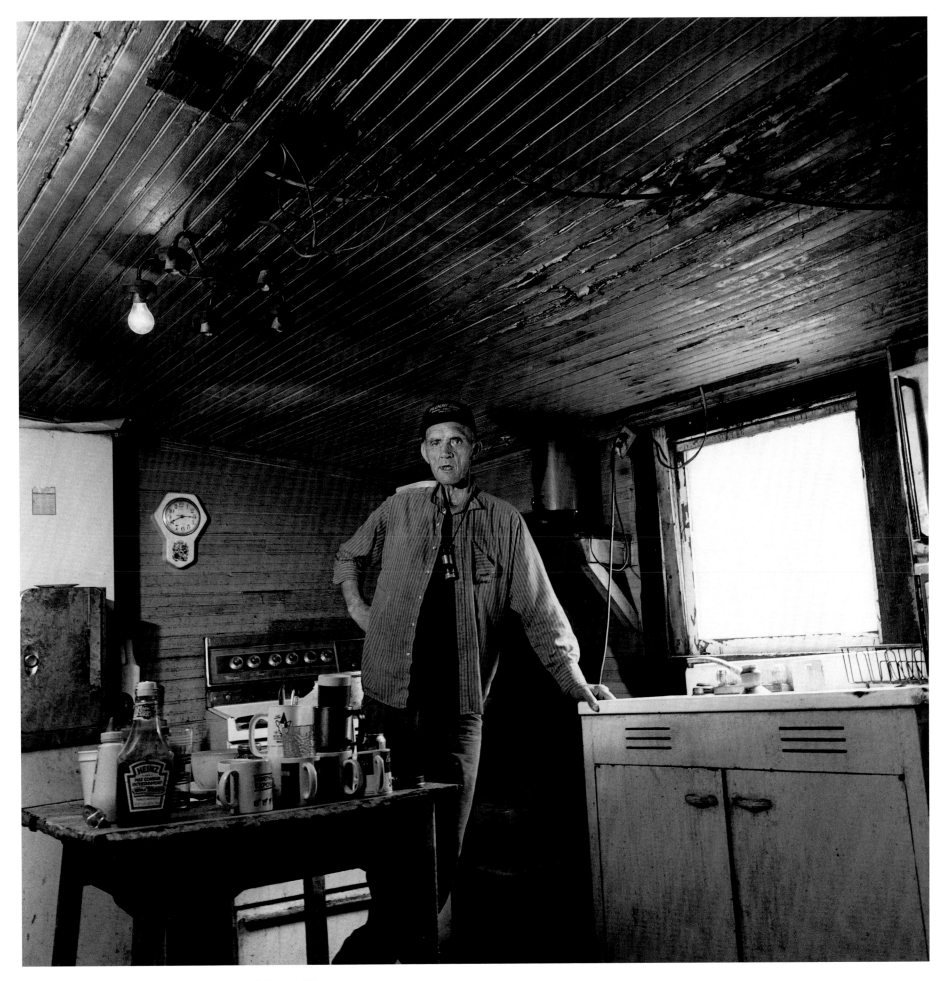

44 James, sixty years old, in the kitchen. Fireco, West Virginia, 2001.

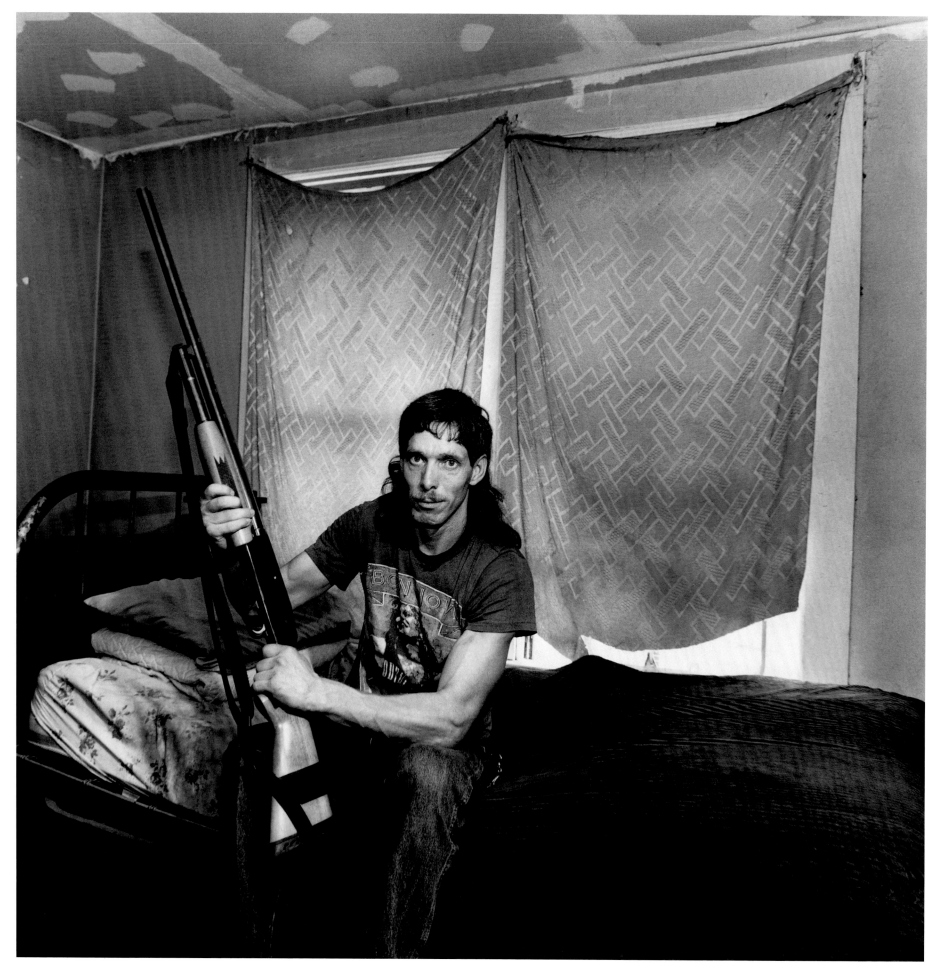

45 Junior, thirty-seven years old, with a Mossberg 12-gauge and a Bon Jovi shirt. Rhodell, West Virginia, 2002.

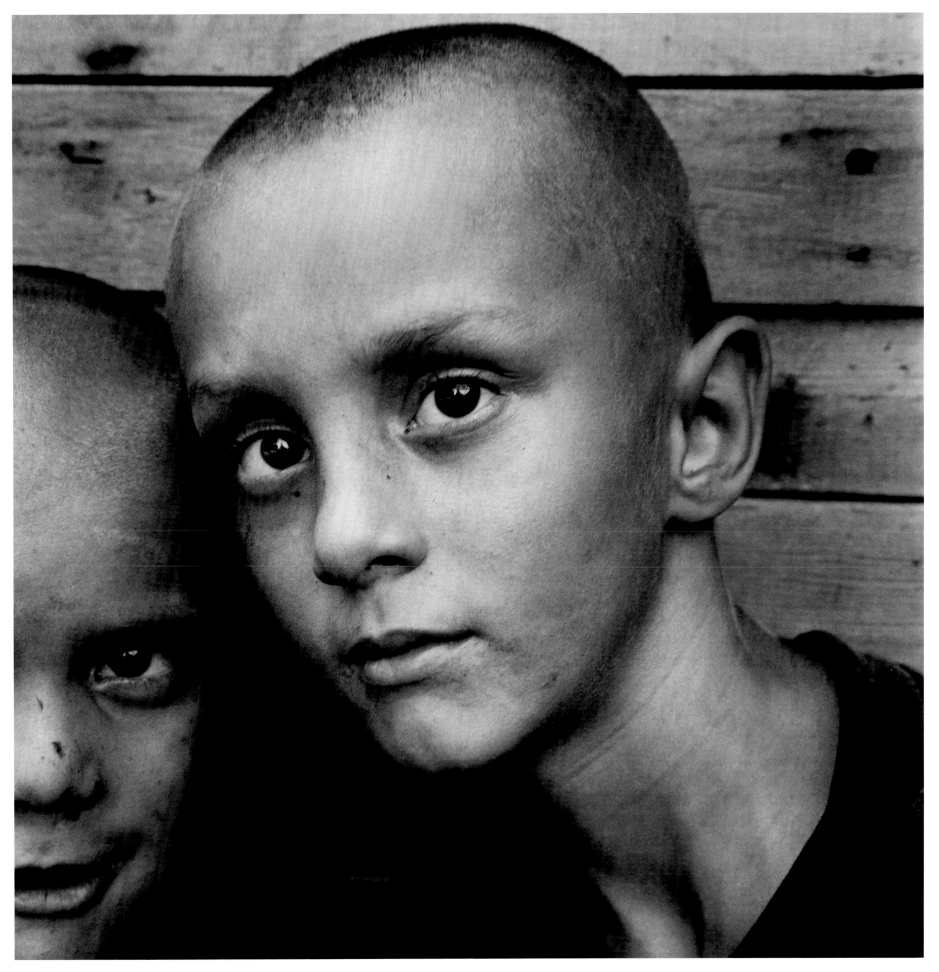

Joshua and Chris, brothers, five and seven years old. Riffe Branch Hollow, West Virginia, 2002.

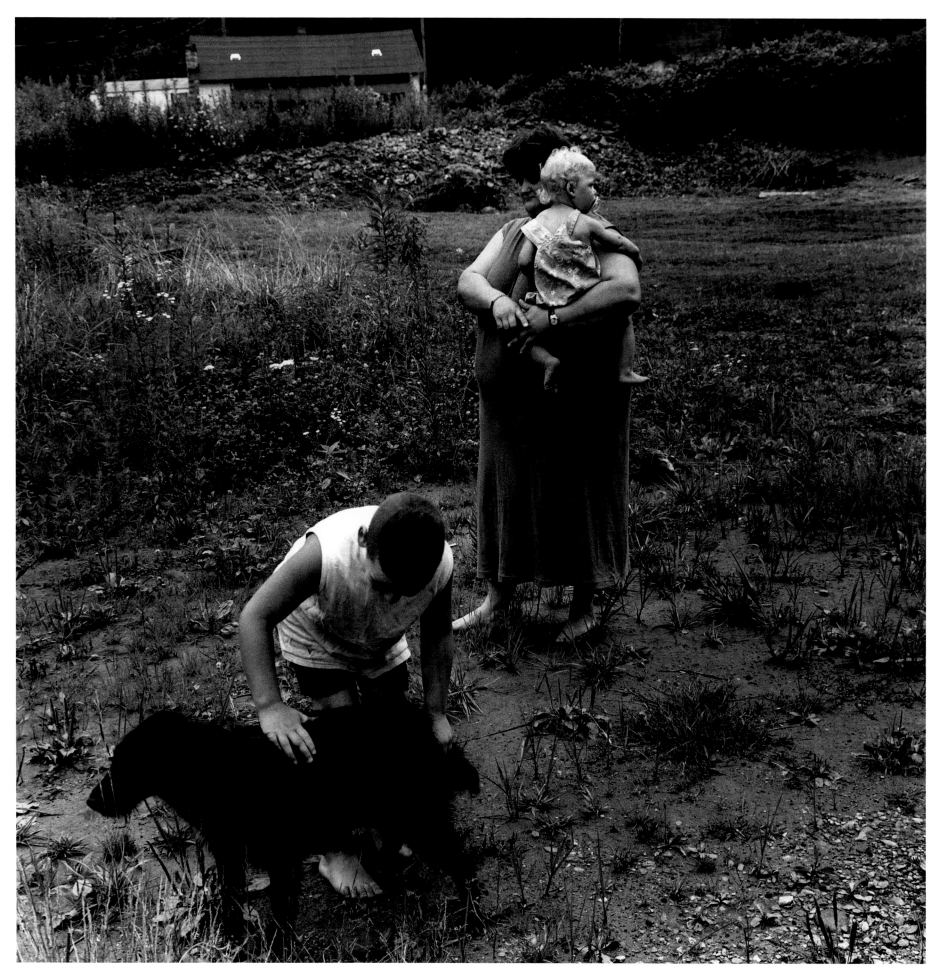

47 Terry, thirty-eight years old, a single mother with her baby and son. Besoco, West Virginia, 2002.

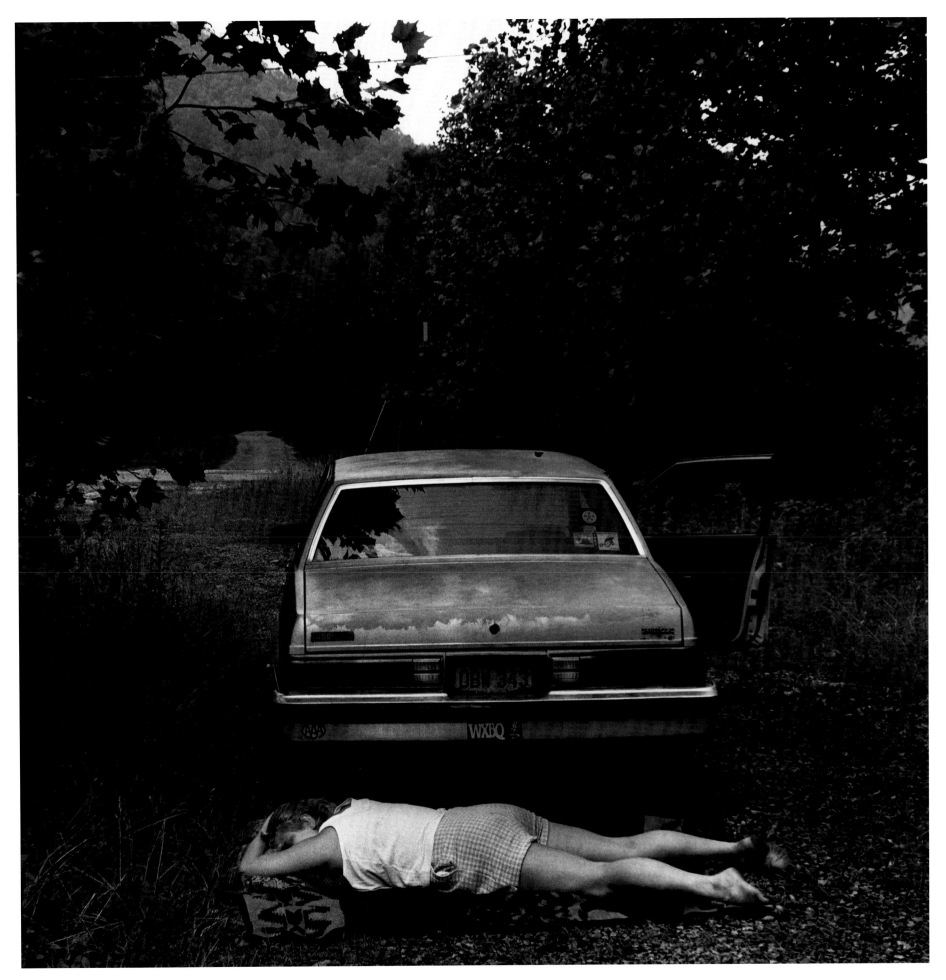

48 Sleeping on a hot July afternoon. Amigo, West Virginia, 2002.

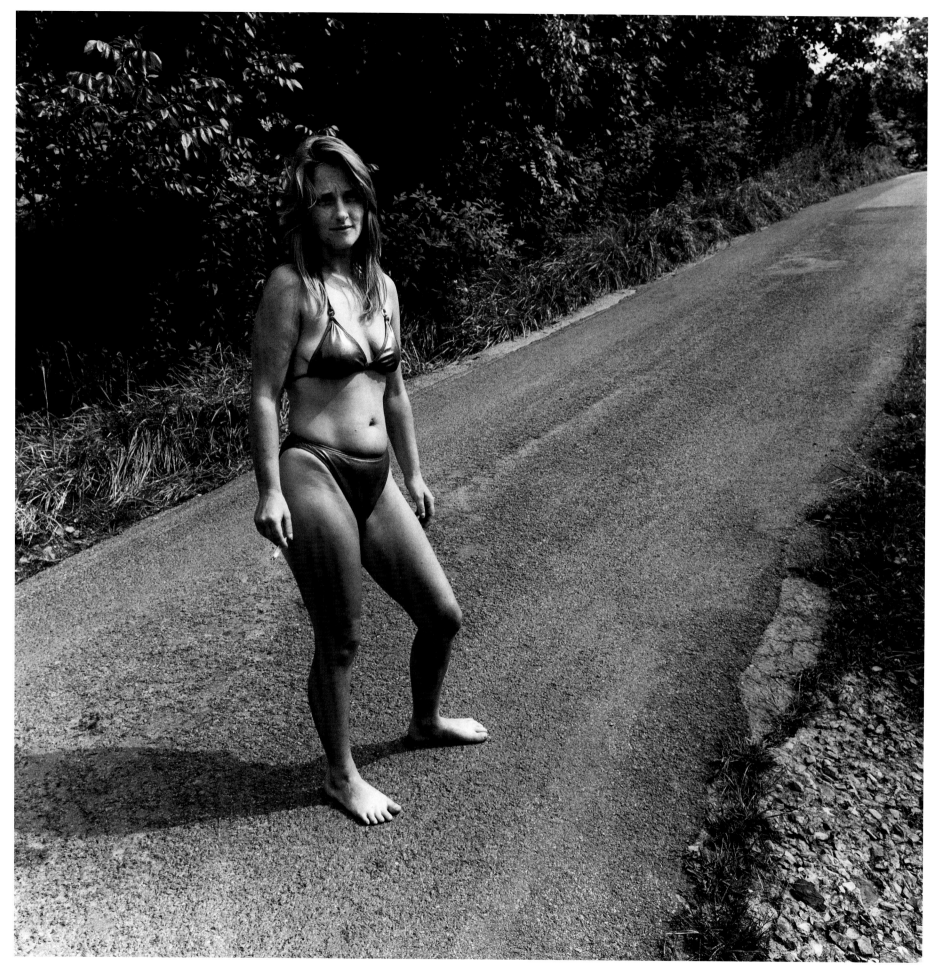

49 Summer day. Stephenson, West Virginia, 2001.

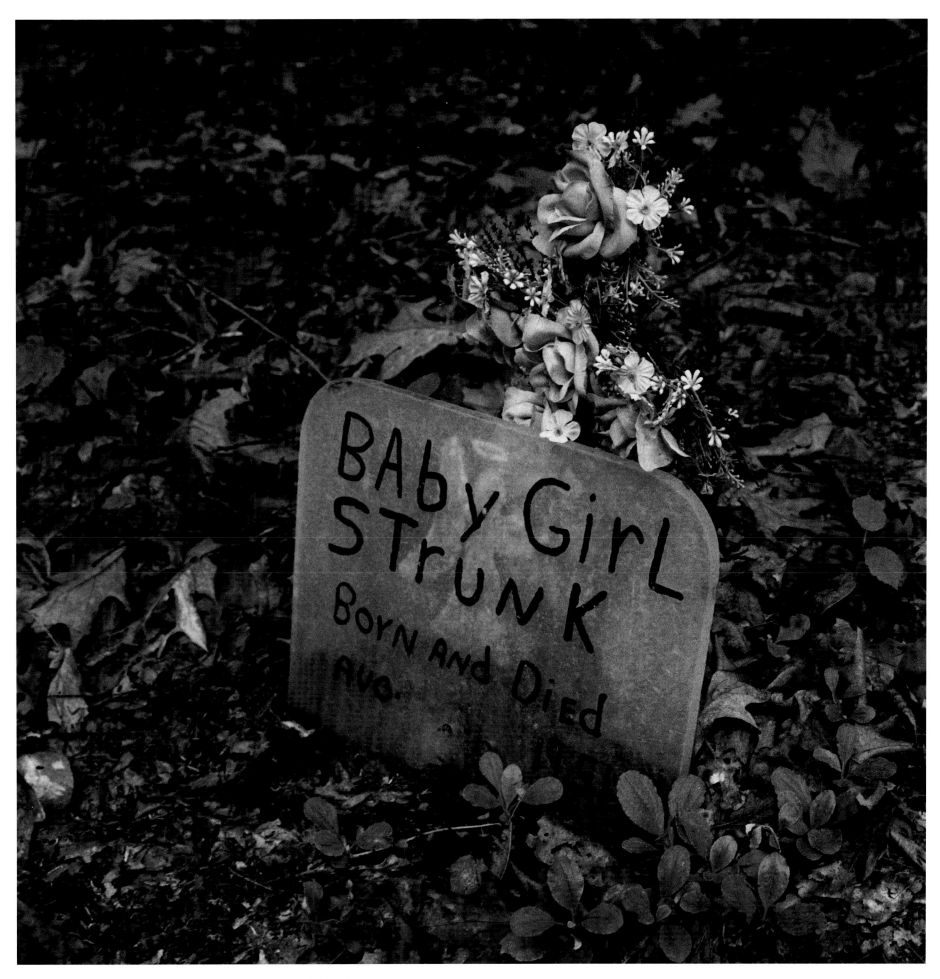

"Baby Girl Strunk," family graveyard. Wyoming County, West Virginia, 2001.

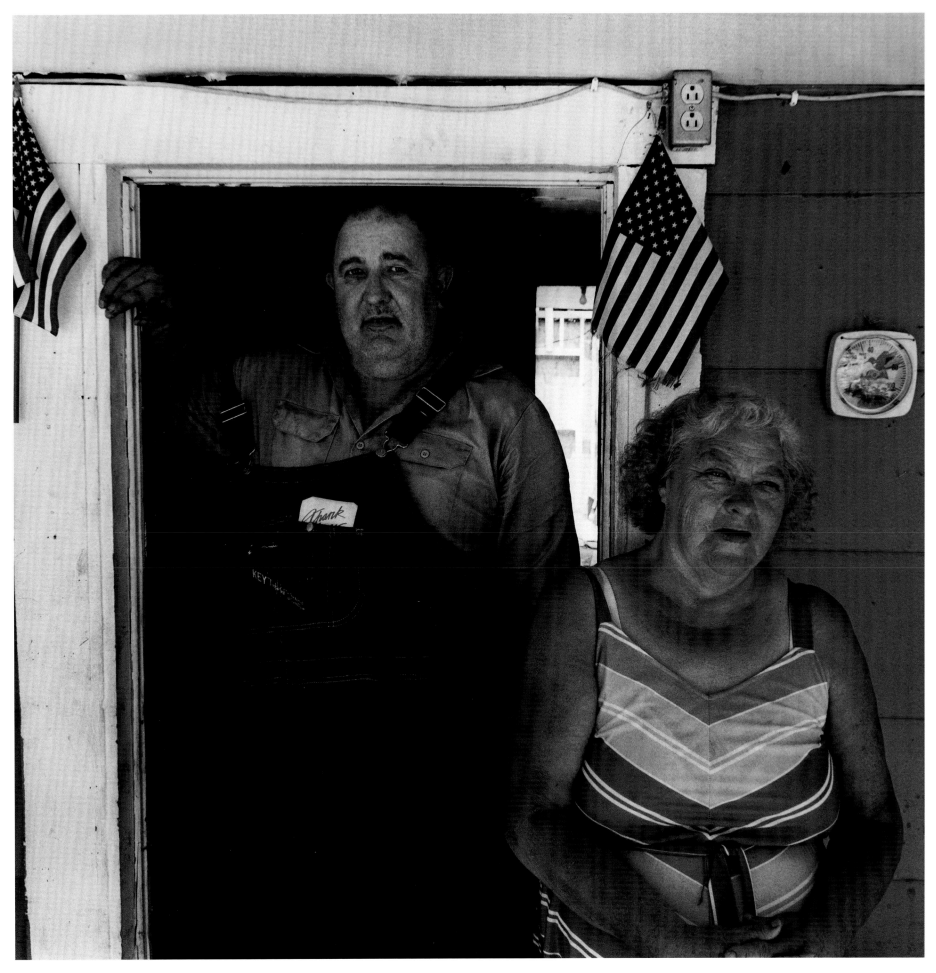

51 Cody and Ocie, his girlfriend of twenty-two years. Oozley Branch Hollow, West Virginia, 2002.

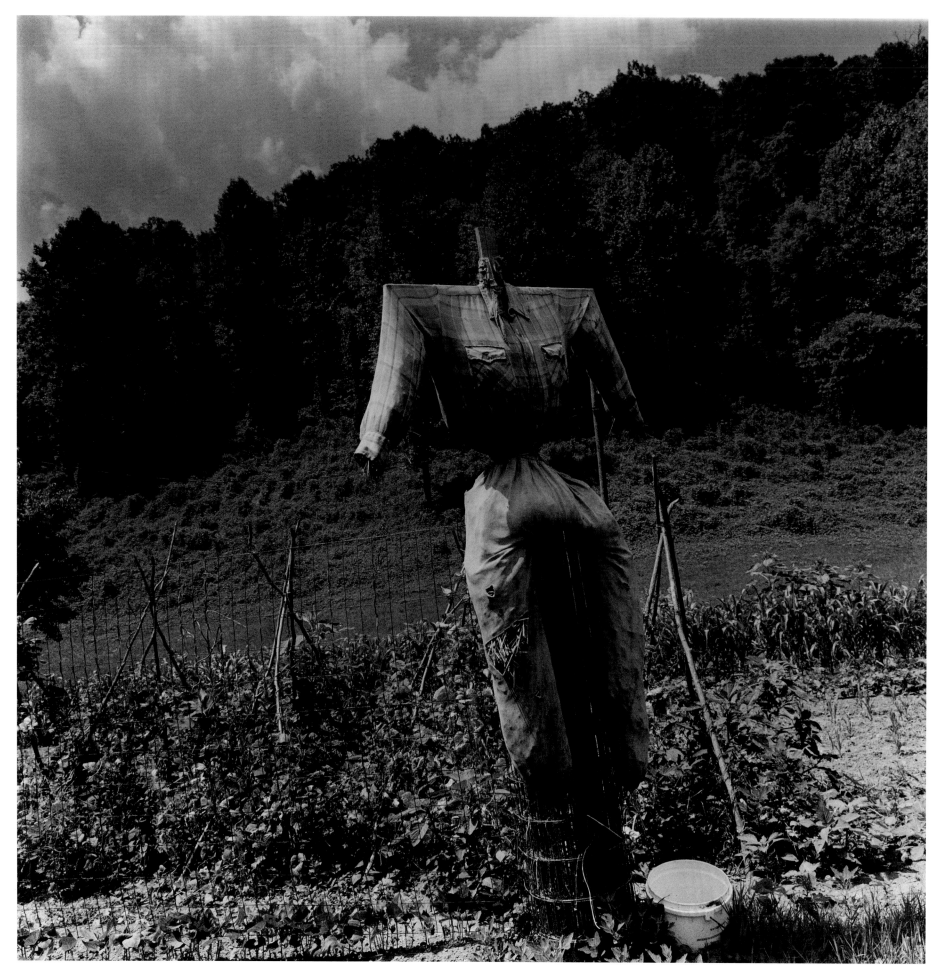

Scarecrow. Mingo County, West Virginia, 2002.

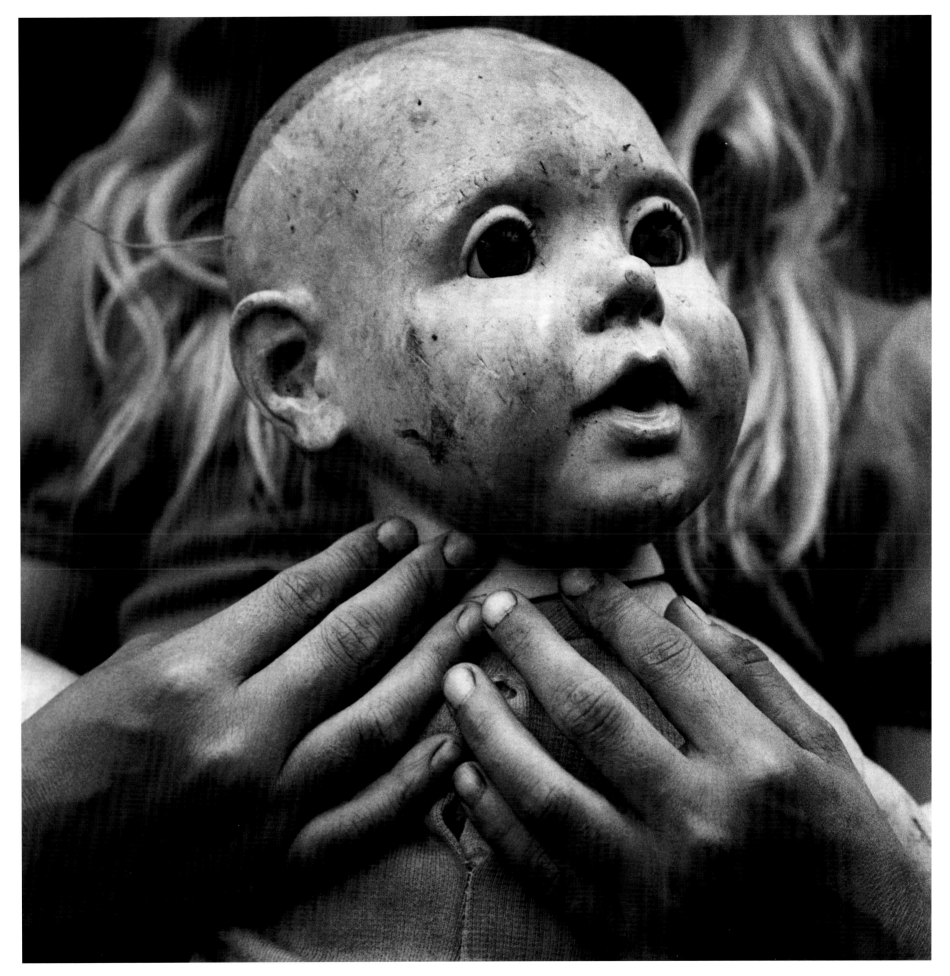

53 Amy, nine years old, with her doll. Besoco, West Virginia, 2001.

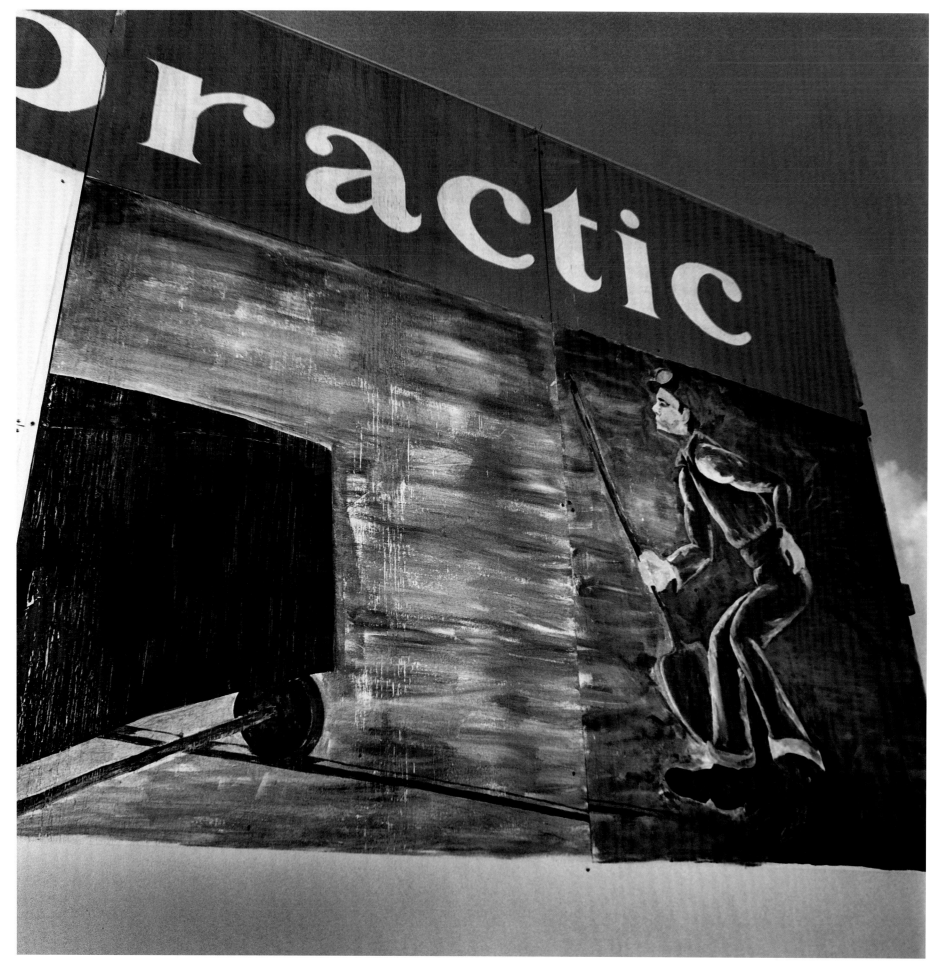

Chiropractic billboard. Raleigh County, West Virginia, 2002.

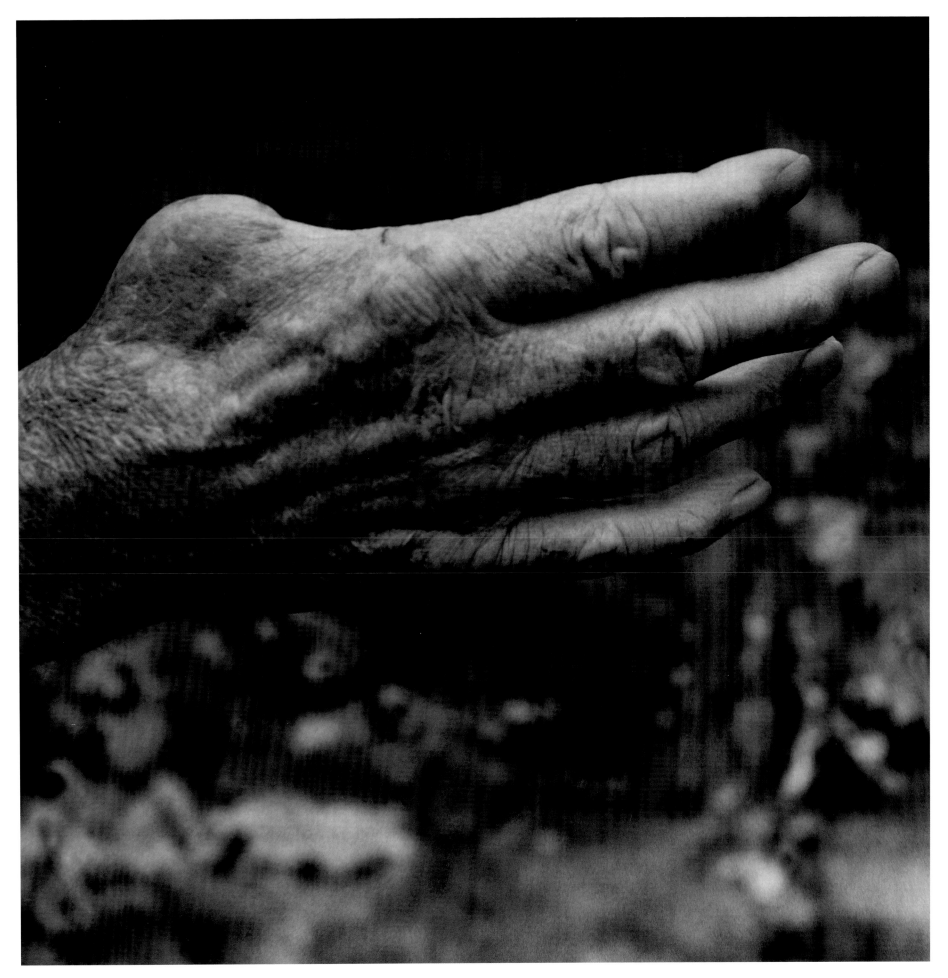

55 Mining accident, 1965. Devils Fork Hollow, West Virginia, 2002.

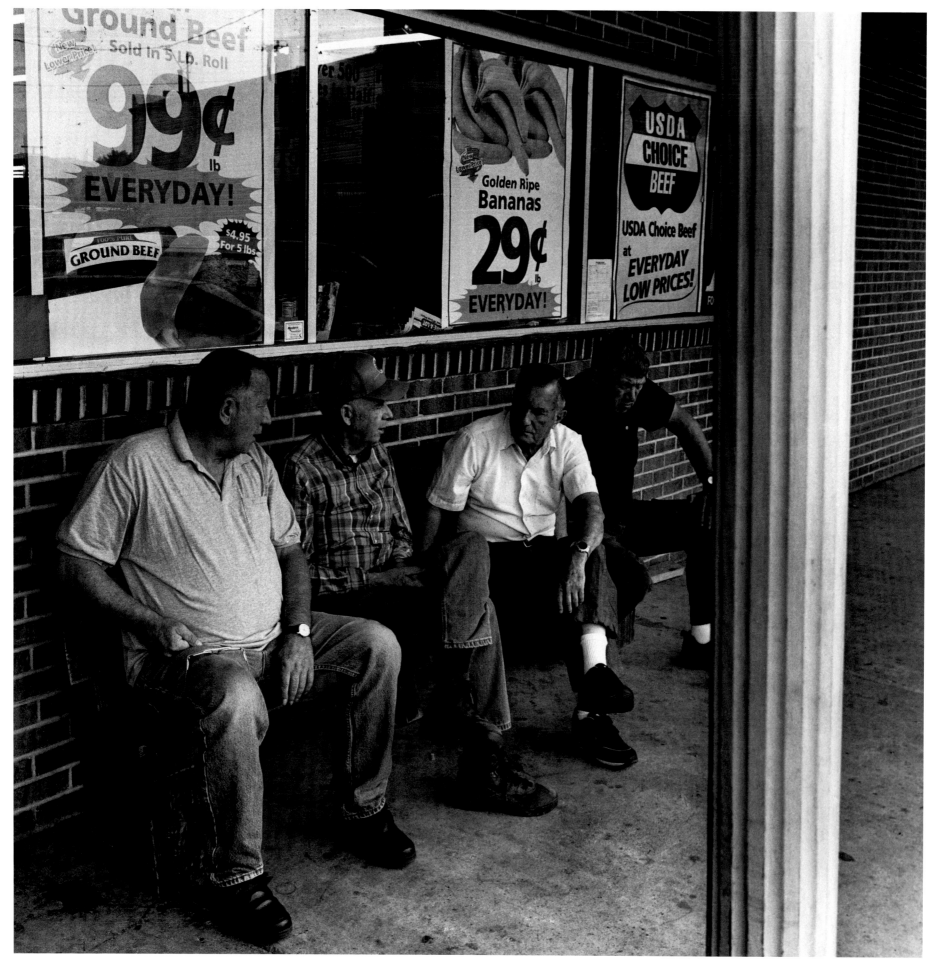

Saturday afternoon. Summers County, West Virginia, 2002.

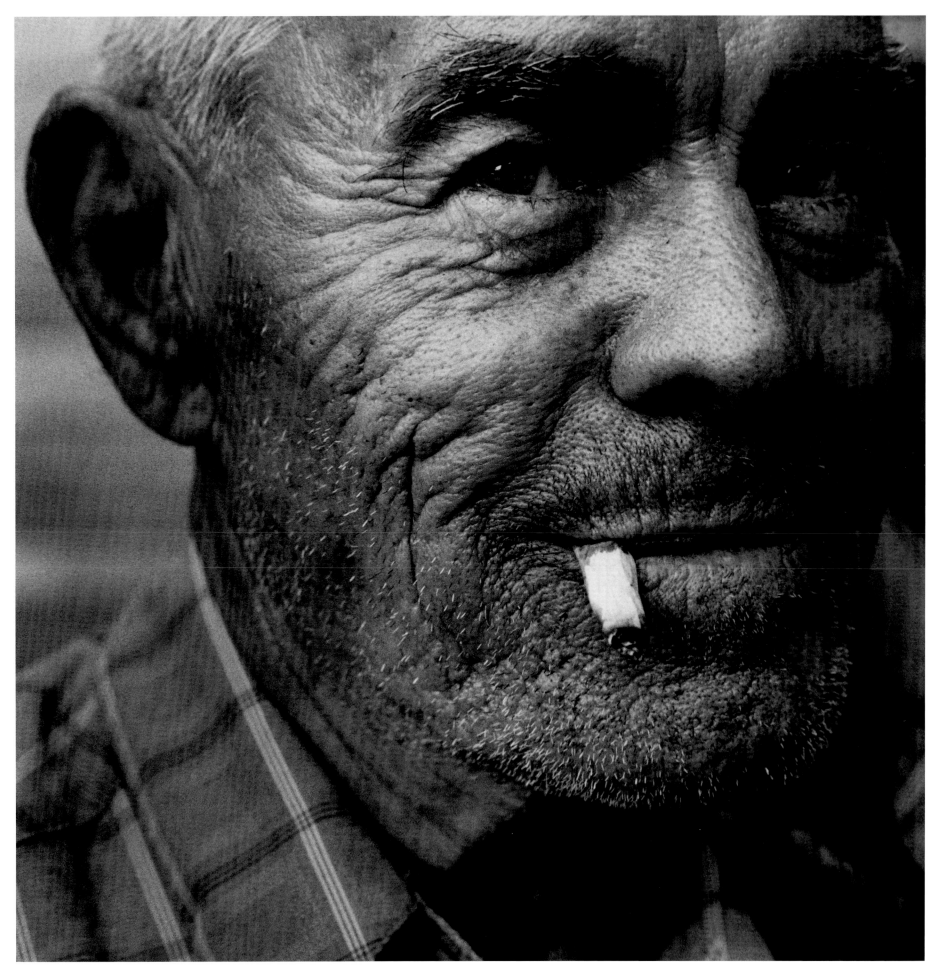

57 Willie with his hand-rolled. Riffe Branch Hollow, West Virginia, 2002.

Gourd birdhouse. Southern West Virginia, 2002.

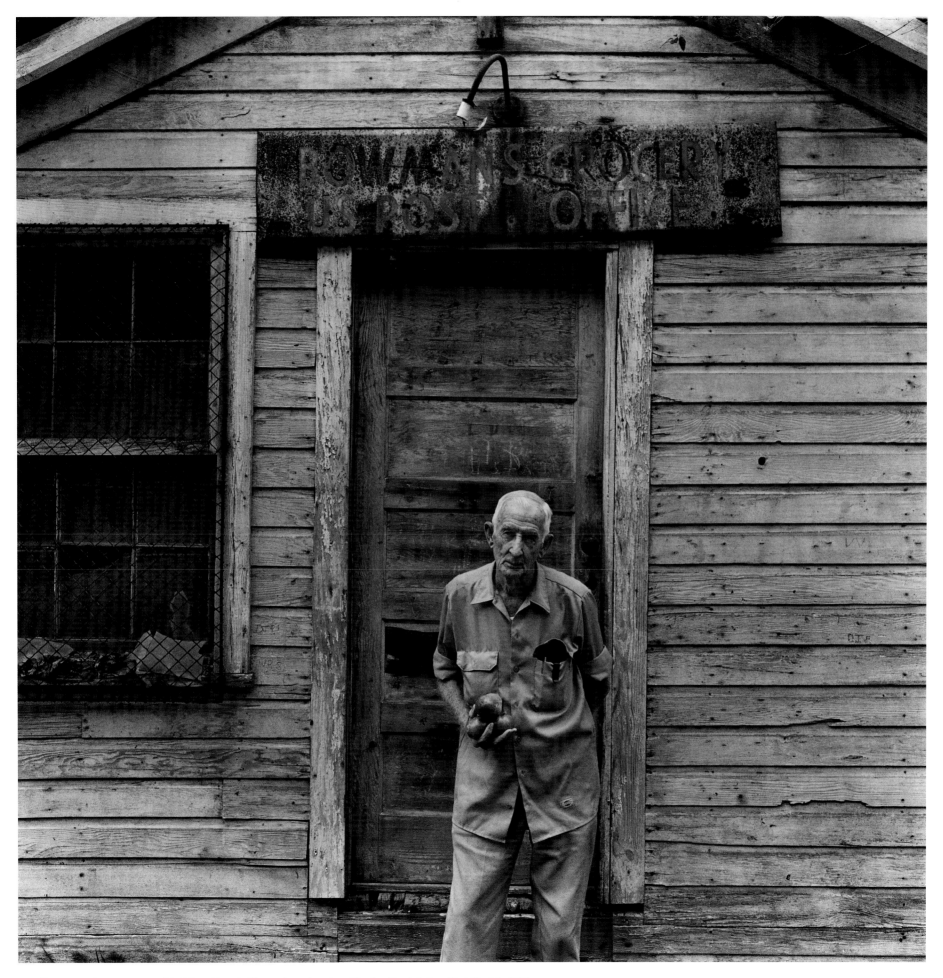

59 Harry, seventy-seven years old, at the old post office and country store. Thacker Creek Hollow, West Virginia, 1999.

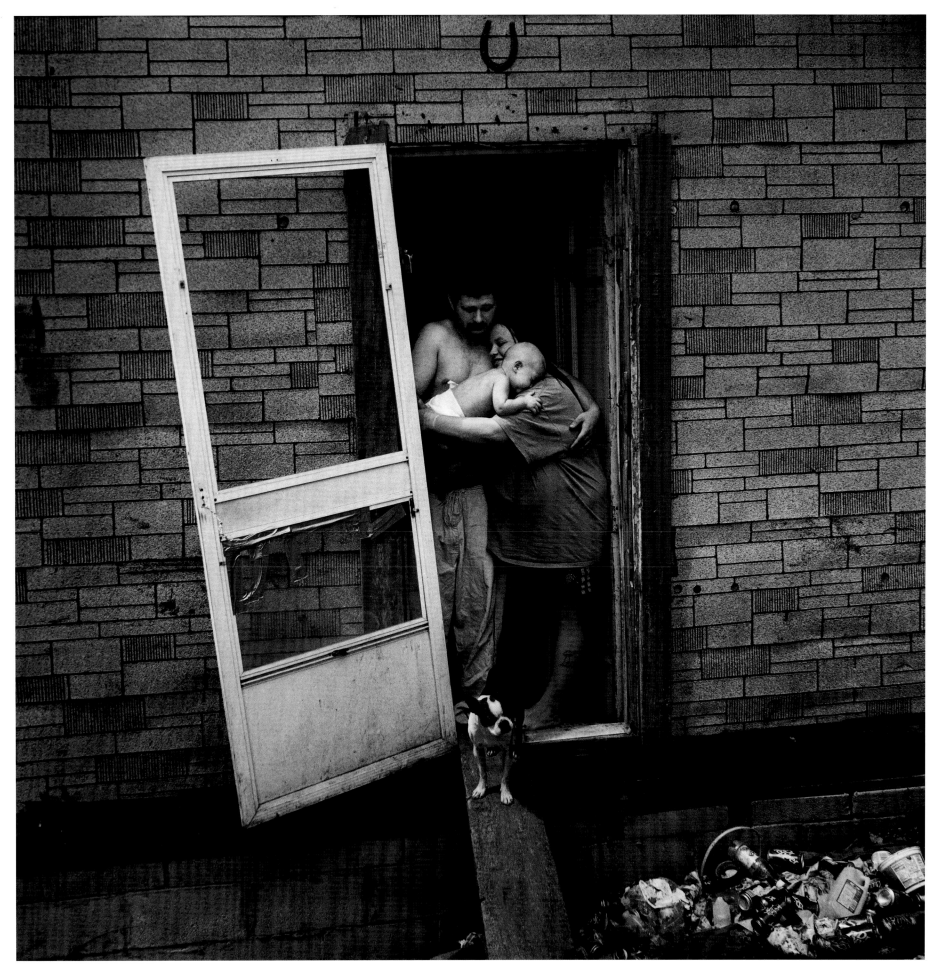

Jeff, Donna, and baby Grace. Pickshin Hollow, West Virginia, 2002.

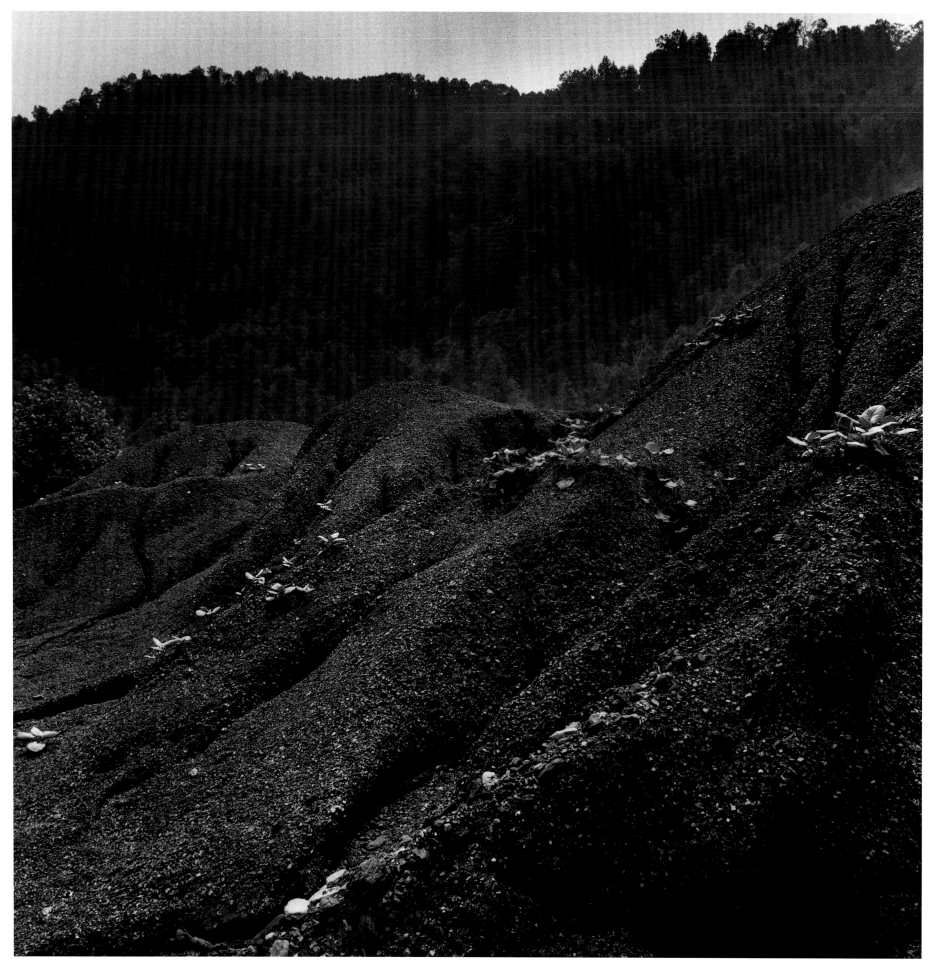

61 Slag heap. War, West Virginia, 2002.

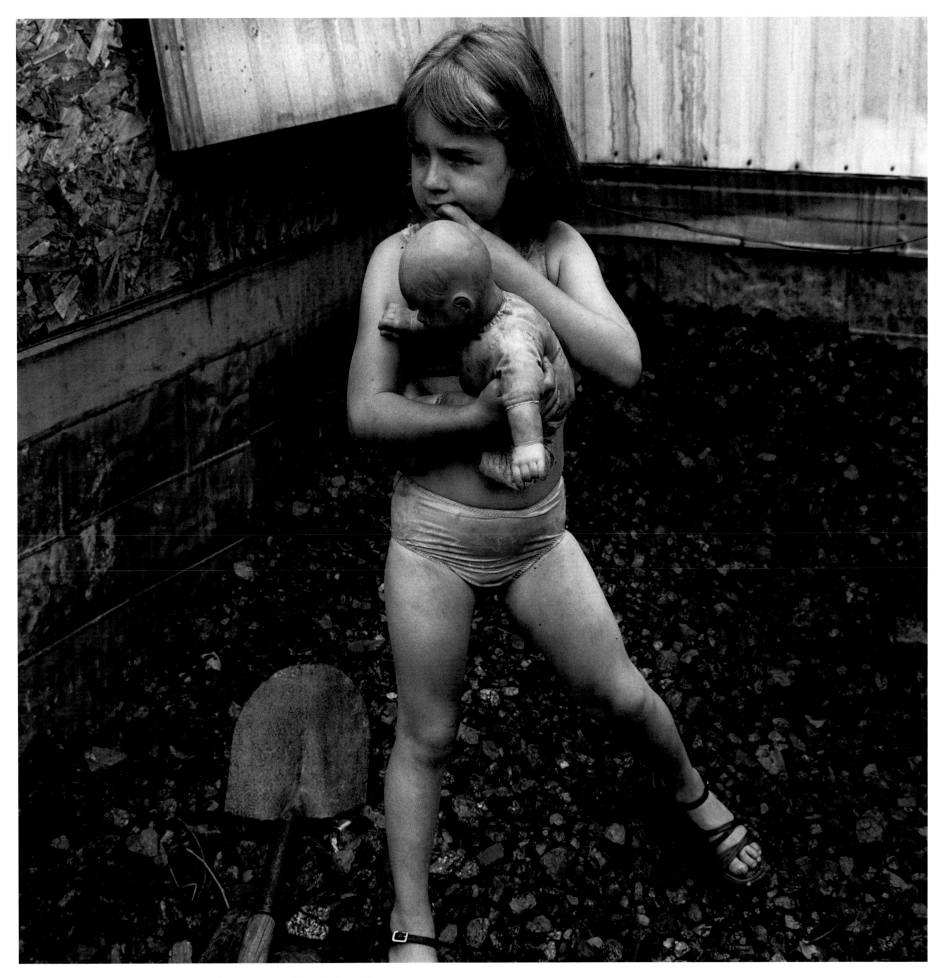

62 Chelsea, six years old, playing in the coal bin. Stephenson, West Virginia, 2001.

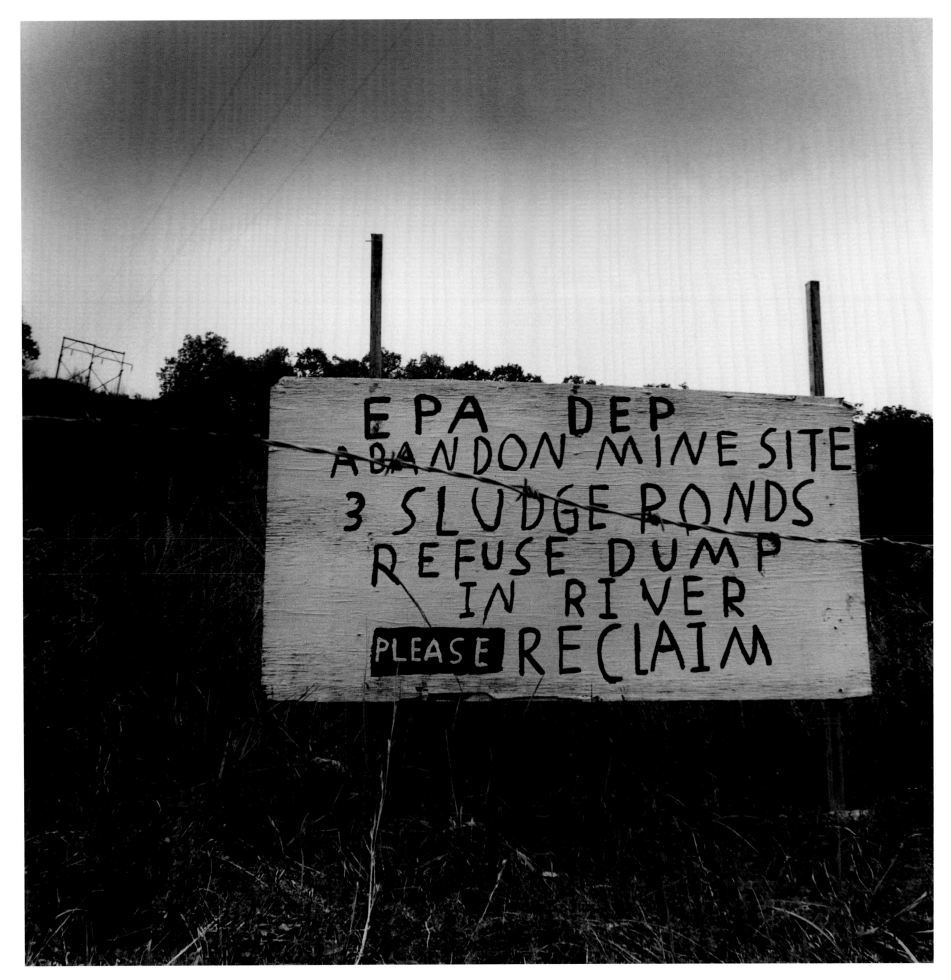

63 Environmental Protection Agency "Please reclaim." Turkey Creek Road, Wyoming County, West Virginia, 2002.

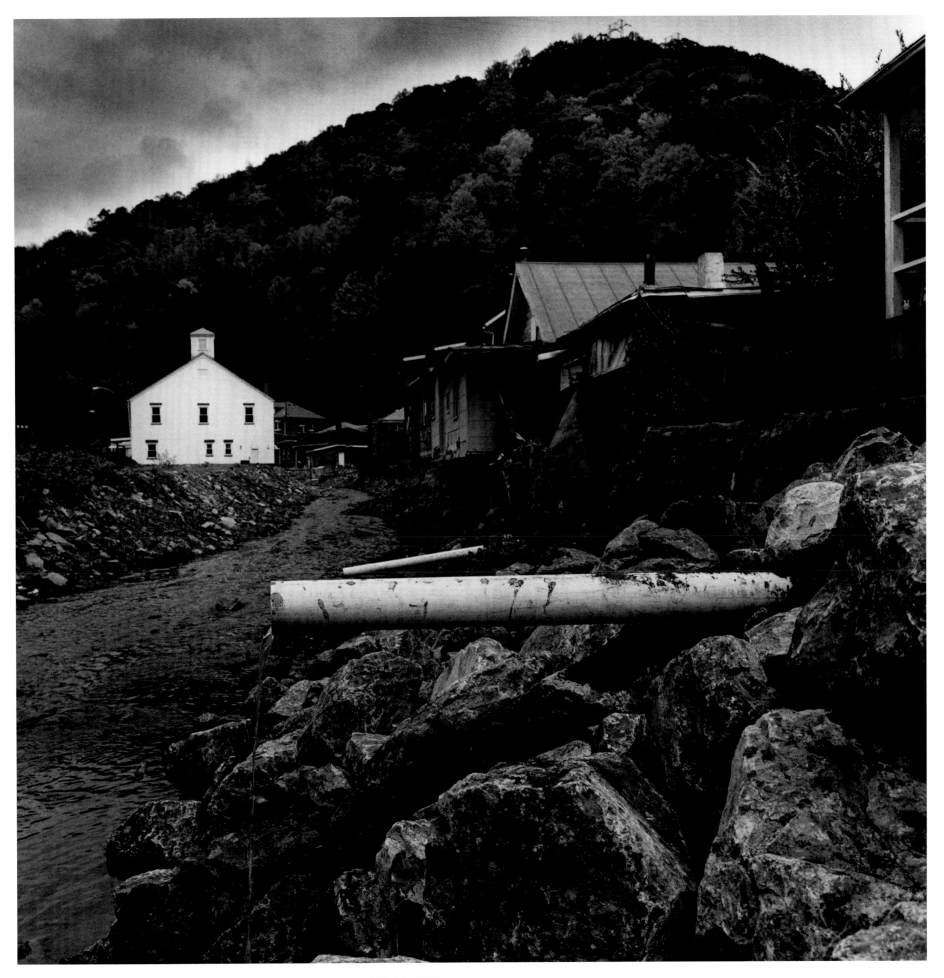

64 Raw sewage runs into the Elkhorn Creek. Rolfe Bottom Road, Northfork, West Virginia, 2002.

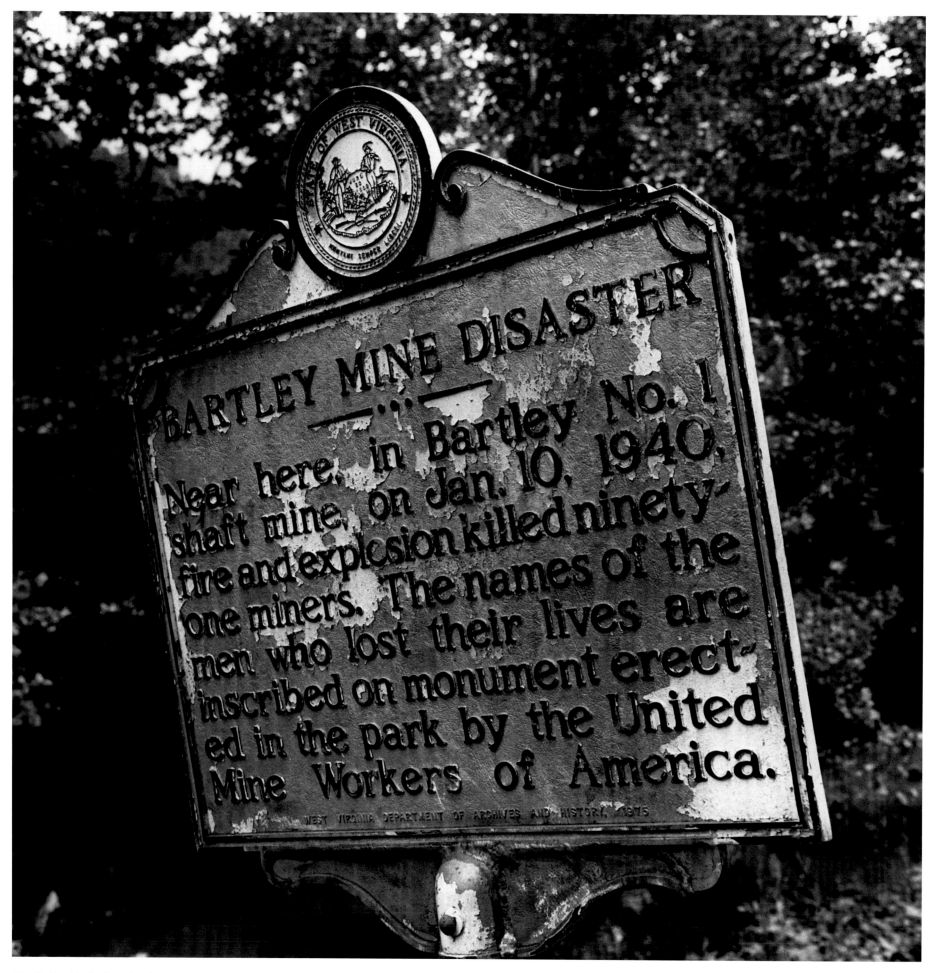

BARTLEY MINE DISASTER

Near here, in Bartley No. 1 shaft mine, on Jan. 10, 1940, fire and explosion killed ninety-one miners. The names of the men who lost their lives are inscribed on monument erected in the park by the United Mine Workers of America.

WEST VIRGINIA DEPARTMENT OF ARCHIVES AND HISTORY, 1975

65 Marking the Bartley Mine disaster, in which ninety-one miners died. Bartley, West Virginia, 2002.

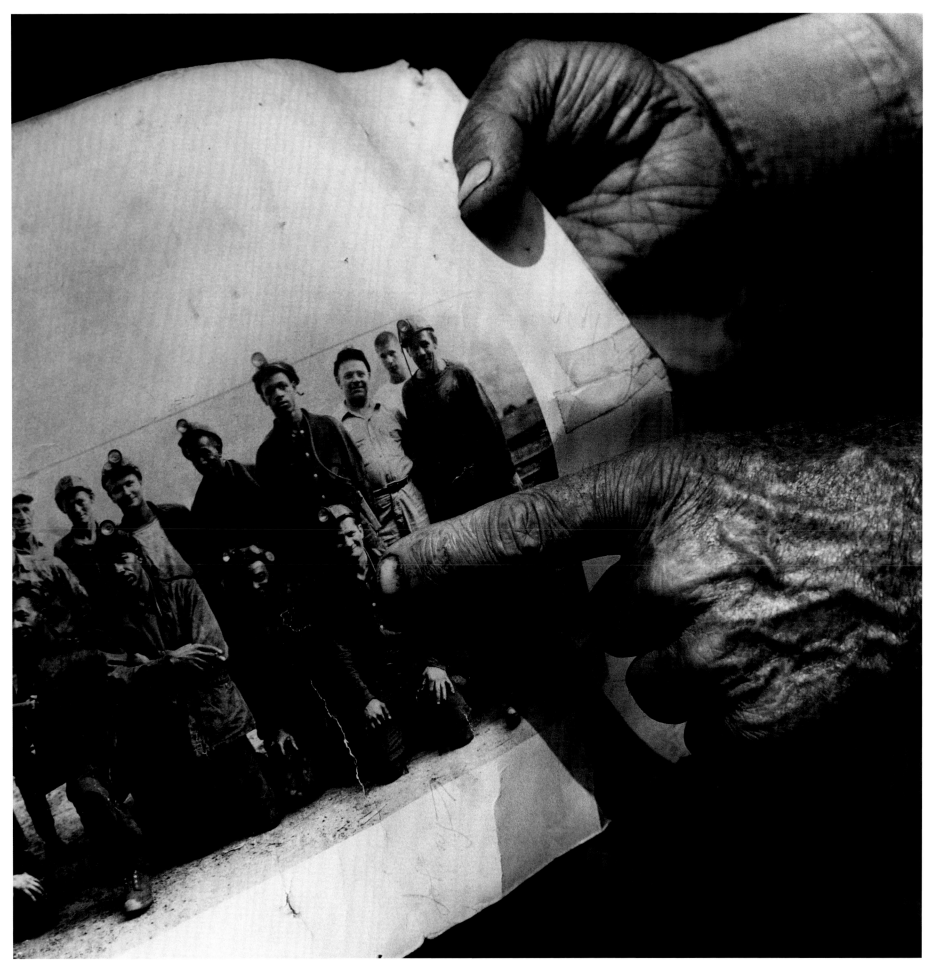

66 John, seventy-seven years old and missing three fingers, points to himself in a 1952 panoramic by Rufus Ribble. Amigo, West Virginia, 2002.

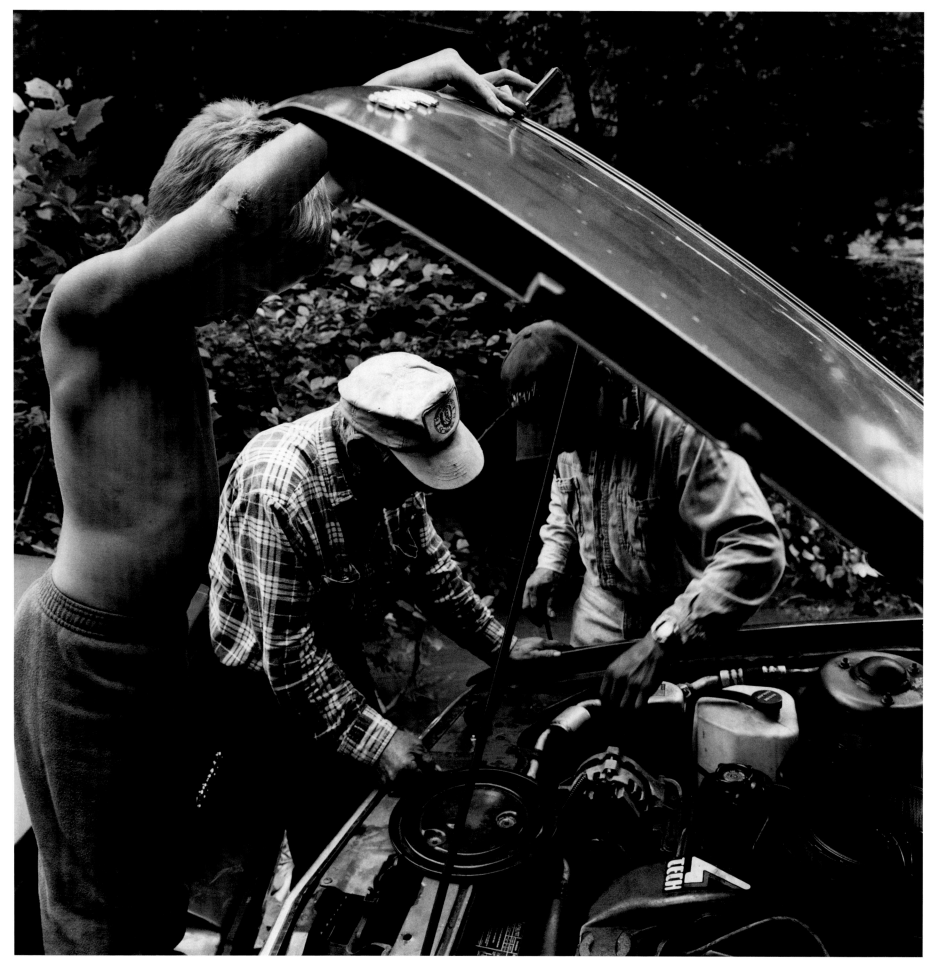

67 Three generations fixing the car on a Sunday. Riffe Branch Hollow, West Virginia, 2001.

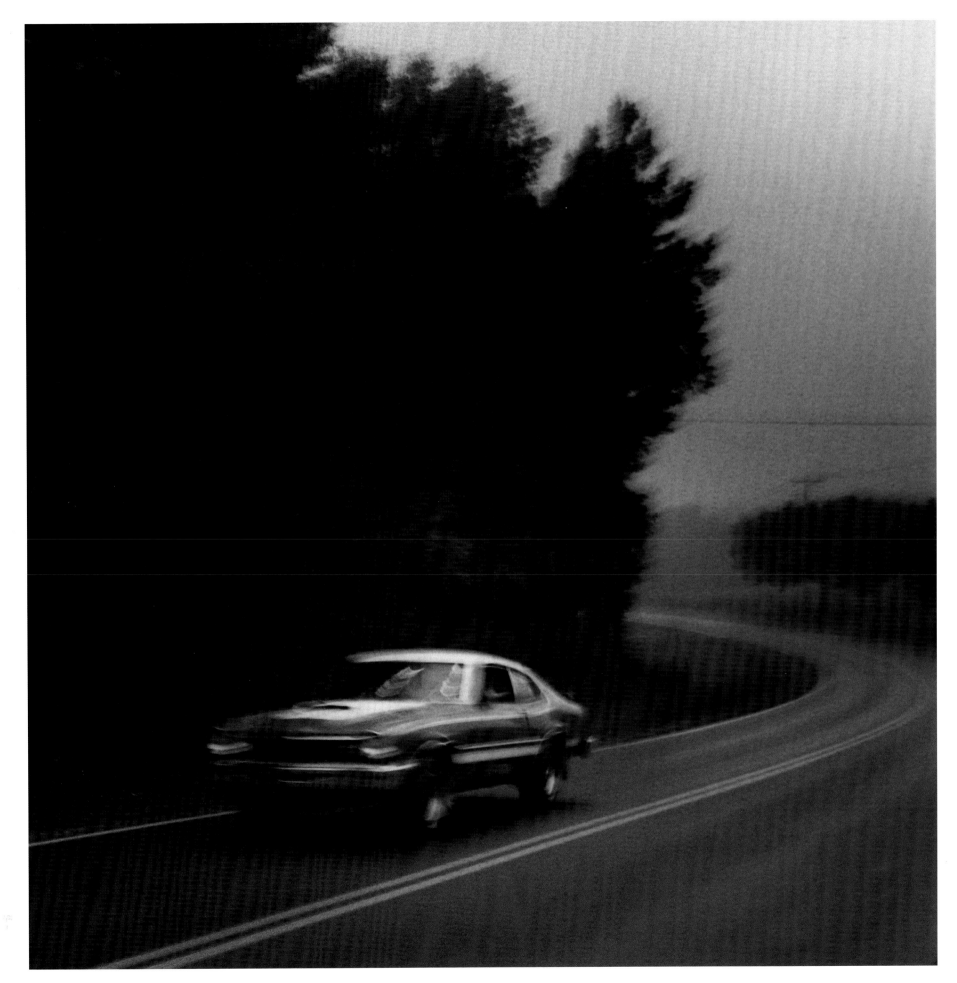

Souped-up car. Raleigh County, West Virginia, 2002.

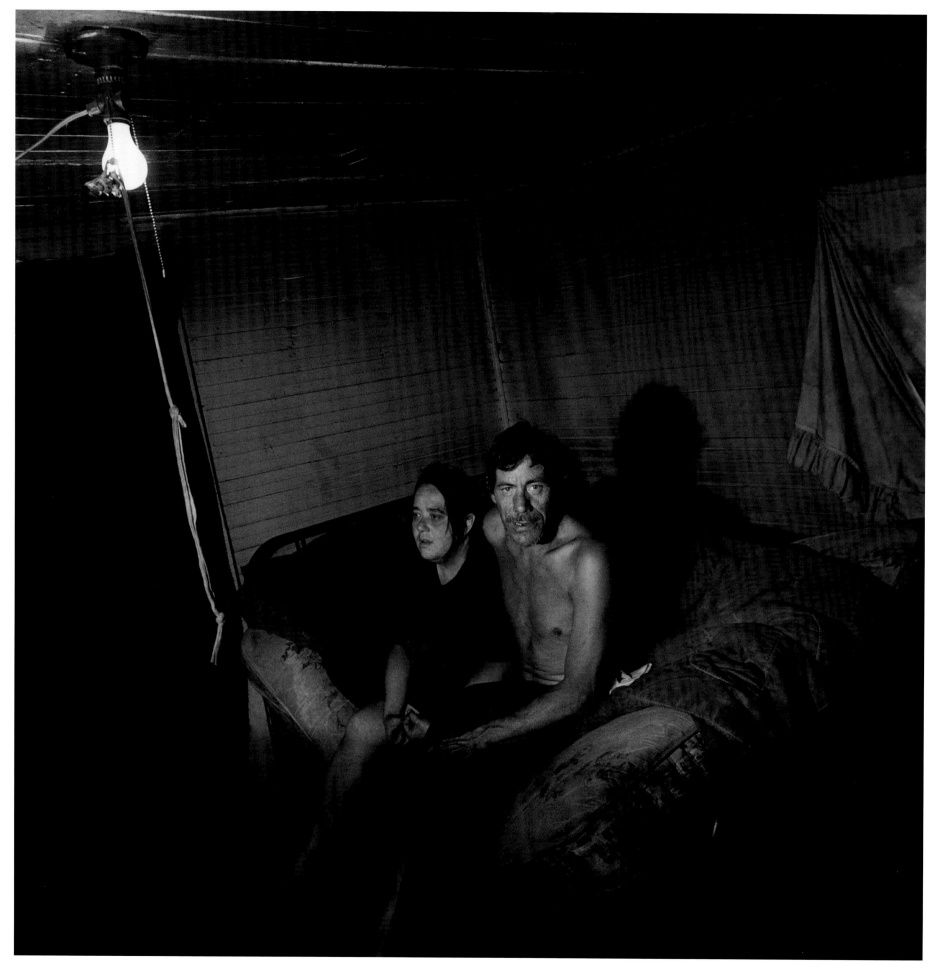

69 Ricky, forty-seven years old, and Eva, forty, husband and wife, in their bedroom. Fireco, West Virginia, 2002.

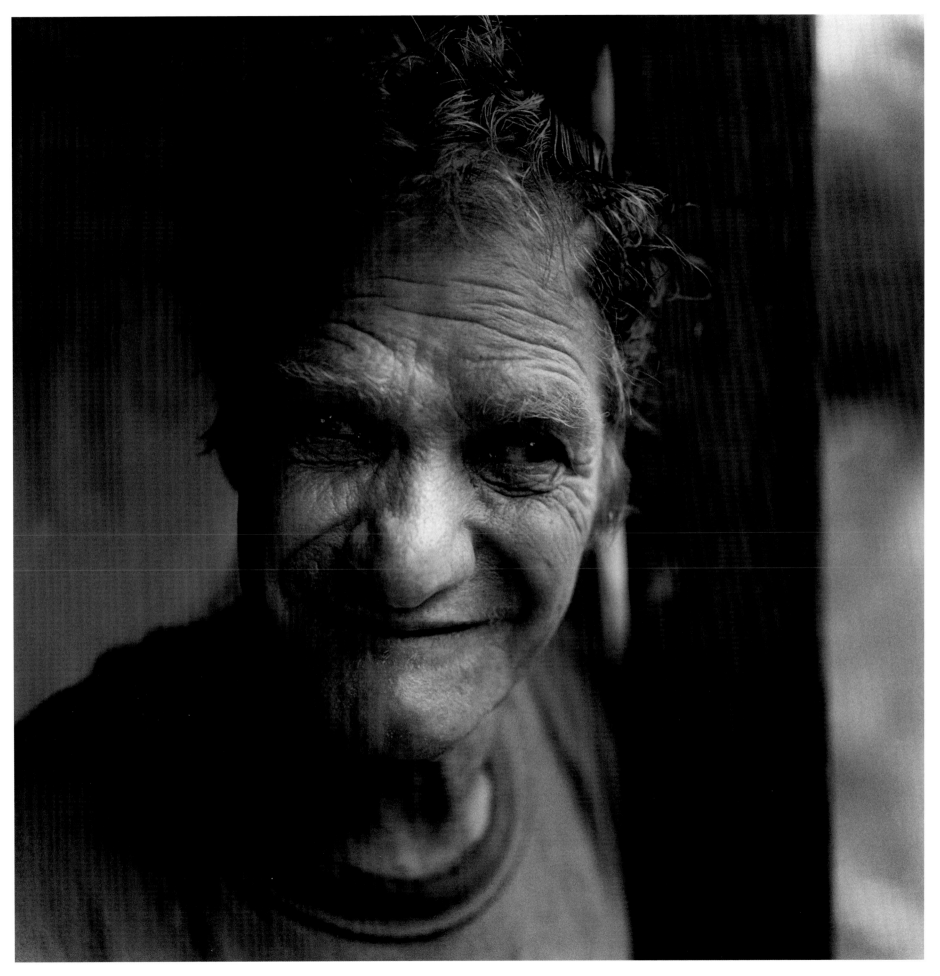

70 Freddy, fifty-six years old, from a family of fourteen children. Tommy Creek Hollow, West Virginia, 2001.

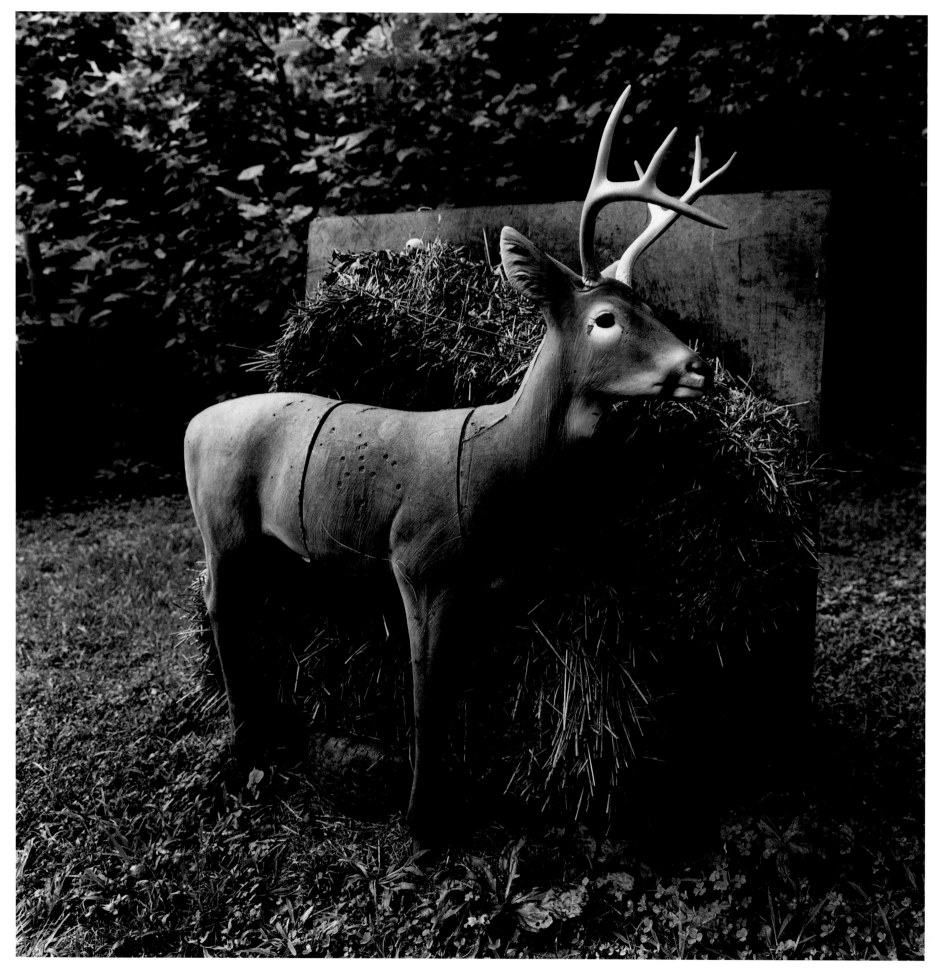

71 Target practice. Gilbert, West Virginia, 2001.

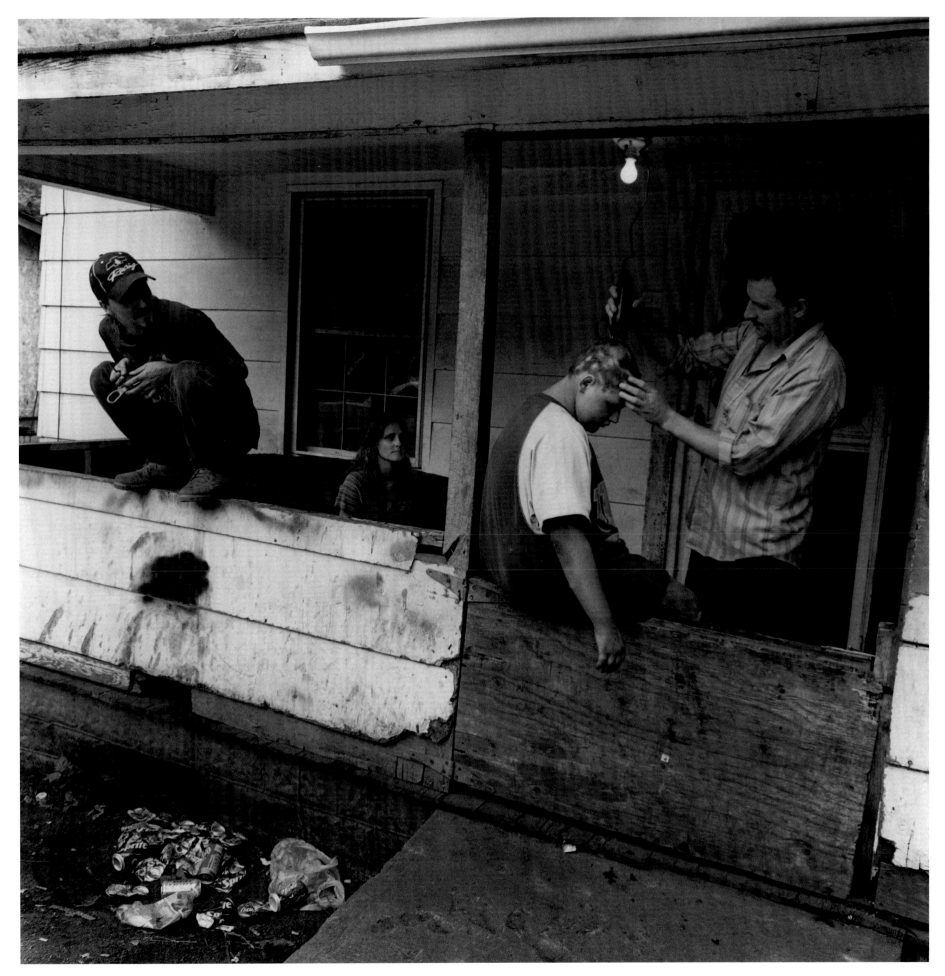

Hollie's haircut. Devils Fork Hollow, West Virginia, 2000.

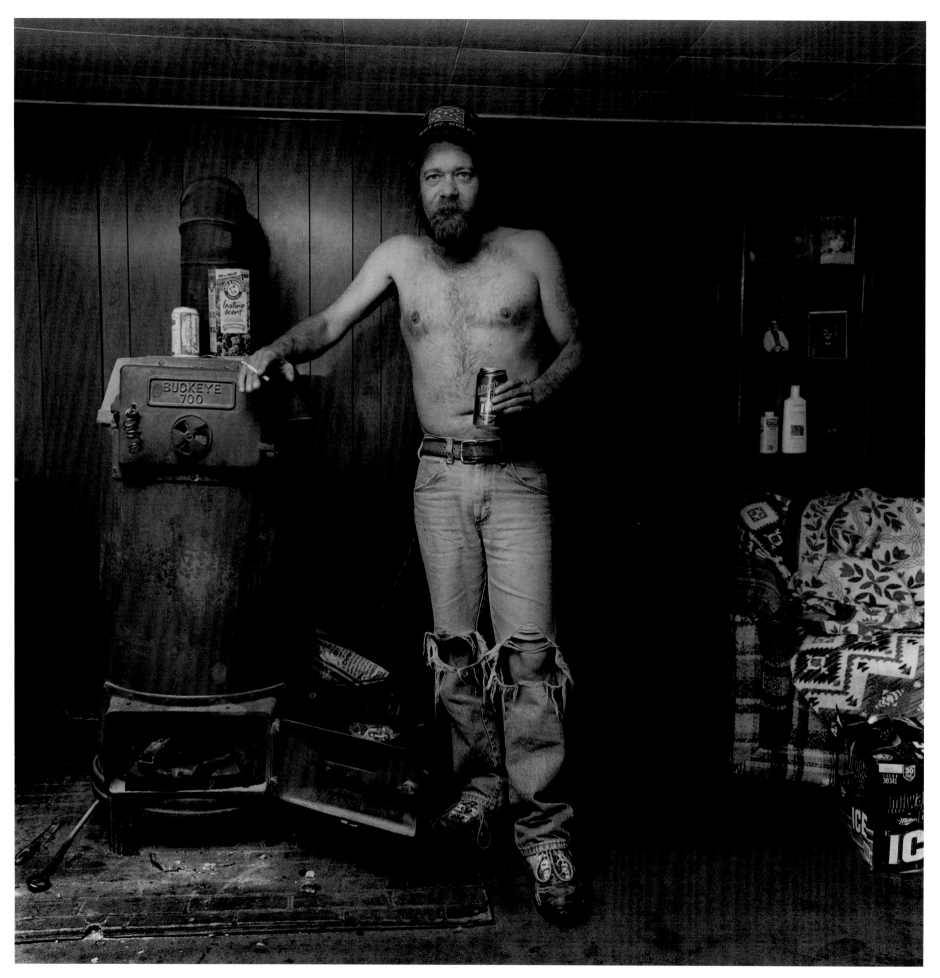

73 Ricky, forty years old. Coal City Road, Raleigh County, West Virginia, 2000.

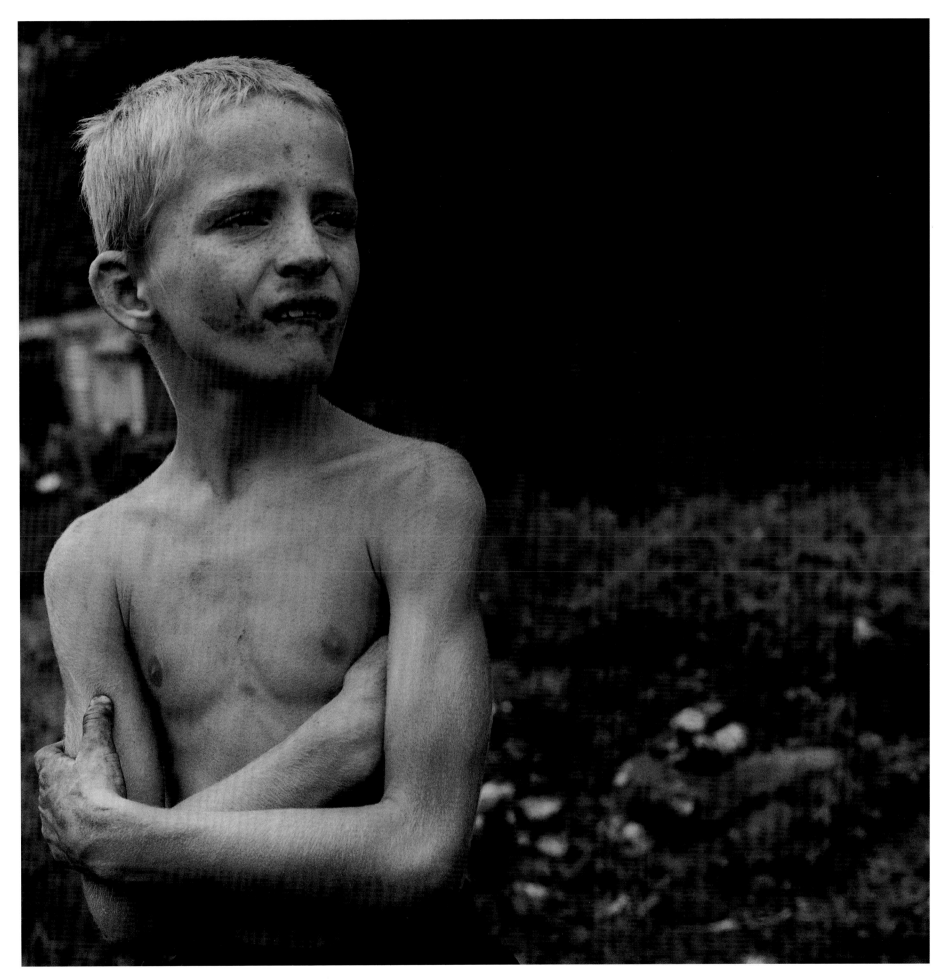

74 Fred, nine years old. Devils Fork Hollow, West Virginia, 2001.

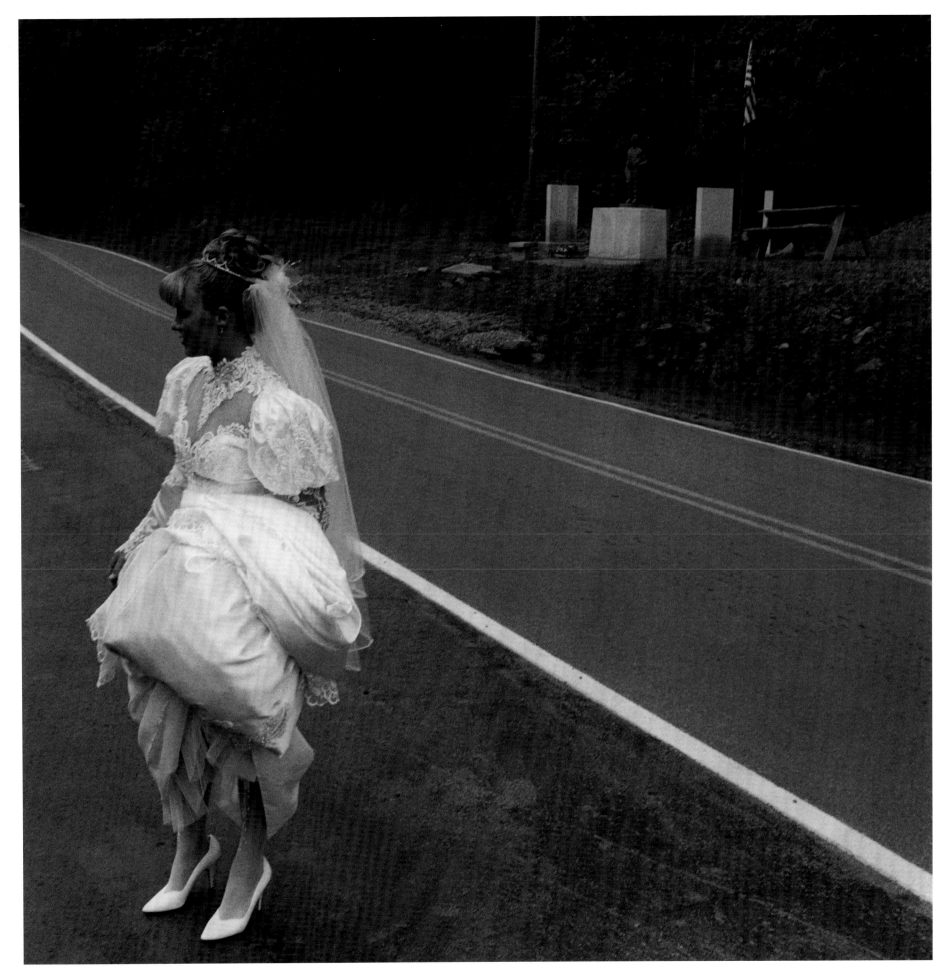

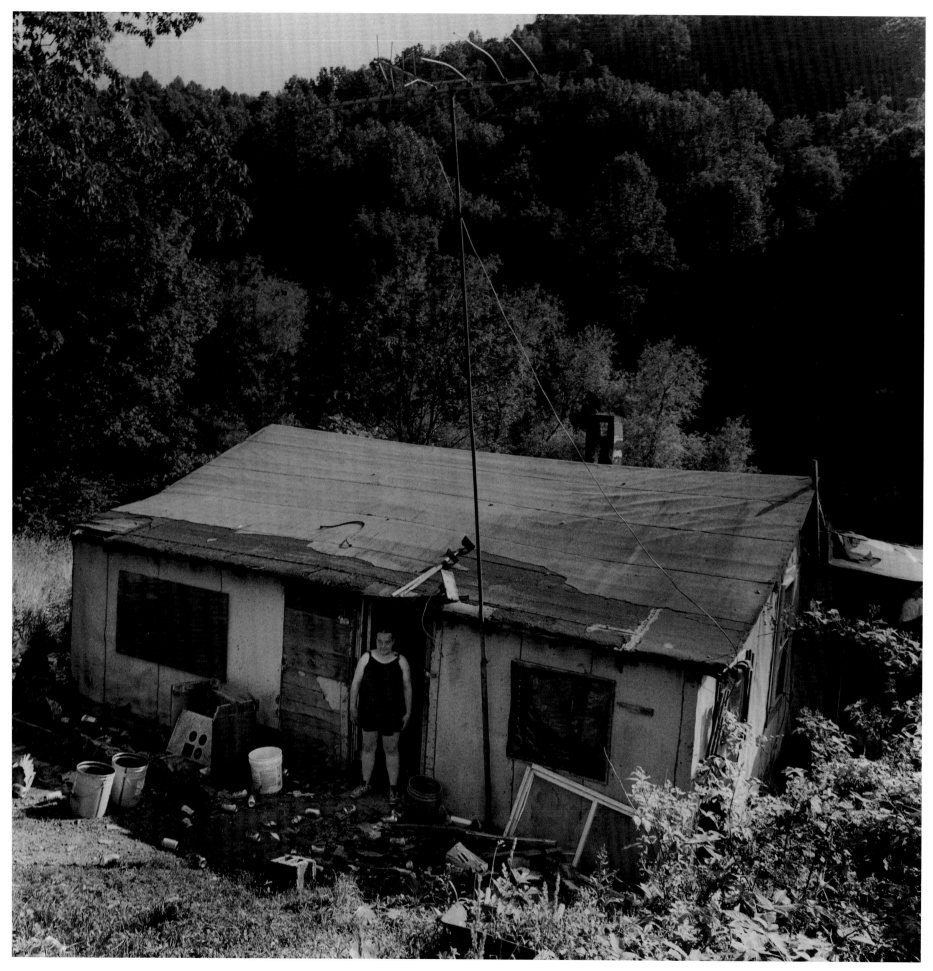

76 Eva, forty years old, at home. Fireco, West Virginia, 2000.

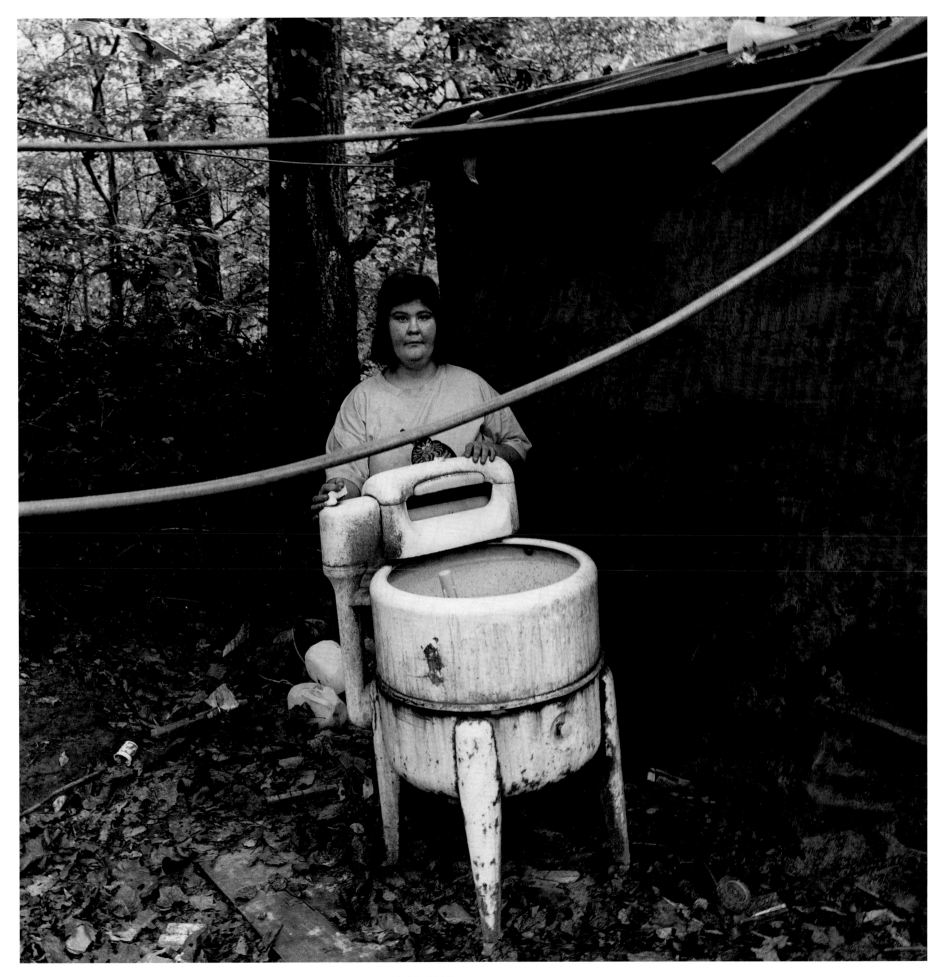

77 Madeline, twenty-four years old, with her clothes washer. McDowell County, West Virginia, 2002.

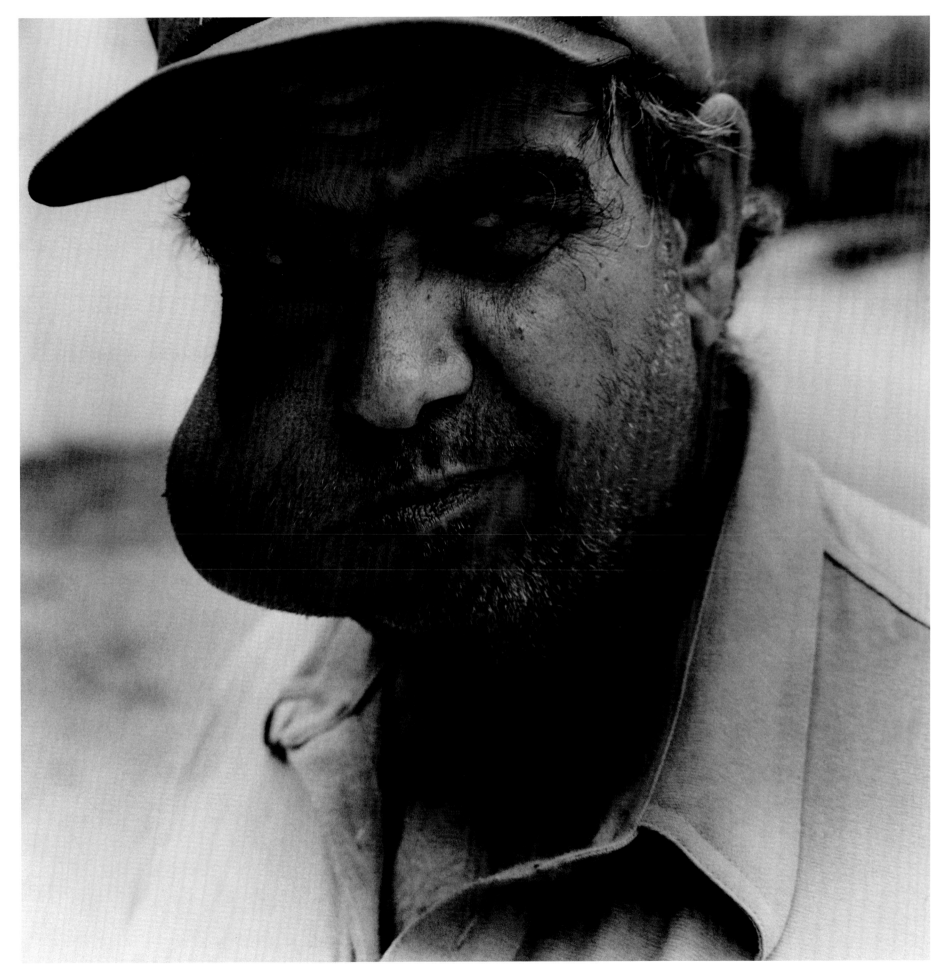

Johnnie, fifty-two years old. Crane Creek Hollow, West Virginia, 2001.

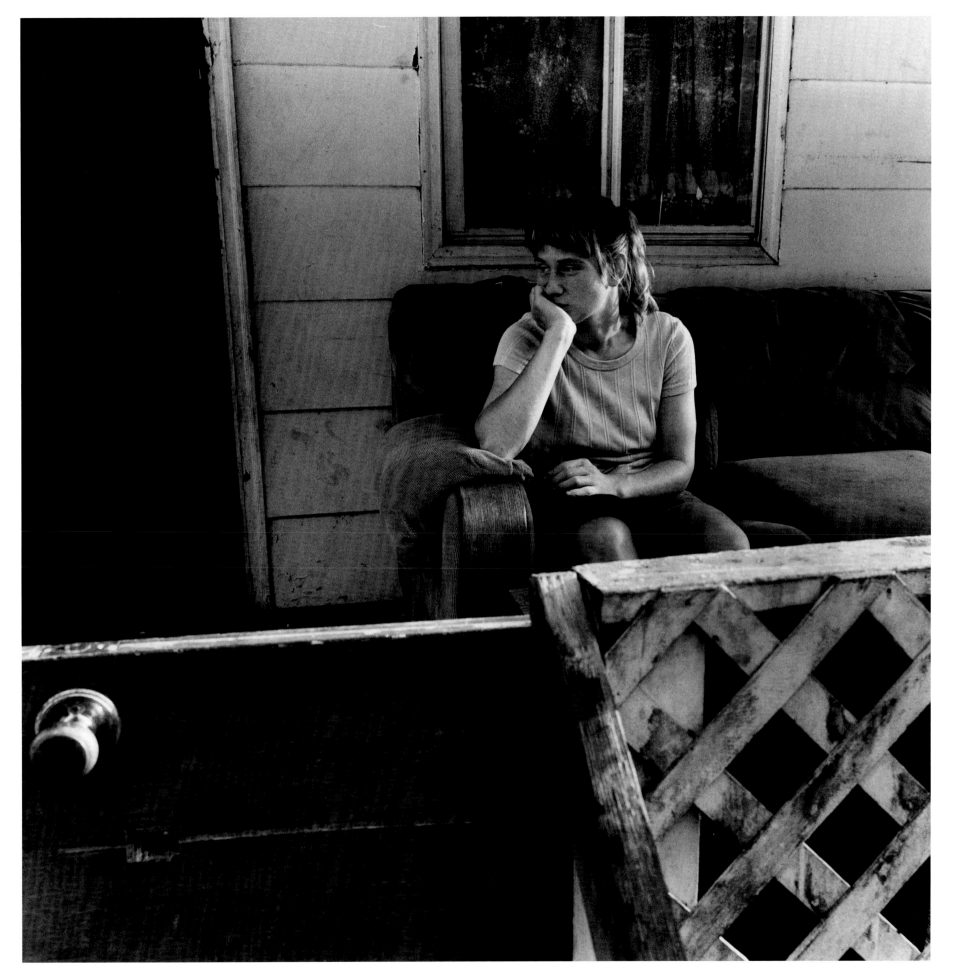

79 End of a long day. Wharncliffe, West Virginia, 2001.

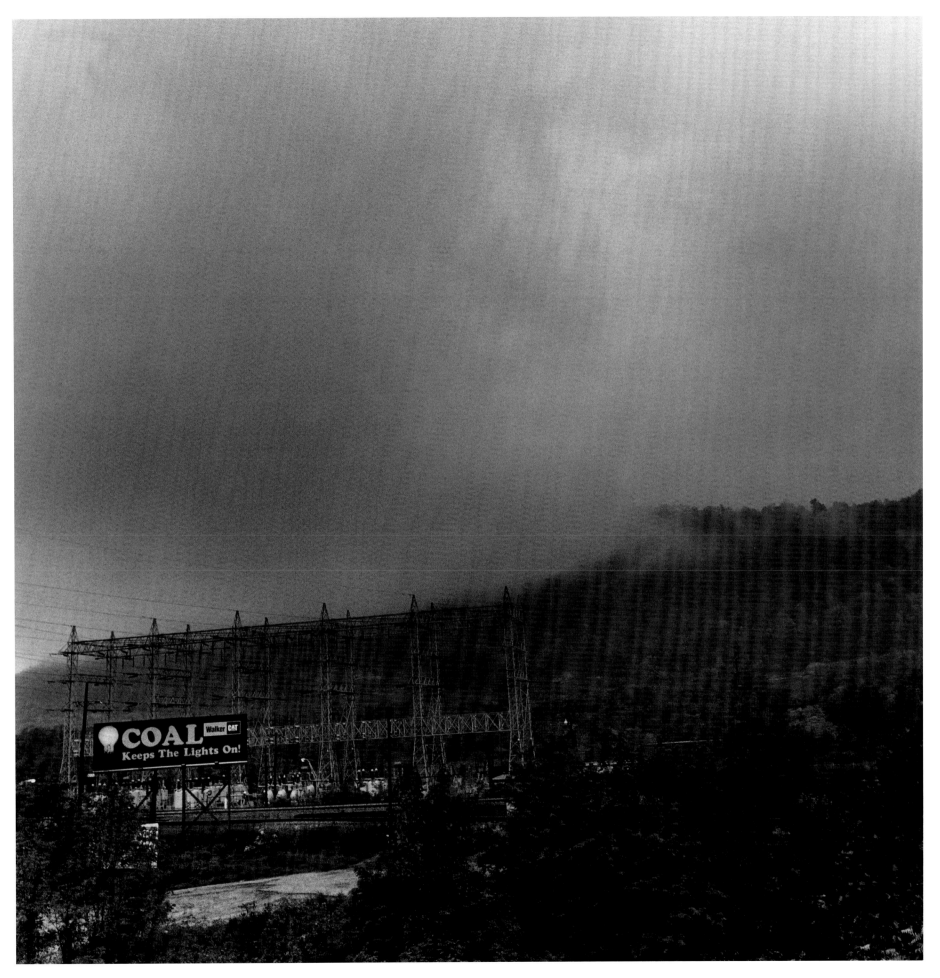

81 "Coal Keeps the Lights On!" Cabin Creek, West Virginia, 2002.

ORAL HISTORIES

recorded and edited by MELANIE LIGHT

Melanie Light interviews a seventy-seven-year-old former miner. Amigo, West Virginia, 2002.

FIELD NOTES

Melanie Light

It took quite a while before I really let this story into my heart and mind because it seemed very, very far away from my life. My husband, Ken, has been fascinated with the lives of disenfranchised manual laborers in our country for decades, and I had seen many pictures of their struggle. He had been bringing back pictures from West Virginia for three years, but I had not become completely engaged. The people in these photographs looked so poor that if I squinted my eyes, they might have been in Africa or Peru. It seemed to me that life had always been rough in Appalachia, but this degree of poverty was the ugliest, toughest poverty I had ever seen. It was too hard.

Then Ken brought home some archival panoramic photographs of miners and church groups taken by Rufus Ribble in the 1940s and 1950s (see, for example, p. vi). I was shocked to see the difference between the old pictures and the new ones. Those earlier miners looked like rough-and-tumble laborers, but they also looked more alive, as if they had pride in their ability to bring home a paycheck. The families seemed to have some energy and hope in the future. The kids wore clean clothes that matched and fit, and they looked alert and happy. How could conditions have so deteriorated in forty years? Suddenly I started to pay more attention to Ken's stories about the daily challenges of the people he encountered, and the story of this region finally became real to me. It was clear that the images would need an integral text to accompany them if the project were to achieve the original intent of educating the public and stirring the social conscience.

I set out to bring the historical context to bear on the current condition. Beyond the academic research needed for this project, a personal encounter with the environment was in order. So off I went to West Virginia with a brand new audio recorder, hoping to bring back a flavor of the region. Ken had left about a week earlier, continuing to make images and generally scouting out who might be willing to be interviewed. Once I arrived, we simply drove out and about each day from our base in Beckley. We never really knew who might be home or available. When we stopped to ask about setting up an interview, people rarely turned us down flat. Sometimes they sent someone to the door to tell us they were "sick" or "in the shower." But surprisingly, many people looked at us a bit curiously, paused, and invited us in. I would set up my recorder and begin the interview while Ken made photographs. Often Ken would join in the conversation and ask questions too. When we interviewed the retired coal miner, for example, he did not want to be recorded, so I busily took notes while Ken conducted the interview.

After the first trip, Ken made another visit on his own, while I scrambled to read everything I could about the history of southern West Virginia and the rise of the coal mining industry. During this trip, Ken met Justice Warren McGraw, and we realized that I needed to return in order to interview Justice McGraw and to round out our material by contacting people who might offer "expert" points of view. I was able to go back to West Virginia on a research assignment for the *New York Times Magazine,* attempting to find contact information for people pictured in several of Ribble's panoramic photographs. Annette Fox of the *Register-Herald* in Beckley was kind enough to run a story about this research, and I suddenly had access to many more people. It was during this trip that I interviewed Justice McGraw, Neale Clark, and Denise Giardina as well as a host of other wonderful people.

All in all, I interviewed approximately thirty people, including children, teenagers, widows and widowers, single mothers, and retired miners. My aim was to represent, as much as possible, a cross-section of the people in this area. For this book, I selected a group of oral histories that complemented one another and that I felt could help to illustrate the unique intersection of history, geography, and culture in this region. Each interview was edited from a transcript, though I have made every effort to ensure that the individual's voice as well as the kernel of that person's own experience remains intact. All of the people interviewed in this book gave permission for us to use their words and thoughts. Except in the case of public figures, we chose to use first names only (and one fictitious name) to protect the individuals' privacy. We include each person's age at the time of the interview.

You don't see the faces of these people or hear their voices in your kitchen when you flick on the light in the morning and start the coffee. But they are there nonetheless. When you pull some "juice" from the wires, it has been brought to you, at least half the time, courtesy of the coal mining communities. The tired, worn-down faces, the daddies' tired backs, the mamas' pursed lips—all are part of the unseen picture, including the coal operators and a few coal barons, too. All these people now live in our hearts and minds. They have not only expanded our capacity for compassion but also broadened and deepened our understanding of how we are all connected—indeed, given the international scope of the industry, to the farthest geographic and cultural borders imaginable.

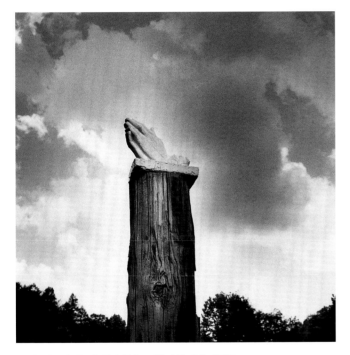

Praying hands. Devils Fork Hollow, West Virginia, 2002.

A SHORT HISTORY LESSON

NEALE CLARK (FIFTY-EIGHT)

Oak Hill, West Virginia

The offices of the Fayette Tribune *are tucked into a low, cement rabbit warren of a building along Main Street in Oak Hill. The walls are lined with award plaques announcing "First Place" for achievements in journalism. Neale Clarke sports a white beard across his jaw, a plaid shirt complete with suspenders, and a direct, intelligent manner. Professional writer that he is, Neale's narrative issues forth easily, in fully formed prose.*

I'm a newspaper reporter for Beckley Newspapers and work out of the *Fayette Tribune* office. I've been with the Beckley paper since 1984. I've been in the news business since about 1972. Grew up in Fayette County, West Virginia. My dad moved us from Falls View in 1955 because Union Carbide sold off that village, which was company housing. We lived in a duplex, and my dad didn't want to live in or own half a house, so we moved up to Fayetteville then. A lot of people came up here when they sold off the village.

My view is that one of West Virginia's biggest problems was its gullibility. People tended to believe a lot of what they were told, and that had to do with their mountain hospitality. This was pretty much a subsistence farming economy around 1880 or thereabouts. What changed things was the completion of the C&O Railroad, which went from Chesapeake Bay over to Cincinnati. It was an important east-west rail route. And it came through the New River Gorge, right by here. Prior to that, there was really no such thing as interstate commerce around here. But when the railroad was completed, the first thing they did was timber. And when I say timber, they took out just

about every tree there was standing. You can see pictures of denuded hills from that time.

Then they discovered coal, and that's when things really just kind of blew up. In 1910 or so, the C&O did something like eight million dollars in freight. Four million of it was processed through Thurmond, right near by Oak Hill. Now you go up there, and you can't even find some of these little communities along that rail line unless you go in there with a brush hook and start cutting down things to find foundations.

Some of the legislators got into bed with these coal operators, and laws were passed giving the coal people mineral rights. People didn't think anything about that at first. They figured, "Well, I've got surface rights on my farm here." They didn't understand that mineral rights superseded your surface rights. The coal operators could come in and rape and pillage your farm to get at the coal underneath. And a lot of times that happened.

What really sparked the unrest with the coal miners was how the coal operators really had you. Let's say you worked for the Alpha Coal Company. You would have to rent the tools you used from the company. They would pay you in their money, their scrip. So you had to shop in their store. If wages got increased, prices at the store got increased. If you went into town to the market, your scrip would only be worth a percentage—say, sixty cents on the dollar—to that shopkeeper. If the company didn't like you doing that, they could fire you. Unless you owned your own farm, you had to live in the house they provided for you, company housing. If you were one of the many, many immigrants who came here to mine coal, you had no other choice—they took rent out of your earnings. Odds were, if you went to church, they more or less owned the preacher, so he preached only what they wanted you to hear. Your kids went to a school that they owned, and they controlled what the kids were taught. If you went to a vaudeville house, or even a movie house, odds were the company owned it. They dictated what you got to see. So they had you coming and going financially, educationally, socially, spiritually. Any way you wanted to cut it, they held all the cards. It was about as close to a feudal system as you'll ever see in America.

At the same time, the United Mine Workers started to organize in the area. And there were some pretty bloody confrontations. The whole bloody shootout at Matewan happened May 19, 1920. That led to the Battle of Blair Mountain, which is the largest civil insurrection in American history, if you discount the Civil War. Something like eight thousand men marched down toward McDowell County to avenge the death of Sid Hatfield, who had been killed by Baldwin-Felts "detectives" hired by the coal operators. Hatfield was a coal mining hero.

They set off mostly by foot. And you think about this. It was 1921, and a lot of these guys had probably been in World War I. So they were combat trained. They got to Logan County and a sheriff down there, name of Don Chafin, said, "By God, they're not coming through my county." He called up the state police and he got the army called out. When they brought the army in, they brought Billy Mitchell, the aviation ace of World War I. He brought three or four planes with him. And back then there were no airports around here. So they had to land in cow pastures and what have you. My father was six or seven years old and he remembers seeing Billy Mitchell's airplanes, the first aircraft he ever saw. Mother Jones was active then, and Clarence Darrow came to see her when she was locked up.

The scales of justice wobbled, but I don't think anybody ever really went to jail over a lot of this stuff. Things really did not start to change until John L. Lewis, the head of the union, got the ear of Congress in the thirties and they started to make the mines safer, improve the wage base and health care. West Virginia had the most dangerous mines in the country. But it literally took an act of Congress to start turning things around.

Of course, you still have that union mentality in this area. As far as a lot of old-timers are concerned, if you don't have a union, you don't have anything. Coal still accounts for about 61 percent of the state economy, and West Virginia is the number two highest producer of coal in America, but you don't have much of a local economy from it. You don't need miners, because you got machines.

As for mountaintop removal, I haven't seen lot of it here in this county. It's more or less further south. But I'm troubled by it. You can't tell me that throwing the top of a mountain down into a creek is not somehow, some way going to affect the ecology somewhere down the road. It may not have an immediate impact, but by God, it will have an effect on my children or grandchildren. Common sense tells me that if you despoil your land, then you're going to have consequences somewhere down the road. Somebody's going to have to clean it up.

There is no actual mainstay of the economy, unless you count tourism, which is still a burgeoning enterprise here. People don't like it because there's so many strangers coming in here in the summertime. And there's traffic jams, and some of these people are rude. But I say, bring them on. This economy is better than no economy. We have extreme outdoor recreation options here. We have whitewater rafting, rock climbing, horseback riding, kayaking, hiking. All that is good stuff. Plus there is what you would call "heritage tourism." This is generally for an older set of people who come in and spend more time here, looking at the culture, the history. They want to see where you came from and

how you developed. They're more friendly to the locals, I guess you could say. The extreme outdoors people come here to party, and they don't think that much about the locals.

· · ·

If outside industries were interested in us, they'd already be here. We need to take control of our own destiny. We have some of America's greatest hardwoods in our forests. We harvest those, send them to North Carolina to be made into furniture. They ship it back here, and we buy it. My question is, can anyone in West Virginia make a damn rocking chair? We keep waiting for someone else to do something. The feudal system of the coal operators drummed a lot of the vision, the entrepreneurialism, out of people. The coal operators froze the economy and discouraged or prohibited any other industrial base from being established here because they didn't want to compete for wages.

I think, too, that when the outside looks in here, they sometimes still get the idea that we're strike-happy, that we're union-crazy. They question our schools, our ability to teach children. They wonder about our roads. These are all important things for someone to think about when investing here. And I keep thinking, well, maybe some industrialist is going to come down here some summer and ride the river and think, "Boy, this would be a good place to build a factory." Maybe. But when he sees some of the attitudes of the people down here toward the tourism industry, he's going to say, "Well, the hell with you. I'll go somewhere else." So, until there's some attitudinal change here, I don't look for a lot to happen.

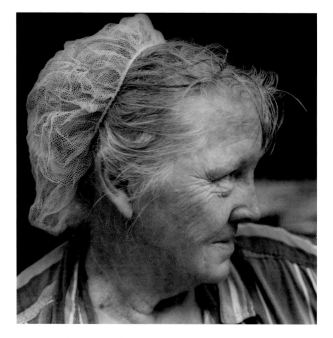

Faye. Groundhog Branch Hollow, West Virginia, 2000.

MOUNTAIN WOMAN

FAYE (SIXTY-FIVE)

Groundhog Branch Hollow, West Virginia

Faye's little house sits deep in the country, on Groundhog Branch Hollow, next to an abandoned gas station. She has cobbled together a life and a living from scavenging things and reselling them. Most recently, she and her grandson were working out of an abandoned yellow school bus on the side of the road, selling miner's overalls for ten dollars a pair. She would scavenge discarded overalls, mend and clean them, and sell them right back to the miners. Faye is a mountain woman, an entrepreneur, and a serious pack rat.

She greets us from behind a power mower, explaining that she wants to get the grass cut before it starts to rain again and before she has to go to a church meeting for a funeral that evening. As she speaks, a light drizzle begins to fall. After a bit of persuasion, she consents to an interview but refuses to let us in her house because there is too much "stuff" inside.

She casts an eye around her backyard to find us a place to sit. It looks like a city dump. There are numerous Kelvinators filled with jars of pickles, seltzer water, and jugs of drinking water. Nearby are stacks of tires, with a yellow-and-white golf umbrella sticking out of one stack. A crisper holds broken-up wood—kindling, perhaps. A stack of conference room chairs sits next to bike handlebars, which lean against a plastic barrel full of grass clippings. An old Campbell's Soup sign is draped against a baker's rack, which is next to a folded wheelchair, a baby Jesus, and a statue of a Turk. Five-gallon buckets are everywhere. A rusted folding chair holds up two boards, each attached to the legs from a folding table. This is Faye's yard sale table. There are boxes and

boxes, loaded with stacks of yellowed and now damp newspapers or canned goods. Several vans and trucks are parked haphazardly in the yard, and all these things seem to be growing around them like kudzu.

Faye makes her grandson pull some chairs from the stack and fetch the golf umbrella. She has raised him as her own and has a fierce desire to make him responsible. He resists, complains, and tries to get out of following her directives. But, finally, he does what she wants, more or less. He's eighteen and wants badly to be a man but isn't at all sure how to do that.

The drizzle turns to a light rain. Faye opens the back of the van that still runs and pulls out a lawn chair cushion that just happens to be on top of the boxes of day-old bakery goods. We sit in the van on the cushion with the umbrella propped between the doors and the roof.

Faye is tall and very strong. She has piercing blue eyes that meet the eyes of others directly and contrast nicely with her warm skin and silver white hair.

I bought this whole place and the house in back thirty-five years ago by recyclin' old stuff. Lord, this has been moons ago. I went to yard sales and sold old used clothes and things like that and got enough money to go buy me three bolts of cloth. And I took them three rolls of cloth and sold 'em—cut 'em off by the yard. I had an old Rambler station wagon. And four kids a-cryin' at night. I'd bake a cake of corn bread, and I'd have some onions, and I'd go get some potted meat and carry it with us on the road. I'd sell that material, pay rent, the light bill, and get some more material and sell it. And just keep a-going, addin' up and addin' up.

And then, later on, down through the years, why, I found out that you can do the [grocery] coupons. And you can have more to eat with the coupons. Go do 'em double time . . . and what you can't eat, cart out and have a yard sale. Sell it and get you some money to go back and buy some more. You just got to know what to spend that penny for.

See, I did so good with these coupons then—but not now. They used to triple the twenty-five-cent to be like seventy-five cents, and forty-five cents'd be like a dollar ten. This young'un [her grandson] went to Avondale and got a grocery store buggy full of boxed dog food and paid thirty-five cents for it. And we sold that cat food and dog food, plus feedin' our own animals, plus made us some money to buy him things that he needed.

I'm Indian and Irish, mixed together. Dad died when we was all little. I was about nine when Daddy died. He was a farmer. He was out in the dankness and wet weather so much he took something called TB and pneumonia, and it killed him. Our grandfather owned the land. I have it now. No coal on it.

We had our own mountain water. We didn't have electricity till I was a great big girl, about eleven or twelve years old. We used oil lamps, and a lot of times nothing. The house was three rooms, made of logs cut, hewed and notched, and stacked up.

Either you worked or you didn't eat. They did not keep no sorry people around. They wouldn't fool with you. What food we had to eat when I was a kid we had to raise in the hills. If we didn't raise something to eat in the summer, we had to do without when winter come. All of us had to work 'cause Mommy only had a little bit of money coming in to buy the flour, the sugar, the coffee, and a little bit, not much of nothing, for clothes. She got forty-two dollars a month for all of us kids. And she did a real good job. We all had plenty to eat.

We come out of the house at four o'clock in the morning to go to the gardens and the field. Take the baby and put him in a washtub. That was Madison. And somebody'd always go back and check on him and see if he was all right and set him in the washtub. And when you come in, it was dark. We raised apples, berries, peaches.

We'd milk the cow, and early in the evening you'd bring the milk home. You'd have a nice white rag to strain that milk, 'cause when milking that cow, you bring that hair down off the titties. And they was really particular with that milk 'cause it was so special. And they'd take and put it in them big jars and go set it in the cellar. Now they have cellars made out of cinderblock, but back then, they just wedged 'em in some wood and put dirt on top of it, so it'd stay cool back in 'ere. Winter and summer. Or they'd just set it in the creek and let it stay cold in the ditch. That milk would set there and get cream on top of it. And Mommy'd go and take the big ol' spoon and take the cream off of it and put it in a thing called a churn.

My brother hunted. He'd go out and kill squirrels and rabbits and things. In the winter, it was the only meat you'd have. Except we raised enough chickens to have some extra to eat.

Mommy'd cook over a hole in the wall. Knock a hole in the wall of a old log house, and the chimney went out the side of the house. And it had a iron basket a-sittin' in that hole, and it'd sit up on legs, and you'd put your corn in and roast 'em.

We'd have "leather britches." It's green beans. They'd let 'em stay on the vine and get real good and full. Then they'd pick 'em, they'd string 'em, they'd take a needle and thread and run through between the beans and hang 'em on a string. Let 'em hang outside and get good and dry. And then, when you went to cook 'em, let 'em swell first.

And if one didn't have something, the others would share. You'd give them a piece of the pig for a sack of potatoes or a piece of the pig for a sack of corn. Today, the mountains are all growed up, and there ain't no food being grown out there.

The schoolhouse was not very far from the house. About two miles,

and we'd have to walk to it. We'd pack our dinner in little buckets, pound lard buckets—little metal buckets. Some days, you didn't have nothing.

There was no games. It was feed the chickens, feed the pigs, wash the clothes. You had to do the clothes on a "gritter" board. Pack 'em, if you didn't have enough water where you live, and take 'em to the creek. Wash your clothes, spread 'em on bushes, and dry 'em. . . . You had to stay with 'em. Sometimes, you'd have to go a mile, mile and a half, to find water.

And when you did get some clean clothes, you was careful what you sat on, what you touched. You made clothes. You'd buy flour in sacks. If you had a pig, you'd buy middlin's in cloth sacks. You took that stuff and made the kids' clothes. Lot of times, they'd just take a flour sack and cut a hole and two armholes, and you went on with it. It was rough.

And when you killed a pig, . . . well, that's something else to think about. You'd have a little outside house. And you took that pig, and you'd go and get you a sack of salt. And you have a couple big old pieces of wood in that build-ing. And you just cut that pig up so many different ways, so the salt would go through him. And you didn't think about a Kelvinator, and you couldn't can him. You just have to lay him on the wood. You couldn't kill him until after dog days, until it started getting cold.

And if you got sick, you doctored yourself, 'cause there wasn't no hospital. If you broke a leg, you fixed it yourself. Two or three people'd come along, and you'd slap that person upside the head to give him a pain shot. If it was broke to where you could see, you'd stretch it back—splintin' it. First they'd put a lot of cloth around it. And they had ways of going hunting for weeds to put in there, too. They'd give you a little drink of moonshine or something. They'd keep that stuff around for pain, called it a "physic." But if you didn't shut up, they'd hit you upside the head and knock you out and tell you to hush up.

If you had to have surgery, some of the family, they'd lay you down and do surgery on you. Grandmother was the midwife. She did over a thousand births. Can you imagine a woman having a baby, and this husband and that husband has to come along and help and put this woman up in a scaffold?

And things got so bad there—Lord, things got so bad. I couldn't stand to see all of them out there running around, making liquor. I just moved aways and got married and didn't better myself. Getting married with four kids was just a rough, rough life. I was married twice, and neither husband was any good. They just wouldn't work, and what work they worked they didn't put to benefit toward the kids. I'd pick up stuff and recycle it. Wash it, clean it up, take it to the yard sale and sell it, like, for a quarter, fifty cents, and feed my kids. Same way my mother raised me.

Well, I'll tell you what. Over the years, I've sat and starved so much and went hungry. I've seen the time when I went hungry for a week. And barely had enough food for my four girls. Like one meal a day for them.

I don't have anything. I'm broke now. That's the reason these vehicles is sittin' out here. You can't do anything if you don't have any money. Now, why, it's got down to where I even have to ask for charity sometimes, to pay my light bill and things. I'm sixty-five. I can't do that no more. And plus, my young'un's left home. People has encouraged him away, and he's left home. That's the reason everything's like it is.

I got hit with this flood this spring, and part of my garden down there washed away. Now I've got a few volunteer tomato plants, and I've got some onions down there, and something else is growing. I believe it's squash or a pumpkin. . . and potatoes, come back from last year. I'm not gonna go hungry.

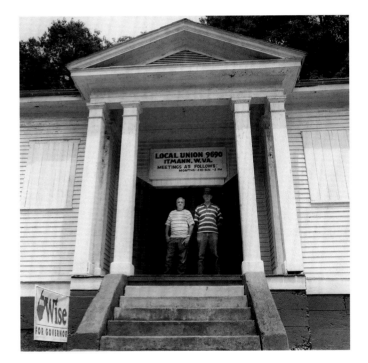

President and vice-president of Local 9690, United Mine Workers of America. Itmann, West Virginia, 2000.

RETIRED COAL MINER

GENE (SEVENTY-THREE)

Amigo, West Virginia

As we come into the mouth of Devils Fork Hollow, it's raining heavily. Gene's house is a beacon of prosperity shining over a wasteland of time-ravaged trailers. A chain-link fence surrounds a clipped lawn. Sprightly summer flowers in violet, blue, and pink line the walkway, defying the rain. On closer inspection, the more buoyant flowers turn out to be artificial, mixed in with real flowers. The house is vaguely Cape Cod in style and has an eagle mounted on the fresh white clapboards of the second story. The carpeted porch stairs are soggy from rain. Across the street, a burned-out gas station is slowly disintegrating into the weeds and mud.

Gene's wife gruffly waves us through the yard to the back. We pass under an archway framed by a vine of artificial pansies and sweet peas and peer through the curtain of rain into Gene's private retreat, a red metal shed. Several deer racks and wasp nests hang on strings from tiny rafters. Turkey beards are displayed on varnished boards that Gene has carved, next to a rattle from a rattlesnake. A beautiful turkey tail is fanned out and mounted on the wall. Gene waves his hand at the spoils of his hunting and tells us that he still loves to hunt, even though he recently had a stroke. That and his deafness have slowed him up some.

He is tinkering with his homemade wine. He picks berries and makes blackberry, raspberry, and blueberry wines, a skill the Italian immigrants brought with them at the turn of the century. Gene doesn't make moonshine, but his daddy did. "Nobody makes it no more. Now they grow pot and sell it at their house." Then he sent us away because he was so busy that day.

The next day we call, eager to hear stories about life in a coal camp. Gene's wife answers the phone and says that it's not a good day. She hesitates and then tells us that their store was robbed. They own the only store in town, the Wanna Stop, run by their daughter. It gets robbed a few times every year. It's the end of the month, and people are waiting for their checks.

The day after that, we ring the doorbell, and Gene comes to the door. He is bare to the waist because of the heat and humidity. His gray workman's pants are held up by suspenders, which stretch over his gargantuan belly. His chest and neck are a soft white, but his arms and face have a ruddy tan, and his fingernails are outlined with grease.

He stands in his living room, looking as though someone had cut him from Popular Mechanics and pasted him into House Beautiful. A tiny Pekingese hovers near his feet, barking a tiny dog bark. Behind him is a huge rococo gilt mirror; a gilt chandelier hangs from the low ceiling. Surrounding Gene are pictures of flowers and artificial flower arrangements. A television takes up an entire wall, sitting on the dark maroon wall-to-wall carpeting. "We bought this house from the coal company. It used to belong to a big shot," Gene says with pride.

He is very grumpy in the aftermath of the robbery and not in the mood to talk, but he invites us in to visit for a bit. He does not want to be recorded but lets me take notes as he speaks. He has been closely following the story of the miners trapped in Quecreek, a deep coal mine in Pennsylvania. On July 24, 2002, nine miners breached a wall into Saxman Mine, an old mine that had filled with water, which then burst through to their mine and trapped the men for three days. At the time of our meeting with Gene, the men are still trapped. Rescuers have drilled in and are pumping warm air into the mine while they continue trying to drill a shaft big enough to allow them to reach the miners.

Gene explains the situation from his point of view. He doesn't know why they hadn't been drilling test holes. He used to drill test holes twenty feet at a time before he started taking the coal. "If you get a trickle of water, you know you should stop. But the coal companies are too greedy now and are in a rush to get the coal, so they skip the test bores."

Gene pauses and tells us that he dealt with a lot of water when he was mining. The company would drill down from above to find out where the coal seam ran. Then, when it rained, the water would leak through. The miners would plug up the holes with wooden stakes and keep on working. He laughs a bit at this. At first I don't get the connection, but then I realize that if water is leaking through, there is a danger of collapse.

Gene returns to the trapped miners. The television reporters have been suggesting that the miners were using inaccurate maps. He waves his hand in disgust and says the companies are supposed to leave a two-hundred-foot barrier at the end of a mine, but nobody does that. These "barrier pillars" have been required by law for years to prevent the water that collects in abandoned mines from bursting through to an adjacent mine, which may be an active one. But miners get paid by how much coal they load, and the company figures that they might as well get as much as they can while they're down there. So everyone up the chain of command signs off, saying that a good barrier pillar is in place, even though it might only be one hundred feet wide. (This practice of "coal robbing" makes it very difficult for a mining operation to obtain and use accurate maps of their mines. In the case of the Quecreek Mine, it was especially important because the Saxman Mine was known to be flooded and posed a serious danger to the miners.)

Gene tells us that the Quecreek had originally been mined by someone else, and now this new operation was going in to "scavenge" it. Both miners and management would play fast and loose with the regulations. It used to be that farmers who owned their land would sometimes lease the mineral rights to a coal company, but if a farmer didn't lease the rights, the coal company was supposed to avoid mining that section of land. "They'd take the coal anyway, because how's the farmer supposed to figure it out?"

We mention that people are talking about the psychological effect of the Quecreek miners being trapped for three days. "I don't believe they'll be bothered by it," Gene says. "Miners expect death every day. Miners is a tough breed." There had been accidents all the time when he was working, he recalls. Most of them happened because the top of the mine collapsed or because equipment failed. But a lot of accidents occurred because people got careless and the companies were greedy.

The main coal seam in Gene's area has already been mined, and no one really wants to mine it anymore. It's called Pocahontas III, and it was thirty-five to fifty inches high. The only seam left now is the Pocahontas II, which is only twenty-seven inches high. The miners work in a space only as high as the coal seam so that they don't waste time and money digging out dirt. It would be hard to be hunched down in a twenty-seven-inch space deep in the earth every day.

Besides, the technology has changed so much. Gene claims that it "used to take seven hundred men to do what it takes fifty men to do now." His daddy logged the timber that was used to hold up the ceilings of the mines—this was a whole industry in and of itself. Now the companies have a machine that bolts the roof. It requires only one person and uses manu-factured steel bolts. When Gene mined coal, he dug it up with a number four shovel. He could get one cubic foot of coal out at a time, in a block weighing eighty pounds. He would earn eighty cents a ton, which was thirty blocks of coal. They called that a bushel. But the whole process is mechanized now.

"Anyway, if coal came back, nobody in the hollows would want to work in the mines. There's probably two hundred people in Amigo, and they all get government checks. You'd have to drive seventy-five to a hundred miles to work every day just to get to the mine. It's easier to get a check."

This starts Gene talking about government assistance. It makes him mad that some people have never worked and still get money from the government with no problem. He never went on government assistance and finds it hard to see those other families on welfare. Some have had "four generations on it." They have new cars, he says, and he drives an old rattletrap. "I believe the government should take care of people, but people should take care of themselves." He is disabled and had to fight for nearly five years to get Social Security disability benefits. "People on SSI has got it made. Medicaid pays for everything. Medicare don't." He also has black lung disease, a terminal illness contracted by prolonged breathing of coal mine dust. He's been trying to get money for that since 1985.

When Gene worked in the mines, he was sometimes laid off for a couple of years at a time. During layoffs, he lived on the money he had saved until he was rehired. All hiring and all layoffs were administered through the union. After being laid off, a miner would generally wait until his name came up again for an opening on the union rolls. During the fifties, sixties, and seventies, however, the time between jobs grew and grew, until finally people didn't get called back anymore. "The union priced itself right out of jobs. They went too far," Gene conjectures. He joined the United Mine Workers in 1948 for ten dollars and still carries a union card.

During the forties and fifties the United Mine Workers union was very strong and won higher and higher wages and benefits for its workers. This pushed the coal operators to invest in and use the new technology to mechanize. Perhaps the real failure of the union was its inability to create a strategic plan for the transition of machines into the workplace, as other unions in other industries have done (notably the International Longshore and Warehouse Union in 1960).

Miners were cast aside as production dropped through the sixties and the use of machines continued to grow. The number of workers has steadily continued to decline, so that now the industry faces a strange paradox. Most miners are like the Quecreek workers: middle-aged and earning about fifty thousand dollars a year, as an article in the Charleston Daily Mail reported (October 11, 1999). Coal operators do not want to train new workers, yet they face a serious labor shortage as attrition and retirement reduce the pool of qualified, trained miners.

Gene claims that George W. Bush got West Virginia in the 2000 presidential election because he said that he would fight for coal to come back. Many people voted Republican for the first time ever, but they can see now that coal is not coming back. They probably won't vote Republican again, he believes.

Dewey dancing with a poisonous snake, Church of the
Lord Jesus. Jolo, West Virginia, 2000.

SNAKE HANDLER

DEWEY (SIXTY-SEVEN)

Jolo, West Virginia

Dewey is snake-handling royalty. Not only was his mother, Barbara Elkins, the most powerful woman snake handler ever, but Dewey helped her and his stepfather start the Church of the Lord Jesus in the 1950s. Dewey's mother was converted to this subsect of Pentecostal Holiness Christianity by the original snake handler, George Hensley. In 1909, Hensley took this passage of the Bible to heart: "And these signs shall follow them that believe; In my name shall they cast out devils; they shall speak with new tongues; They shall take up serpents; and if they drink any deadly thing, it shall not hurt them; they shall lay hands on the sick, and they shall recover" (Mark 16:17-18). He brought a snake to his church; everyone handled it without getting bitten, and a tradition was born. Churches that worship in this way are commonly grouped under the rubric "Church of God with Signs Following."

The ecstatic believers who make up this small community handle copperheads, puff adders, cottonmouths, and rattlesnakes as the spirit "anoints" them to bear witness to the power of God. The service is free-form and open-ended, accompanied by music. It is a sort of rhythmic rock/gospel jam session of organ, electric guitar, drums, clapping, and shouts, which helps to transport the congregants into an ecstatic state in which they speak in tongues, dance, and hold wild, venomous snakes. On occasion, they might be moved to drink a "salvation cocktail," made of a strychnine solution.

Two deaths have occurred in Dewey's church since it was started in the late fifties. One of the people who died was his sister Columbia. Dewey has been bitten many times, and his hands have become crippled and deformed

from the poison. Yet he continues to practice with full commitment. He must rely on his faith and the prayers of others to heal him.

Snake handling has been outlawed in every state except West Virginia, but it is still practiced in Kentucky, Virginia, Tennessee, Alabama, and Georgia. Congregations stay in close touch and spend a great amount of time and energy visiting other churches.

The Church of the Lord Jesus has been the subject of numerous media stories by both mainstream and independent journalists, photographers, and filmmakers. At times, the attention has resulted in violent persecution. Given the potential for their form of worship to be sensationalized or exploited, this group is extraordinarily tolerant of outsiders. The day we visited Dewey, another photographer and a film crew were there, complete with a boom for sound recording. There were almost as many people documenting this "signs following" form of worship as there were people attending church.

Despite so much attention from outsiders, Dewey and the congregants continue to be completely focused on their spiritual work. The community holds the snake handlers to very high standards. These individuals must remain "in the Word," a vague state of being that is partly inspired by the Spirit and partly defined by the group's devoutness. Neither Dewey nor the active members of his community ever seem to be performing out of pride.

I've been bit a hundred and forty-eight times. I got bit maybe three times in three weeks by that one there. It hurts. It hurts. My mom, she always said a snake could just taste fear. When you've got a fear on, they're harder to handle, 'cause you don't have your mind on God. Fear has torment, the Bible said. And if you get your mind all up, then you've got your mind off of God, and God doesn't speak to you through the snake. If the snake would speak to you, it's an old serpent, which is the Devil.

A time or two, I've thought, well, this could be all of it, you know? After I got bit, I just prayed. Then other people prays with you and for you. And that's got a whole lot more strength than your own personal prayers. When you're hurtin', it's hard to pray for yourself. It's hard to do any praying, but you can start believing and manage that. If you're not careful, the pain is gonna override your thoughts and the things you're saying, so you need other people. Well, that's what they're for. That's what we're all for—for each other. And God said the prayers of a righteous man prevaileth much. If they're righteous, it's going to accomplish something. If nothing else, it'll accomplish having a good funeral. My mom doesn't like me to say it, but I've felt this way for years: when my time comes to die, that's the way I want to die. And when I have my wake, my funeral, I want 'em handling snakes.

I was twenty-four when I first started handlin' snakes. Before I gave my work to God, I drank a lot and smoked a lot. When I was about fourteen, I joined the army. I finished basic training and went to California. We went into Stockton, and everybody's putting on tattoos. Cost me five dollars. That's five dollars I could have done anything with. Then they found out that I had lied about my age and asked me if I wanted a discharge. I said I wanted to be in the army like anyone else.

Then they sent me to Korea. Went in on a beach at Pusan, and then they sent us closer to the real action. I have one Purple Heart, one Good Conduct medal, Korean campaign ribbon—all that. I don't really know what happened when I got the Purple Heart. A bazooka might have gone off. Everything was flyin', big explosions. I was in the hospital about six months with some kind of concussion. They just transferred me around from Japan to California to Texas and New Jersey. Then they gave me a medical discharge.

When I got home, I went in the mines. I guess I worked in the mines about twenty-two years. I owned two small mines across the mountain there, and I bossed there and run a cuttin' machine. But I got disabled. They told me I had to quit because of the coal dust, and I had to go into the hospital because I got an infection in my lungs. They had to operate on me, and I went into cardiac arrest. I was exactly dead for forty-five minutes, more or less.

After I got out, my memory was gone. Didn't know my wife, nobody. I had to learn everything all over again, and I went back to my childhood. I was playing with the young'uns and their toys. I went back in the mines and worked about six months. But I was afraid that when I went back, with my memory being the way it was, I might run over somebody.

One thing I never forgot was serving God and taking up serpents. I was a Christian for a while before I began handling snakes. Back then, in the early sixties, there were beer joints. It used to be terrible around here. There was about eight of 'em, and you could just walk in and drink all you wanted and knock whoever you wanted to in the head and walk out. I got my head bashed in a few times, and my nose cracked two times. But I went to church, to revival things, with my mom and stepdad. I just liked to go to meet girls there and have a lot of what you call fun—I wasn't interested in the Lord or church or nothin' else. So I guess that might've been all leading up to it.

I had just got out of jail and went with them on a Sunday. I just felt like I wanted to pick up a snake, so I picked up a big yellow rattler. I just felt it. I just had a feeling right here in my belly. And it just started crawling up to my throat, and then my head and my hands got an odd feeling. Then I got to reading the Bible, and once you read your way into it, you can't read your way out.

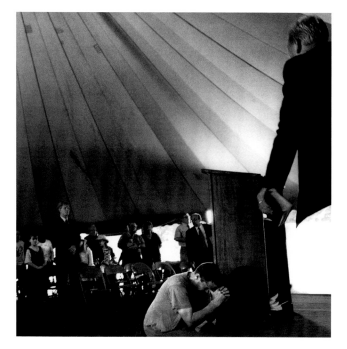

Preacher at a tent revival. Amigo, West Virginia, 2002.

PREACHER WITH A MISSION

BRIAN (THIRTY-FIVE)

Rhodell, West Virginia

On Route 16 between Rhodell and Amigo, a few men and their families struggle to raise a circus-sized tent alongside the road. We see them working day after day, in blistering heat and humidity. They drive in the stakes and untangle the ropes of the old orange canvas tent. The women prepare meals from a camper and watch the children play in the big meadow. In the middle of the field is a large wooden silhouette of a person with a big hole cut into the forehead. Its features are crudely drawn; only sustained scrutiny might reveal its identity as a Philistine. The children vanquish this enemy over and over.

This band of missionaries is led by Brian, a young man on fire with the Gospel. His face is red with the heat and the effort of his preparations. The swelter of mid-summer pales against the blue-hot intensity of his eyes. All this charged energy is crowned with a thin halo of white-blond hair. He hopes to build membership in his church through one of the oldest and most elemental of southern traditions: the tent revival.

When the land was sparsely populated, tiny towns could not support a church. Preachers would circulate over a broad area, delivering services in a different town every weekend. Often these services were held under a tent. As tents gave way to churches and towns were able to build a religious community, the tradition evolved. Weeklong tent revivals complemented weekend church services. Church members would gather to sing and bear witness to the power of Jesus in their lives, while the preachers would offer the Gospel message of salvation. As much as the tent revival was intended to gather new

souls into its fold, it also served to reaffirm and revitalize the commitment of the hosting church.

Brother Brian's tent revival is attended mostly by other church people, preachers and their families who drive in from other parts of West Virginia and as far away as Ohio to support him. Everyone is dressed up for the service. The girls wear pink and white straw hats, the men are in suits with suspenders. A seven-year-old boy with a crew cut, wearing a striped t-shirt, is asleep in a metal chair.

Despite having given himself body and soul to the service of God, Brother Brian's heart seems to be feeling overwhelmed and defeated by the enormity of saving souls deep in the hollows of West Virginia. Only one local man has found salvation at this revival, and this new convert seems almost lost amid the group's need to revive itself through the week of evening prayers and songs.

I'm originally from Easley, South Carolina. Two years ago, we moved up here and opened this church in Rhodell. I was in my fifth year of Bible college at West End Baptist Church when I met the missionary Brother Tom Milam. He said to look at West Virginia as a mission field rather than just as a state in the Americas. And right then and there, the Lord seemed to speak to my heart about considering this as a mission field. I had been preaching for about four or five years before that. But I'm a servant of God, and I want to go where God wants to lead me. It seemed like this was the answer to what I'd been praying for.

Originally, we set our goal to have the church be self-supporting in seven years—you know, where it doesn't need any outside support, where it can pay its bills through tithes and offerings. But whether God will be done with us by then or not, I kinda doubt it.

Right now, we just have a burden for these people. And it really brings back a lot of my childhood memories. Where this place has a coal town around a coal mine, we had a mill village around a cotton mill. The way the houses are set up, row after row, is very similar. I can see myself in a lot of these kids, with no Gospel witness. That's what got to me. It's very frustrating to see it. I could point out a lot of children here who are raised in drunkards' homes, that don't know where Dad is, don't know who Dad is, don't know where Mom is. That's very frustrating when you've been on that side and now you're on this side.

All my funding comes from individual churches. We're not a part of the Southern Baptist Association or any other association; we're an independent Baptist church. My home church is in Seneca, South Carolina. They sent me out. 'Course, they're not obligated to give me anything except their blessings and prayers. They do that, but they do also financially support me.

This place is about what I expected, but, environmentally, it's worse here than what I expected. It's a lot more rugged than I'm used to. Where I'm from is not really a big city, but it's developed—you got good roads, a developed septic system, clean water, a place to bring your garbage, things like that. Not like here. You got extremes here. The weather is extreme. You got floods here, extreme winters, extreme water that you have to deal with. It was kind of surprising, how rugged it is.

And the folks are a little bit more traditional, more close-knit than where I come from. They're not real receptive to an outsider. They're friendly, but blood is thicker than water for them. I try to get into the community just by doing good works. We clean up, and we give away food at times, as needed. If nothing else, just being friendly. That's the big thing. See, if you're snobbish, of that nature, it don't matter. It's amazing, but even in a small town like this, everybody won't wave at you when you go through. I don't know if you've noticed that. Some people will wave, but not the majority. They've got to get to know you a little bit.

What has really ruined people, I think, is that they don't have to go out and work and they can stay home and watch TV. When you go to someone's door, you expect a lot of friendliness, but you don't see that as much. Because who needs you? I've got my TV, I've got my Internet. It's like they don't need anything outside their house. A lot of children have been raised as if it is some kind of profession to get on the check.

That same problem happens in church. Before all the entertainments came in, church was a place of social activity. It was a place to see everybody. Right now, mornings, you'll see a group of people up at the Wanna Stop filling station. A lot of the older men go down there to drink coffee, smoke cigarettes, and talk. I go and pass out a few tracts. Just put a few tracts on the table, get a cup of coffee, and put a few tracts in the restroom there.

People feel like they've been hurt; they've been offended. They feel like they're not worthy to go to a church and be around "righteous" people. But they'll come to a tent. They feel like that's level ground for them. You don't see much pride under a tent, and that's the truth of the matter. This tent was loaned to us from the Baptist Ambassadors to America. 'Course, this one needs a little work, and we're raising money for that. I understand one of these tents costs twenty thousand dollars to get made. My idea with this tent is that since most people don't want nothing to do with the church, this is an open playing field for the Gospel. This is just a great location, in this curve in the road, to have a revival meeting. So many people come by and see us for testimony reasons. You can feel the good testimony.

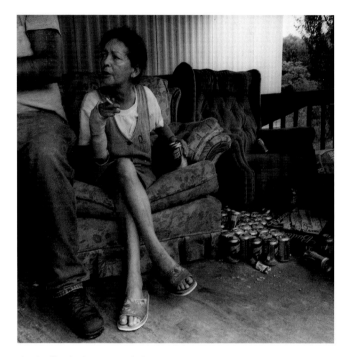

RETURN TO THE MOUNTAINS

JANET (FIFTY-TWO)

Stephenson, West Virginia

Janet spends the hot, muggy days of summer sitting on the porch of her boyfriend's trailer. Janet and Danny chase the heat with beer, either straight from the can or in a teacup. They unload all twenty-four cans from the "suitcase," the extra-large cardboard packaging, into a cooler with ice and toss the empty box into the yard. They pull the TV out onto the porch and just wait to see what the day brings. By the time we arrive, there are eight empty suitcases and one nearly empty cooler.

Janet lives up the road in her sister's house, which some church people are fixing up. She doesn't want to drink around them. A church crew is also working on the trailer across the road, but it is far enough away that they would not be offended. When the last beer is fished out of the cooler, Danny gets ready to leave. He is going to set up the still to make blackberry wine.

My great-great-great grandfather on my mom's side founded the town of Mullens. He should have kept that property, but he sold it in lots. Really, he was cheated out of it by Slick Lilley. He should have kept at least some of it. But I did just buy me a piece of land. I haven't seen it, and I don't know where it's at—somewhere in Mabscott. It was a good deal for two hundred fifty dollars. It's two lots, probably itty-bitty lots. How ugly can it be? West Virginia is so pretty everywhere, so I really couldn't go wrong. The highway is supposed to go through there.

I was born in Carew Hollow in my aunt's bedroom, delivered by a horse doctor. So was my sister. It was my granny's house. Mom used to go off, get in

trouble all the time, and leave my younger brother and sister home with us. We fed them ketchup sandwiches. The neighbors used to steal all our food. They were the same ones that shot my dad. They was just thieves, stealing all our feed. And we would make them sandwiches, too. You know, we made them Tabasco sandwiches. They ate 'em.

We lived up there until my daddy got killed, when I was about ten. He got shot in the living room. It was bad. I saw it happen. Mac Lester, the neighbor, shot him. It was a set-up. They went and opened all the chambers of my daddy's gun and took all the bullets. I saw 'em. Dad didn't know it wasn't loaded, so when he went for his gun, he got shot. They got him to the doctor, and he lived a few months, but then he was paralyzed from the waist down. After that, he got pneumonia and died. You're not going to believe this, but I bought my land from Franky Lester, a great-nephew of the man that killed my daddy. But it wasn't his fault—he wasn't even born then.

We moved down into Alpoca, and then my mom began to drink like you wouldn't believe. When I was twelve, she gave me away to my grandparents, so I moved up on the mountain outside Mullens till I graduated from high school. We lived up there and carried all our water and coal and wood and food. Everything. Didn't have no electricity or a bathroom or nothing. That was rough. I am glad I don't have to do that anymore—I would never make it. These hills is hard to climb. My sister, Diane, went back home to Mom, but the younger kids stayed with me. Lord knows if they are still alive. I have no idea.

Then I graduated and went into the air force for four years. Got married after the first year, wound up with three stepkids, and had four kids of my own. I was in Colorado for about thirty years, and then I got into some legal trouble. I got a DUI, so I came back here and have been here for about three or four years now. I left my kids back there. Everybody out here has a DUI; ain't nobody out here got a license. I love it here, but I love it there, too. My sister tells me to make a quilt with the Colorado mountains on one side and the West Virginia mountains on the other side and me in the middle. It's hard to grow stuff in Colorado, though. Here, I have a garden up the hill. You should see my tomato plants; we had to retie them today. I got the biggest jalapeños you ever saw. I have bell peppers, asparagus, rhubarb. And I got two hens and a rooster.

The way I broke my arm is Danny's wife came over one day. I was sitting inside watching TV. His wife came down with Junior, her boyfriend. She come through this window, grabbed me off the couch, and threw me down the steps, and I broke my arm. She got jealous, but she left Danny six years ago. Danny still lets her come back here and eat, get the dishes dirty.

Well, the police finally got her, but not before she did it again. The day before yesterday, I went down to the porch, figured I would come down and make us some breakfast. I got right to the top step, and she pulls in with Junior. I went right down them steps, and I went home. I don't want to get broke no more.

Next thing I know, she is a-rantin' and ravin', and she sits down and says, "This is my yard, and this is my trailer, and this is my porch, and I'm going to stay here." Danny says, "No, you're not." She cusses him out and cusses him out, and she got slapped upside the head a few times.

I was watchin', 'cuz you can see over here from Diane's house. Then she started marching in front of Diane's house and scared the kids. My sister done had one heart attack, and she said, "I can't stand this no more." She called the law. They got Danny's wife but let her out again on a fifty-dollar bond.

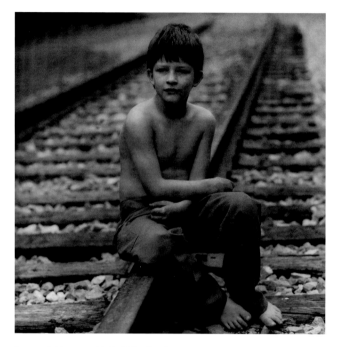

Kenny, eight years old. Coal City Road,
Raleigh County, West Virginia, 2000.

THE LOST GENERATION

ERNEST (FORTY-SIX)

Besoco, West Virginia

Ernest and his wife are third-generation coal mining people. He doesn't work anymore, though he mentions that he has a degree in computer information. He had triple bypass surgery not long ago, evidenced by the scar that extends the entire length of this leg. The couple live with their four children in a trailer that was given to them by the Federal Emergency Management Agency when a flood destroyed their home. They had the trailer put next to the house where Ernest grew up, which he is very slowly remodeling. The lumber and building debris around the house have a settled feeling. The step to the entrance of the house is a single cinderblock. Inside, the walls are torn apart.

Ernest explains the remodel to us, showing us how he plans to improve on the shoddy workmanship of the original house. He proudly waves to a small room holding several five-gallon buckets of various paint colors that he has scavenged. He laughs and comments that it is amazing what rich people throw away. In the middle of the room are a couch, a coffee table, and a TV. He swiftly scoops a couple of half-full, moldy coffee cups out of sight, saying, "Whenever you have visitors, there's always nasty stuff around."

This is originally a house built for the superintendent of the coal mine. After he moved out, my parents bought it—about 1952 or thereabouts. It was built in 1902. Back in those days, there was no such thing as a building code. We froze to death for thirty winters. We're remodeling now, and when we put in insulation, we had to use the blow-in type. There's no way to use the roll-in kind 'cause there's nothing regular in this house. And this is one of the better

ones. You can't do a whole lot with these things. Most people would just go and have it torn down and put in a double-wide or a trailer.

We fought with the county government for two years just to get running water. We heard that they were bringing it to a town not four miles from here. And they says, "No, we're stopping it right there." My wife keeps calling and keeps calling, and finally we have a meeting with everybody. So they bring the water a little further, and then they say the money's run out and they can't take it no further. So then we have to fight with them again to get it moved on a little further. It took from '91 until '94 or '95 to fight with them enough to get it down here. We don't have no mayor or township here, or any services. If you need the police or something like that, you call 911. If you need an ambulance, you call 911.

I was born in this house with a midwife. This house was heated by the coal stove settin' in that corner until about two years ago. In the wintertime, some of these guys run around the mountain and pick up a little coal here and there, sell it for thirty or forty dollars a ton, whatever. Growing up, we had a well outside. And it would go dry in the summer, and you'd be hurtin'. You'd take the jugs and go up the mountain for water. And we had an outhouse. Now I have a septic tank. See, I'm not lucky enough to be able to put mine into the creek. I live on the wrong side of the road.

The creeks do get polluted. 'Course, when I was growing up, we'd swim down here at the trestle all the time. We'd swim there every day in the summer, and we never had no problems. We'd fish for those little old sucker fish that was in the creek, and we'd throw 'em away when we got tired of doing that. And now they got a fish hatchery up there, and those boys run around catching them nice trout. But you couldn't pay me to eat one of them. Knowing what I know, I would not eat one of those fish.

We had fun growing up, I'll say that much. We'd play games like "tin can alley," hide-and-seek, and bicycle tag. And we would play and play, and we didn't have to worry, no matter where you went. If you went to this neighbor's house or that neighbor's house, if you were hungry, there was something to eat. And if I needed correctin', Mommy didn't care if they would wear my butt out, just like she did. You were raised by community, not just by a parent or two parents. We got TV 'round about 1961. We only got one channel—and to get that channel, you had to run a TV line all the way to the top of the mountain. Not too many people was willing to do that. So TV didn't change our world a lot.

When Dad was working, we would go and get candy and pop at the company store. It stood right here, next door. And then they'd just take that right out of his check. But Dad got disabled. He had tuberculosis and was in Pinecrest Hospital for over a year. When he got out of there, I was about ten or eleven. He had black lung and silicosis. He couldn't walk across the room with-

out stopping two or three times to catch his breath. He was in this house for years, and he could hardly get off the porch. He got Social Security and black lung payments, but not from the company. Now the companies are responsible for making the black lung payments, but not when he got them. He died of black lung when he was fifty-eight and I was twenty. It was hard.

Mommy worked for Head Start. She drove her car and picked up the kids and took 'em to Head Start. She didn't make a lot of money. 'Course, there wasn't a whole lot of money to make then, nowhere.

After the last bust, people left and right were moving. Dad couldn't move because he was disabled. You'd see people loading their cars, and they'd take off. You'd see 'em, just leaving. They'd leave their houses with their furniture in it. Most people from this area went to Chicago. All kinds of kids I grew up with—they'd be here one day, and the next day they was gone. Attendance started going way down at the school. It was three stories high, and the next year they used only two floors. I didn't know what to think. My sister is ten years older than me. She and her husband moved to Chicago because he couldn't get a job here.

I graduated from high school in '74 and got a job coal mining. And I worked in coal mines for two or three different places for about eleven years. I worked the midnight shift at Ranger Fielding at Sabine. I had one of those good jobs. I was classified as a beltman. Me and my buddy, our job was to splice continuous conveyer belts. At Sabine, they had over five miles of belts, and they wanted to run them all the time. Our job was to make sure that they were running and that there were no bad splices. If there were, we had to schedule when we could shut 'em down and make the splices.

The conveyer belt would take the coal up to the surface. At most mines, the belt would dump the coal into railroad cars, but the slope was too steep at Sabine, about twenty-one hundred feet, so they had conveyer belts take it down the mountain. We went down an elevator about three hundred fifty feet straight down every night.

I never really liked being a coal miner. I liked the pay: I was making about a hundred sixty-four dollars a day before I got laid off for the last time. You had benefits; all you paid was a hundred-fifty-dollar deductible for the year.

And then, after the last time I got laid off, I didn't go back in. I didn't even look for a job in a coal mine. You'd get a job and you'd work for a year, and then they'd lay you off for eighteen months or two years, and then you'd go back. So I didn't do that anymore. I did a lot of things. I worked as a nursing assistant. We left one time to North Carolina for a couple of years, where I worked in a rock quarry. All kinds of stuff.

In my opinion, what ruined the coal mines was, in part, due to the union. They just kept on wanting more money and more money. They priced us out

of the market. When they laid us off, they told us that coal, in the world market, was going for something like forty dollars a ton. It was costing twenty-six dollars a ton in labor and production just to mine it. And we had five hundred men at one time, so that's a small fortune the company's putting in the mine. And then they can't sell the coal. I think the United Mine Workers was a good thing, but its time was done. My grandfather was a miner before the unions. Whenever he worked, all he got would be enough to go to the company store to buy powder. You had to buy your own powder to blast the coal. That's like working for nothing. When the union started coming about, it got better, but its time is done.

I don't think the economy in this state will ever do any good, not in this area. You've got the rugged mountains, and there's no places for big industries. They opened up this new place in Ghent, building portable homes, but that's only forty jobs. That's not gonna help much. And timber—they've timbered this place to death. That's had a whole lot to do with the floods. I see these timber companies come in here, and they'll cut down a whole mountain with an eight-person crew. Hell, that ain't no jobs. Makes you wonder who's getting rich off a that timber.

The state of West Virginia, they want businesses that are trying to move in here to do everything. They want to get real deep in their pockets.

If you're a kid, you know there ain't nothin' here. There's not a place to go and shoot pool or listen to a jukebox. There's not a place to do nothing. My oldest two talk about leaving. The boy wants to go to college and get a job somewhere, and my daughter's got the same sort of plans. The youngest two are too young to talk about it yet. There's not a lot of young people left to grow up anymore. The school bus for this whole area only has seven kids. The hardest part of living here is knowing that when the kids get old enough, they are gonna have to find employment at somewhere other than McDonald's or Hardee's.

This younger generation that's coming up expects a whole lot. They got those expectations from TV—they see it and want fifty-dollar pants and two-hundred-dollar shirts and a sixty-thousand-dollar BMW. They see these kids on MTV singing and making two hundred million dollars a year, and that's what they want.

But everybody here is poor. We're all poor people here. My philosophy is, you learn to live on what you make. If you make a dollar a day, you can learn to live on it. So people don't have a lot, but people seem to be happy. They're neighborly, friendly.

Most everybody in this community is elderly, retired, or disabled. They're not leaving. In fact, a lot of those people who moved to Chicago eventually moved back. They retired and moved back. If they couldn't move back to their old place, they'd get some other place.

I'm not leaving. It's comfortable here. You can go to bed and leave your door unlocked. Everybody knows everybody. We just kind of let everyone do their own thing. I don't tell you how to live your life, and you don't tell me how to live my life. If your house makes mine look bad, then that's just the way it is. If you're born and raised in the country, you're just country. It don't matter if you go off and get a job and work in any city. You can have forty-seven years of education, and when you come back here, you're just country.

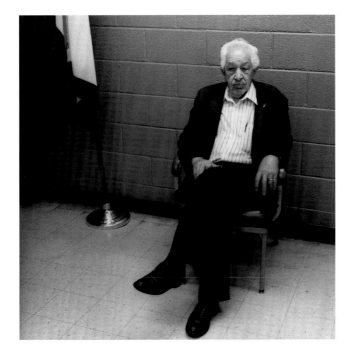

Nick Mason, mayor.
Northfork, West Virginia, 2000.

MAYOR OF NORTHFORK

NICK MASON (EIGHTY)

Northfork, West Virginia

Northfork is deep in McDowell County, historically a hub of the coal mining industry. Today, it is one of the areas where mountaintop removal is most intensively practiced. At eighty, Nick Mason has been mayor of Northfork for ten years. He is a man of extraordinary energy and entrepreneurial spirit. He owns the town pool hall and the small museum, in addition to numerous other small businesses. His son owns the all-terrain vehicle (ATV) shop, around the corner from the pool hall and museum. Nick's daughter owns the barbershop. Between the three of them, they may well own most of the town.

All of Nick's enterprises were shut down by the floods a couple of months earlier. He hasn't had time to put them back together. He works hard for his little town, believing and hoping that good individuals who care about people come to power sometimes—and when they do, it's best to be ready to take advantage of it.

City Hall is a nondescript cinderblock building that was constructed by the Appalachian Regional Commission in the 1960s. The secretary ushers us past the front counter into a cavernous room. Her desk sits against one wall. Each time she opens a drawer or scrapes her chair on the floor, a sound like rolling thunder erupts. In the center of the room, tables are pushed together to form a long conference area. At the head of the conference table is a large, orange Naugahyde chair, reserved for the mayor. Next door to this large room is Nick's private office, which looks like a shrine to President Bill Clinton.

I'm an Italian American. My real last name is Masiono. We had a boarding-house, and we only had Italian boarders—about forty boarders, I think. My dad

worked forty-five years in the mines and never got a scratch on him. All he wanted to do was load coal. That was the job that made the most money.

I didn't work in the mines early. I went to World War II and stayed for about four years. I was eighteen. I knew they were gonna draft me, so I figured I was gonna enlist. And we were real crazy, anyway—we wanted to find out what a war was about. Yeah, I was lucky. I volunteered to go overseas, too, and they sent me to Europe.

After the service, I worked in the mines about twelve years. We built a place of business, and we had a tavern. We had one beer place there and three more right there along the road. The first one belonged to me and my dad. And every weekend, I had to fight somebody. People would work together, they'd fight on the weekends, then they'd go to work on Mondays and work together. I also had a place of entertainment. I had about seventeen ladies that worked for me back in the late fifties and early sixties. That's the best business I ever had. Made more money than I did in any other business.

'Course, I had the coal mine that I operated, too. It was union, but it was a small mine. I had some coal trucks, and what coal I mined, I hauled to the preparation plants. The company that owned the coal paid us for hauling it, too. 'Course, we still had that old reject problem. I remember one time when I went to the office, that lady in there gave me a check. I looked at it and said, "Damn, that don't seem right. Ma'am, I can't understand what happened." She said, "Well, the reject was forty-seven percent." I said, "I hauled both the coal and the reject. Both. It wouldn't make a difference if I was hauling manure. I'm still putting it in my truck." I looked at those railroad cars, and I said, "You got me for two of those gondolas there. That's how many tons you got me for." They still do that now.

When they organized the United Mine Workers, my dad was one of the first that helped. In fact, they sent a fellow down here from Chicago to represent the union, and I think he was one of those Mafia figures. He stayed at our house. It was dangerous. The coal companies had hired these Baldwin-Felts detective agencies, trying to keep the union from coming in here.

I remember the first meeting the union had. They had it at Algoma. The coal companies owned all the properties and wouldn't let 'em meet anyplace. But they had given this place up here at Gillem to a church, and they had a big parking lot. So that's where the United Mine Workers had their first meeting. The coal companies couldn't do anything about that, see.

A detective for Baldwin-Felts come to that meeting to break it up. My dad was at that meeting, and he told him, "You can't break this meeting up. You better leave." Some of the fellas told me that my dad put a gun to that detective's head and said, "Come on, now, take you out of here before we kill you." So that's how they first started, see. They didn't have any more prob-

lems with that detective after that. He was their number one man at Baldwin-Felts, too. 'Course, I used to think my dad was mean, but he really wasn't, you know, unless he had to be. 'Course, I wasn't either.

At one time, McDowell County was the second most populated county in the state. We had one hundred three thousand people here. I'd say at one time this was the richest county in the state, but now it's the most economically depressed. They had a passenger train that come out from Crumpler that had five coaches on that small steam engine. And on weekends, there'd be so many people on that train, every trip, that they'd be hanging on the outside and everything, coming down into town. Now, we only have about twenty-one thousand people since these floods.

Back in the early fifties, it started changing. All these coal mines, when they quit mining after they got all the easy coal, they left. And they took all the money with them. There was never any kind of severance tax on the coal. 'Course, they have got some tax on it now, but it's not set up right. If they had had the coal severance tax on every ton of coal that went out of this county, we'd have some money left. But the legislature wouldn't pass that. I think there was too many connections with the people that owned the coal. To my way of thinking, that's the big thing that happened. The coal companies were from New York, New Jersey, Pennsylvania, and Maryland. When all those mines quit, people had to leave here. They had to go find employment. There wasn't any factories. We just had coal.

You know, the coal companies that were here owned the houses, and they furnished the water. All you had to do was work for the coal company. When they left, that was gone, and people weren't accustomed to paying any of those utilities or anything. The coal companies were selling the houses to people that were living in them, just to get rid of them. But the Pocahontas Land Company still owns the land, see. The houses just started falling down because there wasn't anybody to do the repairs. They didn't last long, so people'd get a house trailer and get on a payment plan.

During the fifties and sixties, the government had what they called commodities. They'd have trucks come in, and they'd give out five-pound blocks of cheese, powdered milk, flour, cornmeal, and canned foods. Some of the people couldn't have survived without that. It was terrible back then. People were leaving this area, going out, south, to North Carolina, different places. I wasn't making a whole lot of money, but I was surviving. I had a service station and a grocery store and a drive-in. I didn't keep the boardinghouse.

John Kennedy came right through here and was campaigning. In fact, we had a cocktail party down here in Welch. I was at the party, and we had a good time. He was a great guy, he was. He went over the whole county—oh, everywhere. He'd just go into drive-ins and get up on the hood of a car and

talk. And crowds—he'd just get right into the crowds and talk to the people. He didn't meet any stranger there. He'd talk to everybody, didn't matter. He didn't have a special group; he'd be right out there with everybody.

Now, Kennedy helped change things from commodities to welfare. I think he's the one that initiated the welfare program. I seen that happen, and I don't approve of that a bit. I don't like the welfare thing a bit because I've seen people that's retired from the mines and I know they're getting probably twenty-three hundred dollars a month; some of 'em get three thousand dollars a month. And I see 'em spending food stamps. Now, that disturbs me. What they do, they've taken these food stamps from people that need them who're selling them for money so they can get beer or some drugs.

The Appalachian Redevelopment Program that Kennedy started brought some government programs, some housing projects. They built two dams around different areas and stuff like that. And that helped some. 'Course, we didn't get much highways down here, but it was better than what we had. We didn't have any before. They'd been trying to get the U.S. 52 upgraded since 1923, when I wasn't but a year old.

I have been in politics for a long time. I had been a conservator, and a judge and magistrate, too. And I just quit that political stuff. I just got tired. We had an Italian mayor here, and I didn't approve of what he did. He wanted to go and try to make some money from it. And, you know, there's no money here. He did things that wasn't ethical, too, and I knew it. Somebody said, "Nick, why don't you run for mayor?" I've been working on all kinds of stuff since then.

I said, "Damn, this is 2002, and we still got one-lane bridges." And so they've changed some of them, and they're going to change the other ones. They always give you the story that they've run out of funds. I don't know if they really do. They run out of funds they wanna spend down in this part of the state. That's what I think happens.

The Department of Natural Resources come in here and said we're going to reclaim these slag piles and we're going to make grass grow on a slag pile. Now, they spent fifteen million dollars down here to make grass grow, and I said, "If you leave that alone, Mother Nature will take care of that, and it won't cost you anything." I can show you some slag piles that you don't know was there, because you can't see 'em. There's trees and grass.

I needed nine million dollars to put a sewage system in here that would help all the people. We can't get that from the government. At a meeting in Parkersburg, I said I have the best sewage system in the state of West Virginia. It's been operating for a hundred years, and it's never broke down. And they said, "Well, we didn't think you had one." I said, "We sure have. It all goes in the creek, and I send it right down to Huntington." And they laughed.

We had some houses that washed out. FEMA, the Federal Emergency Management Agency, came to Northfork to manage some of the worst floods known to have happened in this region. In addition to bringing in trailers and providing food stamps, they were over here buying out these houses, tearing them down. They told me they were going to give the town the property. And the only thing I could put on that property is a garden or a park [because the land is too close to the creek]. I said I'm too old to farm, and I got enough parks. I said I'd just have to pick up the trash and cut the grass.

The state has a program now over at the Council of Southern Mountains where they put so many of these young people to work. They have to be eighteen and work for six months. They pay 'em seven dollars seventy-five cents an hour, but they only work six months, because they're not paying 'em any unemployment, see. So they send me a list, and I pick me some that I want to work in the town here, and it don't cost the town anything. They clean the town up, paint it up, clean the stream out—just whatever I need 'em to do.

They've got a new program that's gonna start the first of the month. I think they've got about fifty-three million dollars. I forget where the money comes from. And they're gonna be able to work almost a year this time. That changes the program a little bit. I might get seven or eight people. When that program's over, they'd be able to go and work with somebody else. They'd get a job somewhere. I'm a hard teacher. I'm a carpenter, and I'm a plumber and an electrician, and I lay bricks. I'm a mason.

Well, the best thing we got going for us right now is those four-wheelers, ATVs. The tourists ride through these mountains. We got people coming through here from all over the country. We had some from Idaho, North Carolina, South Carolina, Tennessee, Virginia. They come in every weekend. And we need to get some places, some cabins and stuff back in these mountains, little places for people to stay. That's going to help us more than anything.

'Course, we're getting an industrial park put in down the lower end of the county, in Welch. They're bringing that King Coal Highway through there. They're working on that now. Then we got a federal prison that they're putting up there, where the industrial park's gonna be. That's gonna be about six hundred jobs. And they're going to have a ladies' prison, and that's going to make about four hundred jobs. Plus we'll have some spin-off jobs outside. If you have that many people, you gotta have a place to eat, and you gotta have some doctors, and you gotta have some nurses, and all those things that come with it.

Well, I think we're gonna recover when we get used to the idea that coal's not the only thing we can do. That's the big thing. 'Course, right now, coal is the number one source of revenue in the state of West Virginia. It is.

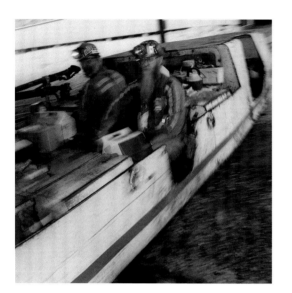

Shift change at a coal mine.
Mingo County, West Virginia, 2001.

LOCAL COAL INDUSTRIES OWNER

JOHN (FORTY-NINE)

Southern West Virginia

John is one of the largest employers in southern West Virginia. His family has owned and operated coal mines for three generations. The family business has grown into a kind of empire, with coal representing only about half of the operations. In addition to the mines, his company owns numerous subsidiaries in business not related to coal. John is prominent in local community affairs and politics. He is on the board of directors of a powerful lobby group that was instrumental in swinging the state's five electoral votes from the Democratic Party to the Republicans in the 2000 presidential election.

His family lives in an unpretentious home in a picture-perfect village in which no coal is mined. They are an exceedingly gracious family and give generously to their community through volunteer work. He and his wife are attentive and proud parents.

My father grew up in a little coal camp. My grandfathers on both my father's and my mother's side had always worked in the coal business, and so my dad kind of fell into their shoes. He went to the university and graduated as an engineer, but he was just a company worker. Through my grandfather's contacts and everything, he got a small piece of coal, became a coal operator. He and his brothers went into partnership and slowly and surely began structuring and building a business.

I went to college and worked for my father for about six months. Then we started developing our non-coal-related business. It was a great way for me to be responsible for one side of our business and my father to be responsible

for the other side. Since 1993 I have grown our business probably six or eight times.

I could never have done it without the United Mine Workers and my relationship with them, and I mean it. That's not hogwash. These people have worked with me, and they've worked hard. You can really get my dander up quick when you portray a West Virginia union coal miner as ignorant, not educated, not a very good business person, a redneck radical. I mean, I work with these people every day. They're anything but that. They're running the most high-tech equipment that you could run. They're hard-working; they're family people; they're good people. They're very reasonable to talk with, and we just work together the best.

Coal has a lot of problems. One is that the coal industry has managed to develop a very poor image. The coal operators as a whole—we've done a poor job of PR. There's no question that many coal operators, inclusive of myself, we've made mistakes. But we've done a lot of good, too. Lots and lots of good. And people close their minds a lot of times on the good we've done. If I thought that I could do something tomorrow that would damage our environment or would endanger people, I would—honest—I would cut my arm off before I did that. And you know what, darlin', there are many, many, many coal operators who feel the same way. But we're not perceived that way. West Virginians are a wonderful people, but we have this deeply ingrained thing that has come from years of bad stuff on both sides that leads us to think automatically that if you're good [at this business], you gotta be bad.

The story about West Virginia is that big rich guys come in here, rape the land and people, and then leave. Now, there's no question that some of it's probably fact. And if you tell that, you're just going to be telling what everybody's told. And if you tell the poor plight of the uneducated, pitiful little coal miners, that's not really good either. That's a story that's been told a hundred times over: these big, out-of-state, rich coal operators or entrepreneurs came in, plucked out the good, packed up, and left town. Left the land damaged, the environment worse, the streams and the water quality worse. The truth is, there are many, many coal operators within the state that have been here forever.

Nobody wanted the coal industry to die. Fifty or seventy years ago, Keystone and other towns in McDowell County were booming little towns. And they were booming because coal was in high demand in the United States at that time. Then a couple things happened. One is that the technology came along where we could make steel with lesser-quality coal. Foreign reserves were found, and, with much less stringent regulations overseas, they could mine those foreign coals. Those coals became very cheap, and so, basically, you just put southern West Virginia out of business.

If you have a five-and-dime store in the middle of the town and a Wal-Mart comes, the five-and-dime store dies. It's no different than if you're operating a mining operation in McDowell, and all of a sudden, Japan doesn't have to buy from us anymore because they find they can buy it from Australia cheaper. The market dives, and suddenly there's no market for coal. It's happened all over the place, and it's happened in McDowell County. From 1985 to 2000, it may have even been worse than after the big bust. If you got a twenty-five-cent-per-ton decrease in price, it could put you out of business.

Then, in 2000, you had a kind of mini-boom, as the coal industry has done many times over. I think that was driven primarily by the economy and all the growth in the nineties. Coal prices on the steam [electrical power generation] side went from the high teens to forty-five dollars a ton, maybe even fifty dollars a ton. In 2001 you had the California blackouts and brownouts. For twelve or eighteen months, coal prices increased dramatically on the power side. And that didn't affect my business a great deal, because 95 percent of our coal was going to make steel, not power. Prices for our coal, metallurgical coal, did increase, but only very, very marginally—probably a dollar or a dollar and a half per ton. Some of the metallurgical coal was finding its way into the steam market, which customarily didn't happen, and therefore the steel companies were short on their supplies. And the steel companies were really struggling anyway. The power companies, fearful of not having supply, bought and bought and bought. And it drove the market like crazy.

It was probably late 2001, people were predicting that the coal market was going to stay really strong for probably twenty years at a time. And just when it looks like everything is running in one direction, things happen. You had the attack on the World Trade Center, a slowdown in our economy, a very, very mild winter compounded by a cool summer. And from the standpoint of electricity demand, those things were significant. The power companies had stockpiles of coal, nowhere to put it, and obligations to buy more. And so they became sellers. There was such an oversupply of coal that it was unbelievable. And the market just collapsed. It drove a lot of companies out of business. From the highs in the year 2000 or 2001 the market has just been flat on its face. The steam market started to move just a little bit about forty-five days ago from a low of twenty-four dollars and fifty cents to twenty-five dollars and fifty cents a ton. Steam coal today is probably selling for twenty-eight dollars and fifty cents to twenty-nine dollars and fifty cents a ton.

You just mentioned all the press that coal has been getting lately, claiming that coal lobbyists set a lot of wheels in motion, that because the coal industry donated heavily to George W. Bush, he has done favors for coal. Well, my take on that is that a lot of it could be coming from people who are probably not real well versed in exactly what's going on. Not to toot my own horn

in any way, but I feel pretty confident in what I know. The natural reaction for people today is, a lot of coal people supported George Bush. Now, this is the natural reaction; this is not my reaction.

With the electoral college the way it is, you could even say that he won the presidential election because of West Virginia! And West Virginia voting for a Republican is almost unheard-of. So you could translate that into the fact that he surely ought to be doing favors for the coal industry, and therefore the coal industry ought to benefit from all that. To move away from coal in our lifetimes may be very difficult to do. If civilization is to continue to advance, it's almost imperative that we have cheap, abundant energy.

West Virginia is blessed with coal. Now, we need to exploit that. We really do. We've created an almost hostile business climate in the state. That's why you see those poor people down there. They can't find a job. They gotta have a job, and I would be the one that would lead the charge. We as an industry need to do the right thing for the environment, the right thing for the water, the right thing for the people. And you know what? A lot of us feel that way. And not at the expense of anybody. Now the problem is, West Virginia is probably way behind other states in trying to develop other industry.

But in McDowell County today, there is a wonderful story. The three commissioners—they love McDowell County, and they love their home. They came up with an idea. They approached Massey Coal Company to dedicate some land back to the county. And then they approached some other people and Senator Byrd. They got the King Coal Highway that's going to come through the county. In addition to that, they bid on land to develop an industrial park.

They could get a federal prison or whatever company to bring employment back to the county.

The idea of the industrial park is being expanded to have housing. They can take people who are now in the floodplains, in those awful hollows that have been devastated by the tremendous floods in the last two or three years. It won't be public housing, not that at all. The county is trying to develop some alternate housing that would be available for homeowners as well as businesses to get them out of the floodplain. I'm sure there's going to be federal assistance dollars for those people that can't afford to buy a house. Honestly, the vision of these three guys oftentimes parallels the vision of those Rockefellers, the way I see it. Now, there's still a lot more stars that gotta line up. But we're on our way.

The future of coal has gotta be that you find a cleaner way to be able to utilize coal or, really, an alternative source at some point in time. Every coal operator wants that, they really do. That may be hard to believe, but they do.

Think about West Virginia. You have a decent infrastructure. You've got maybe one of the lowest crime rates in the country. It's beautiful; you've got four true seasons, pretty decent climate, relatively close to a lot of big-time metropolitan areas. It has every single thing in the world to take off. And yet we still strike out. Something bad is going on, something very, very bad. And beating the same old horse the way we've beat it . . . we've done it and done it. What's happened? Nothing. I say, we gotta get all lined up on the same side of the fence. If we do that, we got all the rest.

Statue of miner at the county courthouse.
Madison, West Virginia, 2000.

JUSTICE FOR WEST VIRGINIA
SUPREME COURT OF APPEALS

JUSTICE WARREN McGRAW (SIXTY-THREE)

Charleston, West Virginia

Justice Warren McGraw understands the electoral process in West Virginia and has found ways to work within it, despite his pro-labor political views, which are in the minority. He has tremendous energy and vitality. His sharp eyes take in every detail of his world, with which he is fully engaged.

The formal decor of the judicial chambers, with burgundy carpeting and colonial furniture, hardly dampens his penchant for regaling visitors with lively accounts of the inner workings of government in West Virginia. While our interview was carefully constructed, Justice McGraw joined me and several other people in the reception area of his chambers afterward and shared more colorful, behind-the-scenes stories as well.

My father's family was made up of farmers and pioneers who came into the Virginia region about 1750 and carved out a life as mountain farmers. My mother's side of the family was part of the world's greatest immigration, from Europe to America in the early 1900s. Most of my relatives have worked in the coal industry. My parents were schoolteachers, but my father also worked as a coal miner. My brothers and I grew up on a mountain, in a place called Low Gap. We had no neighbors, no paved roads. We were the first people in the community to have running water and a toilet in our house. We were mountain people.

My parents had taken it upon themselves to teach their children that there were other things in the world besides Low Gap. I remember, when I must have been five or six, my parents took us to a place called the Carnegie

Museum in Pittsburgh. So here we are, kids from southern West Virginia who barely had shoes, visiting this museum in Pittsburgh to see what might have been back home with the wealth that was earned there. But we had to go three hundred miles and three hundred years away from where we lived to see it.

The people who actually run the coal industry do live here, but the corporate power is somewhere else: Philadelphia, New York, Boston, Pittsburgh, Amsterdam. I've always claimed that we are a mere colony. In fact, we here in West Virginia may be the last colony in the nation where we are exploited for what we can do for other people in other places. Local folks who are in the coal business tend to have a bigger interest in their local community and its welfare. I'm not promoting any of these local coal operators. What I'm saying is, people in Pittsburgh or Philadelphia or New York don't care what happens to us and make little or no contribution whatever, other than wages, to these communities.

I think the same is probably true of much of the natural resource–producing areas of our nation. When I drove through Wyoming and Montana, I was shocked to see that, while the terrain is different, the conditions of the mining areas weren't greatly different from what we have here. I could see that these extractive industries cause people who own them not to have much regard for the local folks. And that's always bothered me.

From college, I went to work in 1957 in Ohio at the world's largest pipe mill. I was making top wages, a dollar and ninety-two cents, and felt it was just the berries. Fortunately for me, perhaps, I lost that job in what I call the Eisenhower Depression of 1957. I came back to West Virginia and went to law school. I started running for office in 1964 but was getting beat in the elections.

Meanwhile, I was representing coal miners in workers' compensation claims, trying to prove that they were entitled to compensation for mining injuries. If you couldn't prove you had been subjected to silicon dioxide inhalation, you couldn't prevail, even though you couldn't breathe. Literally thousands of men were suffering from respiratory disease, which became identified as black lung disease by Dr. Donald Rasmussen, who still practices medicine in Beckley. He set up a lab at the Appalachian Regional Hospital, which was operated by the coal miners union, and started doing studies of coal miners. He was able to determine that coal workers were suffering from the inhalation of minute particles of coal dust, not silicon dioxide, and that the coal dust settled in the lungs and stayed there, affecting the ability to breathe. His conclusions began to be public information by 1968.

That year, I had a plan. I decided to run for two offices because all the political power in our community was centered in this one law firm, which represented the coal workers union, the Democratic Party, and the business

community. They had their own Democratic candidates that they didn't want anybody interfering with. I ran for judge and for the legislature. They were out to make sure I didn't get elected judge and kind of forgot the fact that I was running for the legislature, so I got the nomination and was elected.

We started traveling all over southern West Virginia promoting justice for those who suffered from black lung and encouraging the miners to do whatever they had to do to seek compensation and seek justice for the wrong that had been committed against them. I became very popular with the coal miners. I introduced a bill into the West Virginia House of Delegates to provide coal workers with compensation for black lung. We were the nation's first state to pass a black lung law. Richard Nixon signed the federal law at the very end of 1969.

Later, in 1972, I became a state senator in a big race, which was depicted in Bill Moyers's documentary *If Elected*. I was pitted against the state's largest coal operator of strip mines. We made significant reforms in the way the mining was done, to preserve the land. The laws required reclamation and a return to the approximate original contour of the land. It worked. Everybody was happy, both the mining industry and the people who lived near the mines. Then, in the early nineties, they got into this practice of mountaintop removal, which has become quite controversial.

In 1975, I sponsored and prepared a bill with my brother, Darrell, who is now West Virginia state attorney general. The bill became West Virginia's first coal severance tax. It imposes a tax of thirty-five cents on every hundred dollars' worth of coal severed in this state. That money is split up so that seventy-five percent goes to the county where the coal was mined and the other twenty-five percent goes to a fund that is divided over the whole state, whether you have coal or not. That's how I was able to get it passed, by giving everybody a little chunk of the money. In my county, it has contributed to a number of swimming pools, a couple of health care clinics, a youth camp, and all kinds of things. The money went to building public libraries where we had none. The corporate leaders of the energy industries, whose primary focus is on profits, refer to it as the McGraw tax. Once a month, when the coal company owners, who primarily live out of state, write that check, they remember that I'm the guy that introduced that bill and got it passed. That made me public enemy number one with the coal companies.

It has been somewhat of a miracle that I have survived politically. Without the United Mine Workers of America and the coal miners who took a liking to me, I would not have made it. I would never have been a senator. I would never have been a senate president or lieutenant governor. But I have. I speak out for what is the best interest of people and, as a consequence, I am public enemy number one of big money. The coal industry, the insurance industry, and

the tobacco industry have been very successful at promoting their agenda and identifying people like me as their foe. They're able to convince people that I'm not good for business. And then people think it's just horrible you're attacking the industry. I'm not attacking the industry. I simply want everybody to bear their fair share of the burden and see that people who are hurt or injured receive compensation for their injuries.

The coal industry has changed a lot in West Virginia. There used to be a premium on having a lot of people do hard work. Now miners are highly skilled, highly proficient at what they do. My brother-in-law operates a machine that costs a million dollars. But the coal industry does constantly keep our people in fear. They hold the threat of no jobs, of quitting the area and leaving in order to take advantage of laws that give them special treatment or to get laws passed that give them special treatment.

I see West Virginia's future as being a combination of tourism and industry. We are as diverse in our industries as we are in our geology and topography. We have steel, coal, gas and oil, chemicals, and timber—industries that will remain our bedrock employers. But they will be more mature, run by people who have some respect for the people who work for them and who seem to be more understanding of what it is to be a good neighbor. Hopefully, the coal industry will begin to treat West Virginia people as these other industries have, as people to be respected and regarded with care.

You know, in West Virginia, the issues never change. Sometimes they change a little, but the players are always the same. For example, Cecil Roberts is the president of the United Mine Workers of America. He is the nephew of Bill Blizzard, who was tried for treason in the twenties for trying to organize the miners. Not too long ago, we had a case here involving an issue about who could sit on the state supreme court, and I wrote the opinion on that case. And one of the footnotes was about a member of the West Virginia legislature who was removed because of an oath he refused to take. That man was my great-great-grandfather, who was elected to the West Virginia House of Delegates just after the Civil War.

Postscript: In the 2004 election, Justice McGraw was targeted for defeat by business groups, and he lost his bid for reelection to a novice Republican candidate backed by insurance companies, the U.S. Chamber of Commerce, tobacco interests, and coal operators. Don L. Blankenship, chief executive of Massey Energy, poured three and a half million dollars of his own money into advertising that attacked McGraw (James Dao, "West Virginia Heads Down a Political Road Less Taken," New York Times, November 16, 2004). Justice McGraw estimates that, overall, the onslaught of bad press against him may have cost as much as ten to fifteen million dollars. Justice McGraw's campaign was the subject of Wayne Ewing's documentary If Re-elected.

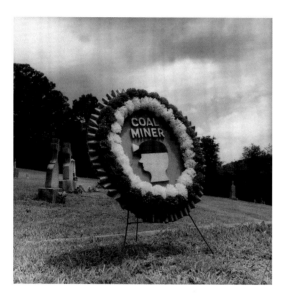

A wreath at a Catholic cemetery.
Carlisle, West Virginia, 2000.

NOVELIST AND POLITICAL ACTIVIST

DENISE GIARDINA (FIFTY-ONE)

Charleston, West Virginia

When Denise Giardina appears for her interview in one of the few bookstore/coffee houses in Charleston, no one would guess that she had run for governor of the state only two years earlier. She is bundled against the winter cold in a long, faded down coat and a large woolen cap. Clutching a giant shopping bag, she stands uncertainly in the middle of the crowded café, as if she had stumbled into the wrong universe when, in fact, it is practically her second office. Her reticent and shy persona belies an incredibly courageous will, a passionate soul, and an acerbic, direct voice.

Denise was born in Black Wolf, a coal camp in McDowell County. She became an ordained deacon of the Episcopal Church and requested to be assigned to a church in McDowell County. She organized a group to investigate local land records, discovered that out-of-state corporations owned 85 percent of the land, and began to agitate to raise tax assessments on the absentee landholdings. Ultimately, the church ordered her to stop.

She abandoned the church and moved to Charleston to continue political work in the office of Bob Wise, then a Democratic congressman. In 1984, she published her first of five novels, Good King Henry. *In 2000, she ran against Bob Wise for governor on the ticket of the Mountain Party, which became a bona fide third party in West Virginia during the course of her campaign. She now teaches at West Virginia State College and continues to write fiction.*

I sorta got talked into running for governor because there weren't any candidates who were against mountaintop removal. I ran on that issue. There was

no money, and I'm not real well known; but because of being a writer, I had some name recognition. It was not much fun. It was interesting in some ways, but it's not something I would ever want to do again.

It took a year and a half to get on the third-party ticket because you have to go through so many hoops. You have to get signatures on a petition. And you have to tell people when they sign the petition that they're not allowed to vote in the primary, because signing a petition is the same as voting in the primary. That seems to me to be unconstitutional. The primary is meaningless, too, because the party apparatus picks who is going to be the next governor. For example, Bob Wise had a challenger in the primary, but the state party wasn't backing him, so it was pretty much a nonissue. It's why we have very low voter participation in this state. People feel like it's a farce.

It was worth it to raise the issue of mountaintop removal, but it was pretty depressing, actually. People in the northern part of the state don't know as much about mountaintop removal because it doesn't affect them so much. It made me realize how little information really comes through the electoral process. I mean, the media is just awful, especially the TV stuff. It's all sound bites, and you don't have time to go into anything in any kind of depth.

Cecil Underwood was the Republican gubernatorial incumbent, and Bob Wise was the Democratic challenger. Even the people that voted for Wise who said he was the lesser of two evils are really disgusted with him now. He's more conservative than a lot of the Republicans.

A lot of people are really very pleased with U.S. Senator Byrd right now, though it's a mixed bag. He's one of the few people who's standing up to Bush on both homeland security and Iraq. He's got an old-fashioned sense of principle and fights for the prerogatives of the legislative branch. He is a coal guy, but he has brought a lot of federal money into the state over the last fifteen years. For most of my lifetime, West Virginia was dead last in terms of federal dollars received, and we're one of the poorest states. For example, we have no military installations. All of a sudden, Senator Byrd started bringing that sort of pork-barrel stuff in, and some of it is job-related. People down in the southern part of the state aren't really benefiting from what he's doing, but I don't see much of anything that would benefit that part of the state now, short of a revolution, which is not going to happen.

I mean, how would you develop the economy there? The land is owned by outside corporations, and they're still raping the place. Who wants to move there? How would you attract businesses there? It would involve land reform, and that's not going to happen. Assuming you could find somebody who could get land and wanted to live there, there aren't any services. The schools are horrible, there's no water, no sewage, no recreational facilities, no cultural life. There's nothing that would attract anybody.

The coal companies operate behind the scenes. It's total naked power. They probably threaten people, for one thing, but they also give a lot of money to campaigns. They have a hospitality suite where they wine and dine and provide prostitutes and stuff like that. They control the counties, they control the jobs—usually jobs with the board of education or something like that. They have slates, and you're told how to vote. A lot of people don't vote anyway. It's basically the way any company controls a Third World country. How do mining companies control African nations? The same way, pretty much. They even control what goes up on monuments and statues and things like that.

They're putting up a monument right now. It was supposedly for coal miners, but it turns out that the plaque says it's for everybody who had a career in mining. It's got all these plaques around the base that celebrate strip mining. When citizens tried to get that changed, they were told that the state had no power to change the monument because the coal association was paying for it.

They know that coal has a limited future. Why are these companies holding on to this land? I mean, you've got Bush talking about hybrids. They know that some things are on the way out, and they're morphing. In the meantime, they're going to make as much money as they can and then move on to something else. Back in the sixties and seventies, some guy who worked for the federal government came up with some documents showing southern West Virginia as a target for a potential toxic dump site. It kind of died down, and they didn't talk about it anymore. But I always remembered that. These companies have hundred-year plans. They think way ahead.

I used to be real idealistic about the idea that we have this Appalachian culture and heritage and love of the mountains and stuff. That's being killed, I think. It's still there in some people, but, again, they have no power. Even some of the most influential people in this community have no power.

Nobody really cares about West Virginia 'cause we're a bunch of hillbillies, a bunch of ignorant, backward people who marry their cousins. That's the stereotype. When the Massey sludge pond broke on the West Virginia–Kentucky border two or three years ago, it was called the worst environmental disaster to hit the southeast. You know, it hardly made the news at all. You could travel out of state and nobody ever heard of it, even though it was worse than the Exxon Valdez. It released ten times as much sludge into the river as the Exxon Valdez released oil. The sludge went into the Tug River on the border there and devastated the waterlife—what was left of it, anyway. It destroyed people's property. There are lawsuits about it now. If it had happened in the northeast, the news would have been all over the place. The worst environmental disaster in the history of the southeastern United States, and it's not even on the news. Give me a break.

DESIGN AND COMPOSITION
Nicole Hayward

TEXT
8.75/15 Interstate Light

DISPLAY
Interstate Bold

DUOTONES AND PREPRESS
Color Tech Corporation

PRINTER AND BINDER
Color Tech International Printing Ltd